REACTIONARY MODERNISM

by

JONATHAN BOWDEN

EDITED BY GREG JOHNSON

Counter-Currents Publishing Ltd.
San Francisco
2022

Copyright © 2022
All rights reserved

Cover design by Kevin I. Slaughter

Cover image:
Jonathan Bowden, *Mussolini with Biplanes*

Published in the United States by
COUNTER-CURRENTS PUBLISHING LTD.
P.O. Box 22638
San Francisco, CA 94122
USA
http://www.counter-currents.com/

Hardcover ISBN: 978-1-64264-166-0
Paperback ISBN: 978-1-64264-167-7
E-book ISBN: 978-1-64264-168-4

Contents

Editor's Preface by Greg Johnson ❖ iii

1. Opening Pandora's Box: An Elitist Defense of Modernism ❖ 1
2. On Modern Art ❖ 3
3. Elitism, British Modernism, & Wyndham Lewis ❖ 6
4. Wyndham Lewis' *The Childermass*: Black Metal, without the Music ❖ 32
5. Wyndham Lewis' *The Apes of God* ❖ 37
6. Wyndham Lewis' *Tarr*: An Exercise in Right-Wing Psychology ❖ 41
7. Ezra Pound ❖ 45
8. T. S. Eliot: Ultra-Conservative Dandy ❖ 68
9. T. S. Eliot ❖ 71
10. W. B. Yeats ❖ 99
11. Zeus Hangs Hera at the World's Edge: Arno Breker & the Pursuit of Perfection ❖ 122
12. Stewart Home: Communism, Nihilism, Neoism, & Decadence ❖ 128
13. Stewart Home & Cultural Communism ❖ 157
14. Against the Turner Prize ❖ 163

Index ❖ 181

About the Author ❖ 198

Editor's Preface

To most people today, the idea of "Reactionary Modernism" in art is a contradiction in terms, like "Conservative Revolution" in politics. But before the Second World War, there actually were Reactionary Modernists in art and Conservative Revolutionaries in politics.

Their thinking has become unthinkable today because the cultural and political establishment in the West has worked overtime to fashion the Second World War, and especially the Holocaust, into a pivotal historical event that changes the meaning of everything, much like the birth of Christ, which divides history into a "before" and an "after."

After Auschwitz, we are told, we can have no nationalism, no populism, no Conservative Revolution, and all cultural forces like artistic Modernism must be aligned with progressive politics and liberal cosmopolitan values.

But those who declared Reactionary Modernism unthinkable never met Jonathan Bowden, who as an artist made it not just thinkable but real again. Jonathan also reincarnated the Conservative Revolution simply by publishing a magazine called *Revolutionary Conservative*. As an artist, publisher, author, and orator, Jonathan Bowden declared spiritual war against the political correctness, cultural philistinism, and moral funk of the post-War consensus.

Reactionary Modernism collects Jonathan Bowden's principal works modern art. The volume begins with two brief statements of Bowden's own artistic credo. These are followed by essays and speeches on such Reactionary Modernists as Wyndham Lewis, T. S. Eliot, and Ezra Pound, plus two reactionary artists with a more tenuous connection to Modernism: W. B. Yeats and Arno Breker. The last three chapters deal with degenerate post-War Modernism in Great Britain through discussions of Stewart Home and the Turner Prize, though even here Bowden sees traces of healthy values and elements that can be appropriated for a renewal of British art.

In editing Bowden's transcripts, I introduced paragraph

breaks and used punctuation for maximum intelligibility. I occasionally omitted false starts. I left sentence fragments intact but corrected the subject/verb disagreements common in spoken discourse. In the transcripts, ellipses indicate where Bowden's train of thought changed direction before completing a sentence. I capitalize the names of artistic movements like "Modernism." In Bowden's writings, I left his sometimes-eccentric capitalization practices unchanged. I was forced to omit some of the poems Bowden read aloud, due to copyright. Their omission is marked by notes. Copyright considerations, as well as a lack of good quality source images, also made it impossible to include Jonathan's illustrations in his "Against the Turner Prize" presentation, but the video can be watched online at the Jonathan Bowden Archive at jonathanbowden.org. I added the minimum necessary explanatory and corrective notes. (All notes are mine.) The passages that appear in quotation marks in Jonathan's speeches are, of course, usually his paraphrases, not exact quotes. If you wish to consult the original recordings at the Jonathan Bowden Archive, you will see that nothing extraneous has been added and nothing essential removed.

I wish to thank everyone who helped bring this book to press: Michael Woodbridge, Jonathan's literary executor, for his imprimatur and encouragement; my transcriptionists V. S., D. B., and F. F.; Millennial Woes and his brain trust for helping decipher the last few unintelligible words; James O'Meara for his index; Kerry Bolton for his blurb; Kevin Slaughter for his cover design; and my team of proofreaders, including Howe Abbott-Hiss, Beau Albrecht, Kerry Bolton, Nicholas Jeelvy, James O'Meara, Spencer Quinn, and Fenek Solère. Any remaining errors are my fault.

This book is dedicated to Matt Tait, who decided that Jonathan's speeches were worth recording for posterity.

<div style="text-align: right;">
Greg Johnson

March 25, 2022
</div>

OPENING PANDORA'S BOX:
AN ELITIST DEFENSE OF MODERNISM

I would like to take this opportunity to respond to various postings which have been placed on the website *Stormfront* in recent weeks. I would like to thank those people who have been supportive of my efforts. Other correspondents have been less charitable, however. But amidst all of the silliness and abuse, these people are contriving to make a serious point, and this is: the status of modern or Modernist art.

This happens to be a completely legitimate debate and one which I will respond to now. What large numbers of Western individuals have missed is that a seismic shock went through the art world at the end of the nineteenth century. This was completely adjacent to the creation of photography as both an art and a science.

Once a classic early photographer like Edward Muybridge produced an interconnected series of images featuring Greco-Roman wrestlers and running horses, the world was forever changed. Fine art now had a choice — it either replicated photography badly or in a stylized way, which was loyal to a tradition running from Rembrandt to Orpen, or it contrived to do something else.

What it did was to go inside the mind and tap all sorts of semi-conscious and unconscious ideas, fantasies, desires, and imaginative forays. All these relate to iconic art, religious painting, and the art of the occult, spiritualism, pornography, and even the images of the insane or the marginally so. It also relates to religious art as exemplified by Pacher, Giotto, Cimabue, Bosch, Brueghel, Grünewald, and various modern masters of a similar sort.

The point about this art is that it is highly personal and powerful because it comes from inside. This means that people often of a highly rigid and morally defensive character find this work heretical, blasphemous, evil, and even degenerate. (Indeed the theory of degenerate art originates from the 1880s when this

change of direction took place). A large number of modern masters like Bacon, Buffet, Ernst, Paolozzi, Balthus, Dalí, and Labisse have all dealt with these themes.

What has happened to art in other directions is that representational, classical, traditional, and academic work has been taken over by cinema. The moving image and the tens of thousands of individual films produced for well over a century now are a testament to this. Great filmmakers like Lang, Hitchcock, Stroheim, Gance, Truffaut, Renoir, Syberberg, and Tarkovsky are all examples of this. They inherit the tradition of representation which has gone elsewhere. In the end you either love or loathe this.

Two regimes in the twentieth century tried to prevent painters and sculptors producing Modernist work. These were Nazi Germany and Stalin's Soviet Union. Both failed. The reasons for this are the dynamism of the modern current—even though German sculptors like Arno Breker and Gustav Thorak were excellent artists, but they were also copyists who were returning to the Greeks and Praxiteles. The dilemma which painters and sculptors have faced is either to create purely imaginatively or just to make films in another medium.

Turning to my own work, various currents are discernable. These are the demonic, strength, and a concern with pure power, ugliness, and fury as well as erotica and shape, or purely imaginative formulations. In my own mind the softer material balances the harsher, more violent, and aggressive work. Nonetheless, I have also done a large number of relatively traditional pieces which hark back to classic art by Bosch, Rops, and Caravaggio. Some are also based on Hellenistic form. Obviously a subjective element intrudes into art, but I believe that Modernistic fury is the correct vehicle for elitist and hierarchical values.

I always sign everything I produce—whether in writing, on film or as an image—with my own name.

Jonathan Bowden

Counter-Currents, August 11, 2010

ON MODERN ART*

ON MODERNISM

I'm an ultra-Rightwing Modernist, let's make that clear. Even though some of my work is traditional, restorationist, historical, and semi-classic in spirit . . . nonetheless, I'm a Modernist, even on some occasions an Ultra-Modernist. Let's be definite about this: some of my pictures do relate to Bosch, Redon, Klimt, Bacon, Pacher, ancient Greek sculpture and so on, but primarily I wish to create new and ferocious forms. They must come from within; what you really require is an image the like of which no one has ever seen before, even dreamt of prior to your conception.

Bacon always declared that he wanted to paint the perfect cry, after the fashion of the nurse on the steps facing the White Guards in *Battleship Potemkin*. I never wished to paint the greatest scream a la Poussin's *Massacre of the Innocents*. No. For my part, I wanted to paint the most ferocious image of my time — these works are not neurotic, paranoid, schizoid, disturbed, or mentally ill, as some might suggest . . . they are passionate integers of fury. The effort is to project strength and power.

One cares nothing for the aesthetic standards of the masses; they are children who only like what they know or feel comfortable with. What really matters has to be the ecstasy of becoming — early or classic Modernism happened to be exactly that. It was an attack on sentimentality; it proved to be an art purely for intellectuals. It was anti-humanist, elitist, inegalitarian, vanguardist, misanthropic, sexist, racist, and homophobic — all good things. It gave witness to the Neo-Classic bias within the Modern that related to the theories of T. E. Hulme, a revolutionary conservative, and Ortega y Gasset, a mild fascist.

In the latter's *Dehumanization of Art* he preaches a new style against the Mass — that notion has always intoxicated me; to

*Two excerpts from "Revolutionary Conservative: An Interview with Jonathan Bowden," by Troy Southgate.

trample upon the masses and synthesize them into a new evolutionary surge has to be our object. The failure of extremist conservatism, fascism, and National Socialism was material; revolutionary Right-wing ideas may only really flourish spiritually: art has to be its vehicle; the stars its limit... *Homo stultus*, the putty.

Early Modernism found itself penetrated by these ideas... only much later did it become a vehicle for liberal humanism. A move which in and of itself related to the academic, restorative, and conservative aesthetic tendencies in Soviet and Nazi art. One of the ironies is that revolutionary art becomes liberal wallpaper, while revolutionary movements adopted philistinism as their watchword. Their anti-formalism became a rigid fear of upsetting the majority.

Art partly exists to disturb expectations, but liberal anti-objectivism has gradually dissolved this influence. An image like Tato's *March on Rome* becomes more and more diffuse... until you end up with a David Hockney sketch, a Yorkshire scene bathed in light and adorning a corporate office anywhere in the world. But let's not fall into the trap of talking about the revolution betrayed—that's such a bore. Also, revolutions are always betrayed; that's their purpose. It's only then that we recognize the salient truth: namely, they are part of life's warp and weft. They have to be taken—to use Truman Capote's axiom—in Cold Blood. A dilemma which brings us to the exposed issue of postmodernism, I dare say.

ON HIS OWN ART

[B]etween around six or thirteen years of age I used to draw comics or graphic novels. They were my first form. Around two thousand images definitely came into the world as a consequence of these endeavors. They were my first love, I suppose—primarily due to their combination of words and images. A factor which also accounts for my interest in the graphic, the horrific or Gothic, the linear and the pre-formed. Contrary to the desiderata of pure Modernism, in graphic work you always know where you're going but not necessarily where you intend to end up.

After a brief gap—grammar school and so on—I started to

produce images again. Yet now a subtle change had taken place. The pictures underwent a metamorphosis into full-scale paintings and over around thirty years have mounted up to at least 215 works. . . .

Personally speaking, I find them to be captivating in their allure. They are extremely varied in their focus—some are ferocious, savage, and expressionist; others are erotic, playful, and sensual; still more have a classic, restorationist, or historical bias; while the remainder embody autobiographical and ideological themes. Some pertain to child art or the ramifications of Art Brut: that is, a willing or known primitivism in terms of artistic silence. Certain other paintings are literally portraits of people known to me; whilst early on I experimented with the psycho-portrait—here you illuminate a person's nature and not their looks.

Although eschewing abstraction—unlike Norman Lowell—I've never been interested in pure representationality after the invention of photography to do it for you. Do you recall those nineteenth-century series of photographs by the master Edward Muybridge? He was one of the great pioneers of slow-motion, frame-by-frame photography when this art or science was in its infancy. A sequential art motif featuring two men engaged in Greco-Roman wrestling has to be an early classic. These images in particular had profound influence on Francis Bacon's *oeuvre*.

Anyway, if we examine it closely then this tradition splits several ways. It leads to the strip cartoon, the cartoon or funny, comics, and the story board—a development that prepares the ground for early silent cinema. So, *inter alia*, the fantastical and linear presentation of action becomes art's necessity. All of which involves going inside the mind so as to furnish provender—imagination then facilitates change, transmutation, forays from within, and the custody of inner space—an eventuality which portends Modernism.

Counter-Currents, January 31, 2011

Elitism, British Modernism, & Wyndham Lewis*

Wyndham Lewis is a paradoxical figure in all sorts of ways, because you could argue on one trajectory, certainly from a very traditional and perennialist one, that Lewis is actually a part of everything that exists now. He was an ultra-Modernist and an arch-Modernist. Indeed, he founded the only meaningfully indigenous Modernist movement (called Vorticism) in these islands. And yet, Lewis was also an ultra-Rightwing and hierarchical figure. So, in a way, my interpretation of Wyndham Lewis—who died in the 1950s, and so we now have quite a perspective on him of at least half a century—is that he was a man who believed in a Right-wing version of what we can now call the Modernist project.

Now, what did they want? One of the ironies and conceits about Modernism is that it is in some respects *new*. It's been around since the middle of the nineteenth century, and there are predecessors in all sorts of currents of art that predate that. Lewis believed in a Promethean way that the world could be made *again*, and this was because, in a sense, he was a Nietzschean.

One of his first published articles was "The Code of a Herdsman."[1] This is the idea that the artist comes down from the mountain and communes with the masses, often by using masks, often by using stratagems, often by manipulating them, by bullying them, by attacking them, by working on them and trying to raise them and their level.

One of the things about Lewis is that Lewis is totally opposed to "entertainment" and the idea that the artist has to sell himself to the mass of people, particularly through commercial middle-men. This has had an unfortunate consequence, be-

* A lecture to the eighth meeting of the New Right, London, Saturday, May 28, 2006. Transcribed by V. S.

[1] Wyndham Lewis, "The Code of a Herdsman," *The Little Review*, July 1917.

cause a large number of Lewis' books are entertaining and very readable, but many of them are deliberately rebarbative and are an attack on the audience. *The Apes of God* is an attack.[2] *The Childermass*, for example, which was published in 1928 and is a part of an enormous sort of tetralogy, only three parts of which were written, attempts to deal in a Heideggerian way — without any of Heidegger's discourse — with ultimate matters of life and death and purpose.[3]

Lewis was a great artist, flawed in some ways, but great because he attempted to reach the stars. His view of art was almost that it should be a religion for secular, postmodern man. He had an *enormous* amount of energy, and he wrote fifty books. He painted at least two hundred very large canvases, a significant number of which are in the Tate Gallery and elsewhere and owned by major museums across the world like the Guggenheim, the Peabody Museum, and so forth.

He's probably the only figure that we have in early twentieth-century British high culture who combines painting and writing — very different discourses that come out of completely different parts of the brain — in one individual. He comes out of the nineteenth century. He knew virtually every major cultural and artistic figure in the British Isles and beyond during his lifespan. He met *every* great Modernist from Picasso onwards. He met *every* great politician, including Sir Oswald Mosley with whom, of course, he was reasonably intimately politically associated.

One of the reasons Lewis is less fashionable than [the rest of] the Gang of Four, as they're called — namely Yeats, Eliot, and Pound, the men of 1914 — is because he has never been forgiven for some of the political discourses that he came out with at particular times. Now, this is rather remarkable, because Pound was put in an insane asylum after the Second World War where the poison of alleged treachery to the United States of America by virtue of his allegiance with Mussolinian Italy was virtually

[2] Wyndham Lewis, *The Apes of God* (London: Nash & Grayson, 1931). See also chapter 5, below.

[3] Wyndham Lewis, *The Childermass* (London: Chatto & Windus, 1928). See also chapter 4, below.

burned out of him through a sort of Harry B. Duty shock treatment. And Eliot went into the bosom of the Anglo-Catholic, Anglican, and Tory establishment in this country, despite his American birth. And Yeats, of course, more than made his peace but was a part of the new Irish Republican dispensation, in the state that became the Irish Republic after de Valera and was the Free State before. It's arguable who was the most Right-wing amongst these particular people.

Yeats in many ways can't be seen as a Modernist, although he was most alive to Lewis' talents at certain times partly because of his extraordinary ability satirically. Yeats deeply admired that tradition from Swift through to Lewis. The canvas is a sort of negative, harsh, critical, and yet poetic discourse in our culture which manifests itself through the savagery of an Evelyn Waugh, through the poetry of the Churchill of many centuries ago who was a member of the Hellfire Club, through Nash's prose, for example.

Lewis is an outsider, and he always styled himself as such. He adopted various strategies which in turn relate to the wearing of masks and in further go back to his little credo "The Code of a Herdsman." One of the masks that he liked to wear was that of the enemy, the enemy of received values and opinions. Although it wasn't entirely articulated in this way, he fought against liberalism in the arts and in the general culture all of his life.

In 1926, he wrote a book called *The Art of Being Ruled*,[4] which is a genuinely extraordinary book, because he predicted many things which were from so far off the agenda then that very few people had thought of them, and indeed this book was regarded as slightly madcap even in its era. It looks at theories through Georges Sorel, it looks at theories through Charles Maurras, but in the end it's Lewis' thesis that ultimately in the West—if we don't watch it, and it had partly arrived in Weimar Germany and contemporary pre-Depression Britain anyway—we will have Left-wing capitalism. This was a heterodox and absurdist

[4] Wyndham Lewis, *The Art of Being Ruled* (London: Chatto & Windus, 1926).

thesis in the 1920s, which partly sophisticated Marxian critics and so on laughed to scorn! But we have all around us a global, itemized, Left-leaning capitalist order.

Lewis' real view was that you've got this strange combination between thinking that conservatives of the more rigid type are the less Modernistic and Futurist and energy-based type, as he would configure it, have always been bemused by. Even politically today you sense this, that many conservatives think that they're running the world, and yet they're alienated from the very streets that they walk through, and they have this odd double-take in relation to reality. They feel that culturally, instinctively they've lost everywhere, and yet history tells them that they've triumphed over Communism, over state socialism, and *dirigisme* and so on.

But Lewis' real point is that the market is the greatest egalitarian leveler that has ever been developed, and that more rigid and "conservative" structures statally to enforce egalitarianism aren't really necessary, because the market will do it *for* you. If you decide taste or concepts of beauty or honor or national pride or elitism or voluntarism, and you have a plebiscitary vote through tickets of commerce via the market, you will *always* get a *lumpen* and a reasonably leveled-down and drivelish answer.

Lewis' career began really with his studentship at the Slade School of Fine Art, which is now part of University College London. The most famous fellow student when he was there was Augustus John, whose sister Gwen John was also a famous painter and in turn was Rodin's mistress for a while. Now, they clashed quite considerably, and Augustus, to this day, is regarded as in a sense an academic artist; freed up, maybe, Romantic and energetic in spirit, but still largely loyal to naturalistic portraiture and traditional Western art.

Lewis broke with all of that, even when he was a low student at the Slade College in the center of London. Lewis was probably linked conceptually to the Formalists and Constructivists in pre-Soviet Russia. We're talking about the proto-Soviet revolution of 1905, long before the Bolsheviks had even been heard of on the world-historical stage.

The interesting thing about Lewis is that Lewis creates for a

period the most savage and the most Modernistic art possible, and in a later phase he rejects it. In the early 1950s he published a book called *The Demon of Progress in the Arts*,[5] which has never been reprinted, incidentally, and which is actually a criticism of many of the tendencies that he himself helped to create fifty years before.

But the criticism is because his view of culture is essentially energy-related and discourse-driven. He believes that you can take modern culture and adopt a Rightist view of it by hierarchicalizing it and by dinning it into the masses through every organ of propaganda. He basically believes that you can have a Right-wing Modernist culture, essentially.

When he saw that by the middle of the twentieth century, Modernism, which initially a lot of liberal humanism was reluctant to touch—except for separate, isolated individuals—and reluctant to embrace in the way that we now have . . . If you sit back and watch your television screen today about art and artistic matters, people will tell you that the Turner Prize is received culture, is the culture that New Labour and Cool Britannia endorses. You have to step back in time, when these sorts of discourses which have led to that point were much more fugitive, much more formative.

In a way, there's a subtext to the politics of art in the twentieth century which has never really been explored. Whenever Modernism is taught in universities, the political partiality of many early Modernists—Céline in relation to writing, certainly ultra-Modernist writing of the sort exemplified by Beckett or Joyce, Pound in relation to the hard-edged, semi-classical early modernity of his Imagist movement, and many, many of the others—their incorrectness politically is always slightly elided over. They are crucial to the Modernist project and experiment, and they therefore cannot be voided from it, but there is a reluctance to admit where their politics began and where it ended.

There is a school of what is called deconstruction, which is a late type of linguistic theory whereby all culture is considered to

[5] Wyndham Lewis, *The Demon of Progress in the Arts* (London: Methuen & Co., 1954).

be relative and a play of words and signifiers. It's the latest of the most destructive types of Critical Theory which have convulsed the Western academy during the course of the twentieth century. Now, this school produced a particular variant in the United States at Yale University and is known as the Yale School of Deconstruction. Fredric Jameson, who was a prominent professor there, wrote a book on Wyndham Lewis called *Wyndham Lewis, the Modernist as Fascist*.[6] Of course, that in itself is a paradox, because to many minds the radical Right and modernity or radical Modernism would appear, superficially speaking, to be antithetical. Yet, all of these ultra-Modernists that I've just listed in their early formulations at the beginning of the twentieth century, 100 years ago, were ultra-Rightwing and were anti-democratic.

Why have artistic movements that were championed by many of these people and other lesser lights of similar ilk come to mean the exact reverse of what they postulated a century on without falling back into traps like "the revolution betrayed" and so forth? In many ways, it's complicated, and a particular key text that we need to look at is a Spanish work by Ortega y Gasset called *The Dehumanization of Art* which was one of the earliest statements of Right-wing Modernism.[7]

In this work, this particular Spanish philosopher said that he likes a modern art which is a break from the past and is an attack on the sensibility of the people. He likes Modernism because the people don't like it. He likes it because it looks like material that's landed from outer space, essentially. He likes it because it's misanthropic and because there's a strong element of that in artistic creativity.

This is a very insightful point, because if you ever move in the circles of the arts the bulk of the ideological trajectory is and has remained well to the Left. But if you associate with a lot of

[6] The full title is *Fables of Aggression: Wyndham Lewis, The Modernist as Fascist* (Berkeley: University of California Press, 1979).

[7] José Ortega y Gasset, *La deshumanización del Arte e Ideas sobre la novela* (Madrid: Revista de Occidente, 1925); *The Dehumanization of Art and Other Essays on Art, Culture, and Literature*, trans. Helene Weyl (Princeton: Princeton University Press, 1968).

artistic people for a long time you realize that art isn't really about an empty-minded and globalist love of humanity. All artists compete savagely with each other. They're obsessed, many of them, with fame. And although they're not materialistic people, they'll take what they can where they can get it. There's a sort of interesting inhumanism about all custodians of beauty, even if certain people, both absolutely and relatively, don't believe that what they are producing *is* beauty.

The modern movement in a sense became by default the cultural vanguard of contemporary liberal humanism because the radical Right has become associated retrospectively with the aesthetic discourse of National Socialist Germany, which was Neo-Classical and looking back, whereas the partial Modernisms, that were partly agglomerated into the states of an authoritarian Rightist character in Portugal and in Spain and in Italy, are partly being shunted to the side or disprivileged.

Let's take the Soviet example and its many satellites throughout the Second and Third World, now many of them collapsed, in the century that has just passed. Soviet art up until 1928 embraced the most revolutionary and the most radical and the most destructive currents of prior thought and brought them all in, despite Lenin's avowed personal distaste for a lot of it. But he welcomed these modern movements because they broke up that which existed before, because before you build a new house you must dynamite what's there before and put in new foundations so that there can be a new structure. There's a famous conversation between Gorky and Lenin where Gorky allegedly said to Lenin, "What do you think of all this modern stuff, colloquially?" And Lenin said, "I can't stand it, but we must support it because it destroys."

The interesting thing is that after 1928, of course, the Stalinist dispensation after Trotsky's purging and the purging of the Left opposition from the Soviet Communist Party, reversed this cultural flow, and a cultural restoration of traditional artistry came sweeping in. Many of the Modernists who saw which way the wind was blowing suddenly altered the way that they composed and wrote poetry and wrote novels and so on to fit in with this new wave.

In the middle of this, liberal humanism—which deep down has had many, many doubts about the elitism and the misanthropy of elements of the Modernist project—post-Second World War cleaved to radical modernity, and you see a clique all over the world whereby the most unlikely cultural people, from Prince Philip onwards, evince a liking for Modernist painting and sculpture. You see it almost as a glacial thing right across the Western establishment.

There was even a deeper subtext to this because in the early 1950s the Central Intelligence Agency—believe it or not—actually put money into the sponsorship of Abstract Expressionism. You can imagine these bullet-headed types in Georgetown and the CIA base in Langley, Virginia holding abstract Expressionist paintings upside down—because who knows which way they're up?—and wondering how many millions of dollars they should invest in this sort of thing. They bought into an ideology about this that the Soviet Union was restrictive and reactionary and wanted to go back, whereas sunny America was the new uplands of freedom and participation in democracy, and everyone could *throw the paint on* and do what they liked. We were for freedom and not these old, hide-bound forms! And you can see them not really agreeing with it, but thinking it was a good propaganda line.

So, by a strange, sort of reverse process in the liberal West—which now, post-Soviet collapse, has superficially triumphed all over modernity—a leveling down to the lowest common denominator of the pre-war Modernist space, or virtual reality space, or moral cyberspace has occurred. So, in a way, *all* of the early Modernists who wanted a new world and were full of energy and belief and anger and pain, and power as beauty—which is what this Modernist aesthetic really amounted to—have fallen away, and we're left with something like the Turner Prize, which is interesting and yet sort of ironic because of course this prize indicates the fact that Modernism has died, and died quite far back in the twentieth century in terms of its own internal vitality, never mind any attributions that may be put upon it from the outside.

There's an art critic and academic and curator called Suzi Ga-

blik who's married to John Russell who is a rather well-known art critic and historian.[8] He was art critic on the *New York Times* for many years and wrote books on Seurat and Bacon and this sort of thing. Now, she wrote a book in the 1970s called *Has Modernism Failed?*[9] Like a lot of academics, she couldn't make her mind up, so she presented the case, and she presented the evidence, and she left the sort of terminal paragraph, the one where you have to bite the bullet and answer the question, "Has Modernism really died?" vacant.

But it was quite clear from the profiling of the evidence that the belief that there could be a new world, that man could be energized and transformed by art, that art could be meshed with technology so as to create cyborgs of the real or the hyper-real and that we could take a new evolutionary leap by virtue of these sorts of discourses characterized by Vorticism (Britain), Cubism (France), Surrealism (France), Expressionism (Germany), Futurism (Italy), and so on and so forth, with all sorts of various tendencies, has failed and hasn't come to pass.

With a movement like André Breton's Surrealism an enormous number of shards and interconnected revolutionary and pseudo-revolutionary movements came out of that as it collapsed: Lettrism, Situationism. Tiny little groups with small numbers of people, but actually strangely influential, because when many of the Paris students rioted in 1968—and this is called a New Right group, and, of course, the New Right as a conception was essentially, if things have a foundation, a foundation created by Alain de Benoist and other intellectuals of the ultra-Right as a response to the rioting in 1968—because these people had taken over the streets and were rioting with the CRS,[10] and blood was flowing in the streets, and they were putting slogans on walls saying, "Imagine" or "We want everything

[8] It does not appear that Gablik and Russell were married. But they coauthored an exhibition catalogue called *Pop Art Redefined* (London: Thames & Hudson, 1969).

[9] The first edition of *Has Modernism Failed?* was published in 1984 (London: Thames & Hudson).

[10] France's elite police force the Compagnies Républicaines de Sécurité.

to be different" or "A revolution against all values that currently exist," an odd take, if they knew it, on a Nietzschean phrase of more than half a century before. So, these students were replicating radical Modernist ideas, albeit at the level of street slogans.

And don't forget that graffiti on billboards now sells in Sotheby's today. I've been to exhibitions at Sotheby's and Christie's and Bonham's and Carter's and Phillip's and all the others, and graffiti—Graffiti Art, it's called—is there, praised by liberals as an expression of the urban masses and the vitality of lumpenproletarian exclusion, aesthetically stated. And so a trajectory that begins with hierarchical elitists who wanted a new world has ended with the "art" of Baselitz and of Basquiat and of these sorts of people.

For those who don't know, Basquiat was a mulatto rent boy and drug addict who was taken by Andy Warhol and made into a considerable artist. This was bought into considerably in terms of financial access to profit through the selling of his texts of oppression which consisted of—I could do one now! I could do a Basquiat for you. You get a big piece of paper. You have a couple of police cars coming to drag you away. Racism. You have a small black man being dragged off, and you write "RACISM." And you put a little flower on the end. It's to say racism, allied to the possibility of sexual identity oppression.

I want $40,000 dollars for it. And somebody would stand between the person who wants to buy it and say, "You're buying into pain; you're buying into redemption; you're buying into modernity. It may not really be your taste. You may actually think it's rubbish that he pulled up in ten minutes. But buy into it, because it might be worth something in the future, and at the same time it relates to ideas about art."

One of the interesting things about modernity—and Lewis' role in it, which we'll get back to in a minute—because Modernism has to be discussed in a way, because it's an extraordinarily complicated area, and Lewis is a very interesting and problematical figure, the one and the other . . . But what Modernism has led to is a fracturing and a dissonance of things and of prior organic forms. It released an enormous amount of energy. It was a volcano and an explosion.

It has now died. It's really died in our art for about forty years, because when the Turner Prize goes to the *Sun* and replicates to the masses, who know nothing about art whatsoever, that this is the coming stuff, it is several levels of lies and mendacity piled upon one another. Damien Hirst: that's taxidermy. It relates to the ready-made. Warhol did that. The Dadaists after the Great War did that. Duchamp specialized in that. Duchamp went to a gallery with a urinal which he'd just bought in a Parisian flea market and said, "This is art!" And the chap said, "Well, you know, not quite sure about that . . ." He said, "Look, I found it, it's purposeful, it's in front of me, we use it for a physiological purpose. How *dare* you deny, in your authoritarian subjectivism, that this is art!" And the bloke said, "How much do you want?" And that's how it started, you see.

But they say the Turner Prize is original. Let's look at the unmade bed by Tracey Emin.[11] Now, this again is a form of a ready-made. It's again a form of a text. "I have a life. I've had this abortion." Not me personally, Tracey Emin. There's a degree to which I had this done to me. Notice that this is an inversion of every artistic credo, because art is something you objectify outside yourself. It's not something that's done to you. It's something that you leave. You leave an object. You leave a trace. Even to use Beckett's terminology, you stain the silence that's external to oneself. She just says, "I'm in *pain!*" That sort of thing, and it's considered almost an artistic statement. "Oh, this is my unmade bed."

One of the more interesting ones, though, in this sort of dying world is somebody called Marc Quinn. Now, many of you who have wandered around Trafalgar Square recently will have seen something by Marc Quinn, because on the fourth pedestal—which they can't decide how to fill—he has a 13-ton sculpture of a pregnant thalidomide woman. You must have seen it if you've been to Trafalgar Square. It's Alison Lapper who is pregnant and thalidomide. And naked, even better. In a way, what Quinn is doing is actually in a strange way—this would be denounced fifty years ago by ultra-Left critics within Modernist art—he's

[11] Tracey Emin, *My Bed*, 1998.

actually smuggling in certain representational and Neo-Classical features even as mockery into the discourse.

You have to understand that in the middle of the twentieth century, partly because of the Second World War and its aftermath, there was a hysteria in the contemporary arts. If anyone painted in a representational way they could be and were hounded out of colleges. They were howled down at conferences. Certain of the art was, in a sense, disprivileged to the degree it was conceptually destroyed even if it still existed in some garage or attic somewhere. Anyone who said they were in favor of beauty was regarded as a "Nazi" or a "conceptual Nazi" or an "aesthetic Nazi."

The irony is that that sort of extremism, of course, docked the market, because ultimately there was a *reductio ad absurdum* here, with many of the Abstract Expressionist painters before big museums came into their work many private dealers were exhausted and didn't want to buy anymore, and a new movement was founded called Pop Art which was recidivistically popular. It rejected Clement Greenberg's theories. He was the main theorist of Abstract Expressionism. And they went back to Batman, if you like. They went for stuff the masses would like, because you could sell it. And many dealers around the world went, "Thank God for that! You've got something that's recognizable and that's popular and that we can invest in *again*." So, that was actually a retreat from ultra-Modernist hysteria in relation to the sheer capitalism of contemporary art.

Many people wonder why pictures—not just Old Masters, but many contemporary pictures—sell for such ludicrously large amounts of money, if one is frank about it. Bearing in mind that at least ten percent of all artworks are forged in every category. At least. Everyone in the art business knows that. The former head of Sotheby's, Mr. Taubman, was placed in prison in the United States of America, despite saying he had thirty-six grandchildren and had to take twenty-six pills a day in order to live, because he had set up a corrupt cartel to prevent other people dealing with Sotheby's and Christie's in art.

Some people wanted art to become a religion in comparison to the post-Christianity of the contemporary era. Other people

see it as an investment for life, because artistic works have become a currency for the ultra-rich, and they are actually very little looked upon or viewed. They're stored in warehouses. They're stored in bank vaults. Many of the people never look at them. Onassis bought things, put them on his yacht, and never looked at them again, even though millions of dollars had been expended on them.

There was an enormous fire at the Saatchi warehouse in Leyton in East London a couple of years ago that burnt down most of the collection of Britart, and Saatchi's share price fell slightly.[12] The Chapmans, who are famous for interconnected labyrinths of quasi-pedophile dolls which they glued together, said, "We can do another one damn quick!" And Saatchi said, "Right away!" So, several new ones appeared.

But back to Wyndham Lewis, the nominal subject of my talk. Now, Lewis in my view is a great genius within the culture that I've just described. His first major novel was called *Tarr*,[13] which of course is an anagram for "art" and "rat." Lewis always liked the aggressive side to artistry. He always liked the fact that he was in some ways attacking the audience, although he didn't really accord with Left-wing ideas of attacking the audience. One thing you have to remember is that Lewis was pathologically anti-bourgeois, and he was totally opposed to what he would have regarded as the culture of sentimentality. "You've got to smash the face of the bourgeois with your fist!" This was his view. He's a Right-winger, but he's not really a conservative at all. He's a revolutionary Right-winger. The mediocrity of the majority of people, their total absence of taste: he wants to *shake* them by the throat! It's a very aggressive form of culture, and Lewis was perforce a very aggressive man.

Pound once called him "Wynd-Damn" with a hyphen because he was always casting anathema on everybody. Although

[12] A reference to the May 24, 2004, fire that destroyed the Momart warehouse, including a large number of "Britart" pieces in the Saatchi collection.

[13] Wyndham Lewis, *Tarr* (London: The Egoist, 1918). See also chapter 6, below.

Lewis, despite his termagant nature, was one of the few people who wouldn't break from Pound when he was incarcerated in a prison, which was an asylum and where the lights were on twenty-four hours a day as he was trying to write the *Pisan Cantos*, just because he'd appeared on Italian radio. So, Lewis remained loyal to his friends.

But his first novel was *Tarr*.

He expected to die in the Great War, and he fought at the front, and he fought at the Battle of Passchendaele. Lewis regarded the First World War as a revolution in the soul of man. He didn't think it was a war. He thought it was a climactic moment whereby machine technology invasively entered the human space. You would see a thousand men charge toward some enclave. Two would be left afterwards, and their bones would be showered miles behind you because of the impact of the bombs that were coming down on them. Lewis turned to people afterwards and said, "This isn't a war. It's something else. It's the mass industrialization of death within modernity." He believed, as much of that generation did, that those who went through this were never the same.

One of the reasons, if you like, for the radicality of his Modernism and his belief that everything should be changed is the belief of that generation, in part, that everything *should* be changed after what they'd been through! They weren't going to come back here and listen to the old men preaching about the same old stuff. They wanted a new world!

Of course, one of the people who wanted a new world was Oswald Mosley, beginning in his class, in hierarchical terms, as a Tory then shifting over to the Left-wing of the Labour Party as the depression of the late twenties and early thirties loomed. Lewis formed a *bit* of a cultural alliance with Mosley, although, like all intellectuals and bohemians, Lewis was very wary about getting into bed with anyone. He wrote for *British Union Quarterly*, which was one of the BUF magazines of the 1930s, but he always kept a certain distance.

In the texts themselves, you can detect the fact that, unlike the other great Modernists—Yeats and Pound and Eliot—Lewis has been demonized less because of association, less because of or-

ganizational joining or not joining, less because he spoke to this person or not, but because the *texts* are in some respects more Right-wing, are more remedially and recidivistically "incorrect" than any of the others.

Lewis' great thesis throughout this whole range of books — such as *The Art of Being Ruled* in 1926; such as the satire on Bloomsbury and Sitwell domination of the arts in the media space, *The Apes of God*, in 1930; such as his analysis through the prism of Pareto and Machiavelli of the tragedies of Shakespeare, *The Lion and the Fox*;[14] such as the short story collection which came before the Great War but that he actually brought into the post-Great War period and reworked and re-edited and reformulated and produced as *The Wild Body*[15] in 1927–28; and an enormous number of other texts, such as satirical texts which he'd almost write in half an afternoon. They were just pamphlets. They were eighteenth-century devices of spleneticism and rage: *Doom of Youth*,[16] which is actually based on a text by Evelyn Waugh's brother, Alec Waugh, called *The Loom of Youth*[17] and was about homosexuality in public schools; and an enormous amount of "Right-wing" pamphlets which Lewis considered as destroyers; strange Panzers that he allowed to loom up into some field and go careering over a cliff. Two of these were pacifist works written in the 1930s against war with Germany which was then quite apparent. One of them was called *Left Wings Over Europe*[18] and another was called *Count Your Dead: They are Alive!*[19] They're polemical works, essentially. Another book that caused a great deal of problems for everybody which

[14] Wyndham Lewis, *The Lion and the Fox: The Role of the Hero in the Plays of Shakespeare* (London: Grant Richards, 1927).

[15] Wyndham Lewis, *The Wild Body* (London: Chatto & Windus, 1927).

[16] Wyndham Lewis, *Doom of Youth* (London: Chatto & Windus, 1932).

[17] Alec Waugh, *The Loom of Youth* (London: Methuen, 1917).

[18] Wyndham Lewis, *Left Wings Over Europe: or, How to Make a War about Nothing* (London: Jonathan Cape, 1936).

[19] Wyndham Lewis, *Count Your Dead: They are Alive! or: A New War in the Making* (London: Lovat Dickson: 1937).

is almost completely forgotten now is a book called *The Jews: Are They Human?*[20] Which was actually based on a funny book, a book which was a sort of Alan Coren book of the time called *The English: Are They Human?* by a German satirist.[21] This is one of the many, many problems. We live in such a relative cultural space that things have been taken completely out of context because there is no context from which to take them, because you have to understand context, go back to another one, realize that it was in it and relate it to something that was different.

Another very controversial text about race [is] called *Paleface*,[22] which is an attack actually on the cult of the primitive in the works of people like D. H. Lawrence. Lawrence and Lewis had a standing hostility to each other. This is very ironic, but also metaphysically true, because Lawrence is a pagan and a vitalist but in some ways really a perennial heathen and a Traditionalist, and Lewis is a violent eruptor of modern discourse. Although not a subjectivist in a relativist and pure sense, he is a Nietzschean. He believes that there is a separation between the modern and that which has preceded it. In a sense, what he's saying subjectively in terms of his teleology in a way is that we don't know absolute truth. Absolute truths exist, otherwise everything is meaningless, but we cannot entirely configure them in our own destiny. We arrive at the understanding of the possibility of their configuration through struggle, through life, through dialectic, through reordering the energy within matter. It's the difference, if you like, between Nietzsche and Evola. That's why the two of them would clash in the way that they did. They detested each other, basically.

Indeed, in D. H. Lawrence's *Lady Chatterley's Lover*, the depiction of her husband as a First World War veteran who's sort of castrated in a way and she goes for a more virile man in the

[20] Wyndham Lewis, *The Jews: Are They Human?* (London: George Allen & Unwin, 1939).

[21] G. J. Reiner, *The English: Are They Human?* (London: Williams & Norgate, 1932). Gustaaf Johannes Renier was actually Dutch.

[22] Wyndham Lewis, *Paleface: The Philosophy of the "Melting-Pot"* (London: Chatto & Windus, 1929).

gamekeeper, Mellors, and the fact that he likes this tubular Modernist art that Lawrence feels is disgusting and maggoty and technologically based and without purpose is, amongst other things, a satire on elements of the culture that Lewis represented.

Don't forget, the great novelists and artists never picked somebody and said, "That's Wyndham Lewis. I'm going to do a hatchet job on him!" They use what Anthony Burgess in the post-war period called sense data. They take twenty or thirty different sources and amalgamate an individual together in order to make a point. It's a synthetic creation that's worked on the way that a writer will work on a number of manuscripts; 1, 2, 3. One of our previous speakers talked about Henry Williamson. He would actually rework a new work nine times before it went to the printer, and so on.

Lewis and Lawrence quarreled bitterly, because Lewis was a quarreler who quarreled with everybody. One of his first cultural manifestos and explosions that launched the Vorticist movement—with Pound and others, with Saunders, with Dismorr, with Roberts, and all sorts of other people, Nevinson, who later went with the Futurist current more closely aligned with Marinetti—was one of the most famous and infamous magazines in Britain in the twentieth century. It was called *Blast*—*Blast!* (there were issues 1, 2, and 3[23])—because it came out of the Great War and came out of the energy of the Great War. Certain people were *blasted*, others were *blessed*, and this sort of thing, this dialectic of approval and disapproval.

Basically, Lewis was arguing for an authoritarian society based on Hellenistic norms seen through the mist of contemporary technology. By Hellenistic norms, I mean that—although there will be discourses such as continuing Christianity and so on—a degree of skepticism based on the possibility of truth is *cardinal*—in other words, freedom of thinking and genuine ex-

[23] *Blast* 1 (1914) (Santa Barbara: Black Sparrow Press, 1981). *Blast* 2 (1915) (Santa Barbara: Black Sparrow Press, 1981). *Blast* 3, ed. Seamus Cooney (Santa Barbara: Black Sparrow Press, 1984) is a tribute volume to Lewis, his associates, and his milieu, published in 1984.

pression, not of the sort we get in the mass media now — are *cardinal* to Western identity and to Western thinking.

One of Lewis' books in his middle career was *Men Without Art*,[24] which is again a sort of satire on Hemingway's book *Men Without Women*. He would often take a title like this, wrench it out of its bearings, and reformulate it in a molten sort of way. Everything with him comes back to Nietzschean ideas, because he believes that you work on a brain. You work on a text. You work on a mind before you. Everything's molten, and you reconstitute it and create new forms and throw them out. Then it's on to the next one. It's a sort of Promethean attitude. A slightly demonic attitude in many respects, and he wouldn't have hidden from that.

When he produced *The Demon of Progress in the Arts* in the early 1950s, he was beginning to go blind, which of course for an artist and for an intensely visual person is a great affliction, possibly the greatest one there could be. He had a particular type of cancer that came behind the nose and pressed upon the optic nerves and gradually dulled both eyes. He lost secondary vision, everything became misted, and finally they went. It's exactly the condition that John Milton had many centuries before.

Now, when he was going blind, the one interesting thing about Lewis, because of his Nietzschean credo, was a total absence of sentimentality. There was no pity for the other, but there was no pity for himself either. One of the cardinal prerequisites that's true for a man like Bill Hopkins, who I discussed in one of my last talks,[25] is the total absence of the ethic of self-pity. When he went blind, he was reviewing fine art for *The Listener* at that time, and he just had a one-line paragraph saying, "I can no longer review because I am blind. — Lewis." And that was it!

A journalist — because of the pervasive pressure of middlebrow journalism that states that it knows everything but in actu-

[24] Wyndham Lewis, *Men Without Art* (London: Cassell & Company, 1934).

[25] Jonathan Bowden, "Bill Hopkins: An Anti-Humanist Life," in *Western Civilization Bites Back*, ed. Greg Johnson (San Francisco: Counter-Currents, 2014).

al fact is postulating on a tiny degree of knowledge that was already well under way in the culture of the 1950s—a journalist said to him, "Oh, Mr. Lewis, are you going to write anything more?" And Lewis said, "How dare you! How *dare* you say I'm not going to write anything more!" He said, "If I could see you, I'd throttle you!" He said, "The lamp of aggressive voltage has turned inside. The mind has many *mansions!*" He was offered a choice by his doctors, because the sort of cancer that he had can be eradicated now by laser surgery, but he distrusted all doctors and regarded them all as quacks, so he'd get ten opinions and then become confused. But the general melting down of the opinions was that if you went in with a knife, bluntly, to get this cancer out from underneath the brain, you would damage the brain. And Lewis said, "Life is the brain. Better to lose the sight than the mind!"

After he went blind, he wrote six books, and two were uncompleted on his death, including an enormously major work that in some respects, given the contemporary and rather faddish vogue for fantasy literature, has never received the kudos that it should, at least in my opinion. This is the *The Human Age* trilogy[26] which is based on Dante's *Inferno*.[27] Because often when you want to go forwards, you go back, because when you confront death, you confront ontology and being and purpose and meaning and absolute values. What are we here for? Is there any purpose? Will there be life after death? What can we expect? Does life have an ultimate meaning, or is it contingent and purposeless and valueless, and we just choose one for ourselves? Which is, essentially, all that Sartre's theory boils down to.

Lewis began this enormous work with *The Childermass* in 1928, which was an extremist Modernist book. I've read it three times. It's an incredibly difficult read, because he's attacking the reader the whole time. He writes these sentences where the

[26] Wyndham Lewis, *The Human Age*, comprises Book 1, *The Childermass* (London: Chatto & Windus, 1928), Book 2, *Monstre Gai*, and Book 3, *Malign Fiesta*, the last two published in a single volume (London: Methuen, 1955).

[27] *The Human Age* is based on Dante's whole *Divine Comedy* trilogy.

stress is between punctuation marks in such a way that the majority of people will give it up after a couple of pages. And he almost *wants* them to.

But when he goes blind, he becomes a lot more accessible because you've got to write in a much more linear way. He said he used a Dictaphone, but this isn't true. What he would do is he would have a board on his knee, he would put a ruler with rubber bands on either end, he would have a pen—biros were coming in, I suppose—and he'd get to one end, and he'd go back. And he would go back. And he would go back. He would fill page and page and page and then throw it on the floor. For all I know, his wife would collect them up, and they'd be typed and collated. Now, obviously, a certain slackness and a little bit of repetition enters in when you are creating in that way, and few people had the temerity to suggest to W. Lewis, Esquire that there should be any changes. But these are still an extraordinary series of works given the state he was in physically when he created them.

This particular series of works consists of *The Childermass*, which is his version of limbo, and we'll come on to that in a minute, *Monstre Gai*, which is his version of purgatory, and you've got *Malign Fiesta*, which is his version of hell. Lewis is very interested in hell and fascinated by it. The devil in *The Human Age* is Sammael. That's the diabolical personification. Paradoxically, in a sort of reversal of the figure known as the devil's advocate in the Roman Catholic Church—during the period of ordination before somebody like the previous pontiff is going to become a saint—Lewis argues against his own positions, because he gives many of his best positions to Sammael and then argues against them in the work. If you ever come across it, the avant-garde sixties publisher, John Calder, published *Malign Fiesta*, and it is an *unbelievable* book in my opinion.

Towards the end of his life, residually, his mother's Catholicism loomed rather large. For most of his life, of course, he'd been a nominal atheist because of his Nietzschean pedigree. But as death approached, and because reception by a Catholic priest in Canada, where he was in exile during the Second World War, partly as a protest against the war, partly as a result of the loom-

ing financial chaos and a desire to get out of Britain, because in a way he'd warned against the looming war for thirty to forty years, and now it had happened, he didn't really want a part of it.[28]

He wrote a novel called *The Vulgar Streak*,[29] which is about forgery in the arts. The idea of forgery always fascinated Lewis and the idea of fakes and how people can buy into it as discourse and aesthetic value. There's also a book which he wrote which is in the modern Penguin Classics called *The Revenge for Love*[30] and which is an anti-Communist satire. It was one of the more humanistic books that Lewis wrote. There wasn't just anti-humanism in theory, there was a more developed, psychological side to his *oeuvre* as well.

One also should mention his painting, which, of course, began to dwindle away as his blindness increased and became more severe. The paintings of the First World War hang in the Imperial War Museum, and most of them are in the public exhibition space. If you're ever in that museum, which of course is based where the old Bedlam Hospital used to be, wander around and have a look. His most famous one is *Canadian Gun-pit* because, although completely British by adoption, he was born off Nova Scotia on his father's yacht.

And there is something primordial and New Worldish about the energy that quite a few of these moderns had at the beginning of the twentieth century. Canadian, American—in this context makes no difference. Pound, Eliot, Lewis—all very different men—but they were the Cassicism of the Old World coming back to the Old World via the New World, and they did come back with some of its fire in the belly, it has to be said. But he didn't enjoy his experience in Canada and was pleased to return.

He wrote a book of short stories about Notting Hill, which of course was beginning to be a center of Third World immigration even in his time after the passage of the Labour Nationality Act

[28] Bowden does not complete his thought about Catholicism.
[29] Wyndham Lewis, *The Vulgar Streak* (London: Robert Hale, 1941).
[30] Wyndham Lewis, *The Revenge for Love* (London: Cassell, 1937).

in 1948. It was called *Rotting Hill*,[31] not Notting Hill, which was a joke between him and Ezra Pound at the time.

I think the one text which demonized and did-for Lewis' behavior pre-war and post-war is a book he wrote almost in half a year, just as journalism, almost with the speed and rapidity of talk, and this was a book called *Hitler*, which he wrote in 1931 and was published by Chatto & Windus in 1933.[32] He was invited, as many writers are, to go and see this movement that was making waves in Germany, to report, to produce a text, and come back, and they published it with just a bit of minor editing. And they did. This book was one of the few books that contemporary British writers produced that was actually reproduced under Goebbels' ministry once the government had come in after 1933, even though, as always with Lewis, Lewis is always critical, always against, never completely supports any positions, and even his own up to a point. As Nietzsche once said, "Believe totally in your own philosophy and then have your doubt" only to maximize the gap that you can then transgress when you return to the sureness of your own faith. So, as always, Lewis is a very uncomfortable man and a very uncomfortable bedfellow.

In the 1930s, he used to go to establishment parties with Lady Abercrombie and these sort of grand dame hostesses and so on, and if people weren't paying him any attention he'd produce a pistol and put it on the table. She'd come around circling and give him some chat and scoop the gun into her handbag. But it was essentially because he was a sort of histrionic artist who always wanted to be at the center of the vortex. He founded the Vorticist movement, and he always wanted to be at the center of his own vortex, if you see what I mean.

He did appear in many fascinating novels even by people who hated his guts, and there were quite a few of them. There's a novel by Huxley, one of his *Crome Yellow*-type novels reissued in the seventies and eighties with Tamara de Lempicka

[31] Wyndham Lewis, *Rotting Hill* (London: Methuen, 1951).

[32] The publication year of Wyndham Lewis, *Hitler* (London: Chatto & Windus) reads 1931 on the first edition.

covers. There's an Edith Sitwell novel largely forgotten today.[33]

Because Lewis was a fascinating character: six-foot tall, eagle-eyed, used to wear this enormous Spanish sombrero tilted slightly to the side, used to wear a cape like Sandeman's port, and just sweep around. He once had a fight in Soho Square, the one with the pagoda in it, when T. E. Hulme—who was a great man who died in the Great War and who was an ultra-conservative theorist of modernity—made a point that Lewis didn't agree with, so Lewis grabbed him by the throat! Hulme, who was an enormous Yorkshireman and had no time for any of this nonsense, picked him up—and people wore turn-ups then—and he put him over the spikes in Soho Square and left him dangling there. And he said, "That pagoda always looks different when you've seen it upside down."

So, he was quite a character, and there are endless stories about him: his affair with Nancy Cunard, his affairs with all sorts of other women. The famous one about how he was into having intercourse with Nancy Cunard until a painting came on him. He shoved her out naked into the street and got on with the painting. He was a character and very, very, very difficult to get on with. He also was in debt most of his life as well because he had people dunning him all the time, bills coming in.

He used to have flits between Kensington studios, you know, these mews flats and so on. He'd have a studio at the back, and he'd hear some creditor banging on the door at one end of the street, and skedaddle with the wife to another place. He was a bit of a rogue, he really was. He also took money from the British government and didn't entirely do all the paintings that he was supposed to do, and then he'd onsell them before they could go to other museums and so on. So, he was a rascal in a way. He was very, very difficult with his pub-

[33] Lewis appears as "Casmir Lypiatt" in Aldous Huxley's *Antic Hay* (London: Chatto & Windus, 1923). Like *Crome Yellow*, *Antic Hay* was one of Huxley's early social satires. Lewis appears as "Henry Debingham" in Edith Sitwell's only novel, *I Live Under a Black Sun* (London: Victor Gollancz, 1937).

lishers, and he was a man who was, as Pound remarked, pursued by the Furies.

The first book on him was by a poet called Geoffrey Grigson,[34] who was a total fan and adored Lewis and so on. But Lewis insisted on writing it himself! Because he couldn't trust Grigson to give him the proper hagiographical treatment. When Grigson included a few criticisms Lewis ripped it out of his hands and almost tried to eat it! He said, "Once you came up against me, peeing against my leg, I should have seen you off with a stick, Grigson!" That was his first biographer.

The most famous post-war biographers are Jeffrey Meyers[35] and Paul O'Keefe.[36] O'Keefe I know personally because he was chairman of the Wyndham Lewis Society for a while. They used to meet in rather august bursar's offices in Bertram's in the City of London well into the late 1980s. I once caused a lot of consternation, believe it or not, at the AGM[37] of the Wyndham Lewis Society because I got up and said, "This society is based on a lie." And they went, "What's he talking about? Who's that bloke?" I said, "It's based on a lie. The reason the society exists is because Lewis isn't acceptable, and the reason he isn't acceptable is because he wrote the book *Hitler*, and because he's Right-wing." And they all went, "Ugh, uh, he's a conceptual anarchist. Uhh, he's metapolitically Right-wing, you know." I said, "Look, well, he's deconstructively and Modernistically Right-wing, but in all essential purposes he's a radical Modernistic fascist, or he's fascistic." "Don't use that word!" they said, because the whole criticism that surrounds him is evasive of that. There's a sort of black hole. It's like you don't mention the war, you know.[38] You don't mention his political affiliations because they're tip-toeing around it all.

[34] Geoffrey Grigson, *A Master of Our Time: A Study of Wyndham Lewis* (London: Methuen, 1951).

[35] Jeffrey Meyers, *The Enemy: A Biography of Wyndham Lewis* (London: Routledge & Kegan Paul, 1980).

[36] Paul O'Keefe, *Some Sort of Genius: A Life of Wyndham Lewis* (London: Pimlico, 2000).

[37] Annual General Meeting

[38] An allusion to the *Fawlty Towers* episode "The Germans."

For people who want to examine the texts, *Apes of God* is available in Penguin. *Revenge for Love* is available in Penguin. The very pro-Islamic, actually, travel book—that's how it's described—*Journey into Barbary*[39] about his visits to North Africa where he did unbelievable things. He insisted on tea in the desert, insisted on dressing in great coats with scarfs in the middle of the desert. The Arabs thought he was totally mad, totally mad, but they left him to it. *Tarr* is available in Penguin as well.

Tarr is an extraordinary novel, a Dostoevskian novel in many ways, written in these sort of bullet sentences. In the first edition, he tried to change punctuation. He introduced the equals mark instead of semi-colon and this sort of thing. That was done away with in the second edition. The publisher that published that was The Egoist Press, a small press in the center of Paris that published *Portrait of the Artist as a Young Man* by Joyce first, before anyone else did, because no one else would touch it. One publisher, Grayson & Grayson, a publisher that no longer exists, was sent the manuscript of *Tarr* by Lewis and they returned it saying, "We can't publish your book, because it's too strong." Too strong! Lewis almost had to be restrained from going around and hurling a brick through the window of Grayson & Grayson, because he was like this.

But that in some ways is a metaphor for his career, because he believed that art should be about *strength* and *glory*. One of his great criticisms of modernity—elements of which he championed—was the idea that our culture has become so wet and so effete and so self-critical and so implausibly plausible and is terrified of making an affirmative statement about anything. One of the theses of *The Human Age* is the cult of infantilism in the modern West, the cult of the child, the cult of the Negro, the cult of the outsider, the cult of the sexually inverted, and so on, all of which they anathematized and anatomized long before it became fashionable so to do.

[39] Wyndham Lewis, *Filibusters in Barbary* (London: Grayson & Grayson, 1932) was republished as *Journey into Barbary: Morocco Writings and Drawings*, ed. C. J. Fox (Santa Barbara: Black Sparrow Press, 1983).

And so Lewis as an artist and as a writer is an American, a Briton, an Englishman, a Europeanist, a Modernist who advocated ultimately the values of tradition within the vortex of force that he put forward, and I personally think he was a great man in his troublesome and vexatious way.

His brain is preserved, because he's one of these people who left his body to medical science. When Paul O'Keefe did the second major biography of Wyndham Lewis called *Some Sort of Genius*, he went to one of these specimen labs in King's College, London, and they have preserved a section of the brain: W. Lewis—Writer and Artist. Then he got this computer number, and it's this section of the brain. You can see the tumor growing up underneath its base. It's an extraordinary photo. The first three to four pages of this biography are O'Keefe describing it. O'Keefe is a lecturer in English from Liverpool. O'Keefe is quite liberal, and this is in some ways a mildly liberal revisionist biography of Lewis, but it's fair to Lewis, and it's factually true. It uncovers many things.

The thing about Lewis that he prizes most is the courage. He goes on writing. He goes on thinking. To write is to think and is to be Western and is to be part—even as a radical Modernist—of our tradition. When you're poor, when the lights have failed, when you can't see, when you can't even see what you're writing, you go on.

I commend Wyndham Lewis to you, a British Modernist life. Thank you very much!

Counter-Currents, August 7, 2014

WYNDHAM LEWIS' *THE CHILDERMASS*:
BLACK METAL, WITHOUT THE MUSIC

Wyndham Lewis
The Childermass
London: Chatto & Windus, 1928

This novel is probably one of the most difficult written in the last century, but it is also very interesting in relation to the phenomenon of the mass media which surrounds us all now. Indeed, the prescience of certain "unfashionable" thinkers like Lewis (*The Art of Being Ruled*), L. P. Hartley (*Facial Justice*), or Ernst Jünger (*The Glass Bees*) is very striking the further we move away from them in historical time.[1]

Do not forget what Lewis posited, in 1926, that unbridled market economics—not communism—would do for conservatism, and Jünger pre-figured a Mankind which is totally at the mercy of media . . . the latter invasive and vertiginous. This is decades before the US military began to link computers together in a way that would become the Internet.

But to return to *The Childermass*, this book was designed by Lewis to be his *Ulysses* by Joyce; a work of uncontrollable ferocity and illisibility (that's elitist unreadability). Believe it or not—Lewis believes in attacking the audience . . . a key component in all early forms of modernist art. In this respect, such intellectuals regarded themselves as at war with bourgeois life, partly by virtue of their own role as outsiders or critics of materialism.

The book concerns two English public-school boys who have just been slaughtered in the Great War (1914–18). (Note: with breezy irony, the most monied, private, exclusive, and rarefied schools in England are called *public schools*.) Lewis did not re-

[1] Wyndham Lewis, *The Art of Being Ruled* (London: Chatto & Windus, 1926). L. P. Hartley, *Facial Justice* (London: Hamish Hamilton, 1960). Ernst Jünger, *The Glass Bees*, trans. Louise Bogan and Elizabeth Mayer (New York: Farrar, Straus & Giroux, 1991).

gard the First World War as a war in the conventional sense, but as a revolution in the soul of Man. The industrialization of mass death which built on the semi-industrial Armageddons of the American Civil War and the Boer Wars, respectively, was something to behold. Most of that generation were rendered speechless by it for at least ten years or so.

For example, Lewis fought at the front as an artillery officer with a Canadian regiment (he'd been born on his father's yacht off Canada), and the corpses of men who'd literally been eviscerated fell down upon him. He was in a bunker with his men in the middle of no man's land. They existed in a small prefabricated cage of steel between the German and British Commonwealth lines. The job of his outfit was to spot Prussian artillery activity and ring back to high command so that the great Allied batteries could rip forth flame and death.

On one occasion the 'phone rang in the dugout. Lewis answered it, and who should it be but his commanding officer. "Lewis," he said in a very upper-class English accent, "what's going on?" To which Lewis replied: "It's a war, sir," and slung the receiver down—as if to say, "Bloody fool, what does he think's happening?" Lewis was always like this—he loved to upset people, most especially when they were on his own side.

The Childermass partly relates to Roman Catholic theory or theology about life after death. Lewis was not technically a Catholic, although his beloved mother had been, and he flirted, off and on, with many of its ideas throughout his career. Had he known the mechanics of conversion, he would probably have been received into the fold before his death. An interesting fate, this, for a semi-pagan figure of utmost truculence who gloried in war, ugliness, modern life, and technology. Nonetheless, there is a growing "endless return" to the old faith during the *Human Age* trilogy with which his life ends in the mid-fifties.

He wrote *The Childermass* in the late twenties as the first part of this trilogy before returning to it at the end of his life.[2] Strong-

[2] Lewis's *The Human Age* trilogy comprises Book 1, *The Childermass* (London: Chatto & Windus, 1928), Book 2, *Monstre Gai*, and Book 3, *Malign Fiesta*, the last two published in a single volume (London: Me-

ly influenced (both artistically and morally) by Dante's *Divine Comedy* in three parts, the classic triadic division in Western art, Lewis' sequence deals with the big themes: Death, War, Is there an Afterlife?, Does God exist?, and, if so, Do we have any sympathy for the Devil? Mephisto—in Lewis' system—is decidedly Talmudic, takes the formulation of Sammael, and yet is strangely sympathetic.

Lewis always sympathized with the enemy. It's what caused him to write *Hitler* in 1931 as an Englishman, a book still effectively banned now eighty years later! He only sympathizes with Sammael, though, in the sense that he's been left to punish a nihilistic, vague, and contemptible species after death. Why didn't God have a better plan?

Furthermore, in the third volume of the triad, *Malign Fiesta*, possibly the most remarkable version of Hell ever written is depicted. This book is truly extraordinary, goes beyond even Milton, and happened to be written at the end of his life when Lewis was completely blind.

This is the thing to remember about figures like Lewis. He wrote such material at the end of his life, returned to the innermost verities of the Western tradition, and yet was universally vilified everywhere as a "fascist." From the point of social success and post-war survival, he certainly opted for the "wrong" side. One of the reasons, *en passant*, why so many people who've followed him in the Arts have been ultra-secretive about where their allegiances lie—even to themselves.

But to return to *The Childermass*, after the fantastical revelation of the after-life in all its surrealness, we return to the meat of the piece. The oneiric vastness can only be hinted at here, but it has to do with reversed perspective, discontinuities in time and space, the non-survival of individuals who were half-formed anyway (they live on as hands, feet, or noses); as well as the humidity, heat, and glare.

Pullman and Satterthwaite (the two dead public-school boys) wait by a river for admission to the Celestial City. But remember this isn't Purgatory or a way-station afore Heaven—it's Limbo in

thuen, 1955).

Catholic theology. (Hence we note the title *The Childermass* — i.e., a mass for children ... in that both of them are child-like, too innocent, profoundly unknowing yet gunned down before their time.)

The real point of this first volume in a trilogy, which Lewis continued and brought to a conclusion later, is the appearance of the Bailiff. About two thirds of the volume — leastways sixty percent — is given over to his speech and interaction with these dead souls. Yet, cannily, Lewis really believes in the occult principle of "as above, as below." Since the Bailiff is entertaining the peons, this myriad assembly of Gogol's *Dead Souls*, prior to their entry into the City.

It's just like Life, in other words, in that the Bailiff is the incarnation of mass democracy, hucksterism, million-ton vaudeville, soft commercialism, the right to vote, as well as every little man's right to have his say. The irony shot through all of this, nonetheless, is that the Bailiff is a cozener and a dictator — but, at least superficially, in the form of a bloated Punch, a children's entertainer.[3]

By this reckoning: the Bailiff is visually akin to the Puppet character delineated by George Cruikshank in the early nineteenth century, albeit taken from Porsini's show as transcribed by Collier. Lewis believes that twentieth-century Man is completely infantilized or reduced to a child-like status — whether before or after death.

The Bailiff is also truly entertaining — his *spiel* (for that's what it is) goes on for hundreds of pages — imagine Hollywood, mass entertainment, shows for the troops, popular television (just beginning at the moment Lewis dies), and MTV/Fox/Sky (in Britain)/MSN "culture" going on and on ... forever.

Moreover, this mountebank jigs about in the box, wriggling, squawking, nodding, joking, and engaging in ridicule, inviting it as well; and yet for one extraordinary moment our figurine turns

[3] See Jonathan Bowden, "The Real Meaning of Punch and Judy," in *Pulp Fascism: Right-Wing Themes in Comics, Graphic Novels, and Popular Literature*, edited by Greg Johnson (San Francisco: Counter-Currents, 2013).

around to reveal that it's a twin. The Bailiff has a sort of coeval or other half, rather like a Siamese twin, and this is only possible because of his manikin or puppet-like dexterity. This other half is Hebraic, Talmudic, *Der Stürmeresque*, quite pronounced in its ethnic charge, and related to Julius Evola's hermetic interpretation of *The Protocols of the Learned Elders of Zion*.

Indeed, the literary establishment has always regarded Lewis as an anti-Semitic version of James Joyce; that's why he's so much less fashionable. The reason for why he hasn't been totally demolished, however, is due to various dissidents who regard him as a great talent (including a Catholic convert like John Rothenstein), his Modernism, and the extreme difficulty of his material.

Crude attacks on figures like Eliot, Lewis, Pound, Yeats, and Céline make the academic or journalist who does them look moronic. Who wants that on their CV? This has certainly helped protect him. There is also his importance as a visual artist as well as a writer—this gives him a double insurance-lock, up to a point.

Nevertheless, his anatomization of the box in almost everyone's living room: its endless patter, lying, entertainment, cajoling, and imbecile fascination is pretty unique. It strongly influenced the media inquiry of Marshall McLuhan—a sort of spiritual son of Lewis'. Only one and a half per cent of people in Britain don't own one. I haven't watched the Bailiff's shape-shifting *alter ego*, mechanization, cube, tube, or box since 1983. A record; or what?

For those who would like to plunge headlong into Lewis' black metal prose—that is, its cold bath of lightning flashes and soundscapes—the first four pages of *The Childermass* have been uploaded to the "creative writing" section of the Wyndham Lewis Society's web-site.[4]

Counter-Currents, November 26, 2010

[4] http://www.wyndhamlewis.org/

WYNDHAM LEWIS'
THE APES OF GOD

Wyndham Lewis
The Apes of God
London: Nash & Grayson, 1931

The Apes of God happens to be one of the most devastating satires to be published in the English language since the days of Dryden and Pope. It appeared in a Private Press edition (prior to general release), and at over 600 pages, it was the size of your average London telephone directory.

The Apes deals, in ultra-Modernist vein, with a catalog or slide-show of *dilettantes* from the London of the inter-war period. It is, in reality, a gargantuan satire against the Bloomsbury Group and all of its works. The historical importance of the Bloomsbury Group is that they were the incubator for all the Left-liberal ideas which have now hardened to a totalitarian permafrost in Western life. This is the real and crucial point of this gargantuan effort — an otherwise neglected work.

To recapitulate some of the detail: the novel concerns the sentimental education of a young idiot (Dan Boleyn) in the ways of Bloomsbury (Apedom). During this prologue he meets a great galaxy of the millionaire bohemia so excoriated by Lewis. The chapters and sub-headings basically deal with his education in ideological matters (not that the simpleton Dan would see it in that way), and he is assisted in his insights by Pierpoint (a Lewis substitute), the Pierpointian ventriloquist and contriver of "broadcasts," Horace Zagreus, as well as Starr-Smith. The latter is Pierpoint's political secretary, a Welsh firebrand, who dresses as a Blackshirt for Lord Osmund's fancy-dress or Lenten party which makes up a quarter to a third of the book.

The liberals who are dissected are James Julius Rattner (a Semitic version of James Joyce), Lionel Kien and family, Proustians extraordinaire, various poseurs and Bullish lesbians, as

well as the Sitwell family group who are depicted as the Finnian Shaws. The Sitwells are all but forgotten today, but they were highly influential in the world between the Wars—as is witnessed in John Pearson's masterly biography *Facades: Osbert, Edith and Sachaverell Sitwell*.[1] It is no accident to say that this satire has kept the Sitwells in contemporary culture, despite the fact that they are the butt of Lewis' ferocious wit.

Throughout this odyssey through Apedom various themes are disentangled. The first is a penchant for the class war—in a parlor Bolshevik manner—from those who superficially have the most to lose from it. This leads to an active collaboration between masters and servants ahead of time. The next "war" to which these pacifists hook their star is the age-war between the generations which is best illustrated by the Sitwells' attitude to their aged Patriarch, Cockeye in the novel.

Other cults or pseudo-cults of the lower thirties (i.e., the twenties) were the cult of the child, feminism of various kinds, the glorification of the Negro (witness the work of Firbank, for instance), and the ever-present cult of homosexuality. As Horace Zagreus—one of Lewis' voices in the novel—acidly points out: as far as Bloomsbury was concerned, heterosexuality was the love that dare not speak its name.

All of these putative forms of political correctness were held together by a rising generation whose most "advanced" adherents were determined to let their hair down during the roaring twenties. Indeed, the cloying, ormolu-tainted facade of the super-rich—anatomized in this novel—only came to an end with the Great Crash, which burst at about the time of the novel's appearance in 1930.

The semantics of the radical bourgeoisie have largely taken over the world—and what was anathema to mass or philistine opinion is now the normal chit-chat of the semi-educated to educated. Revolutionary bohemia—according to Lewis—proceeds in three stages. First you have the aristocratic version of it during the 1890s—the "naughty nineties," the breaking of

[1] John Pearson, *Facades: Osbert, Edith and Sachaverell Sitwell* (London, Macmillan, 1978).

Oscar Wilde, etc., only for this stage to be followed by a mass bourgeois version of *la Décadence* in the 1920s. This makes way for the mass proletarianized version of bohemia which hits the world in the 1960s, after a few beatnik preliminaries the decade before. Lewis never lived to see this period, having died in 1957.

Another very interesting feature about Lewis' prescience is his understanding of revolutionary ideology and its aftereffects. For, as early as *The Art of Being Ruled* in 1926,[2] Lewis was positing the notion that the emancipation of women to work would kill off the family far more effectively than all the feminist route-marches put together.

One of Lewis' most extraordinary judgments is that many Marxian values, floating freely and slip-streaming their historical source, could make use of market capitalism to achieve their ends. This was an insight of such penetration and Chestertonian paradox in 1926 that it must have appeared half-insane.

Other ancillary positions which were part of this Superstructuralist ramp (*sic*) were the cult of the exotic and the primitive in art, Child Art and children's rights, psychoanalysis, and hostility to all prior forms.

The revolutionary thinker Bill Hopkins once said to me that one of the reasons for the obsession with primitivism in early modernism was a reaction to Western thought's compartmentalization in the late nineteenth century. This led to a desire to kick against the pricks and develop contrary strategies of pure energy in the arts. Whatever the truth about this, a hostility towards the martial past, nationalism, imperialism, race, and empire—the entire rejection of Kipling's Britain—was part-and-parcel of the Bloomsbury sensibility.

Nonetheless, it goes without saying that Lewis, the founder of the Vorticist movement inside Modernism, saw modern art as a weapon in his battle against *The Apes of God*. In this regard Lewis was that very rare animal—a thoroughgoing modernist

[2] Wyndham Lewis, *The Art of Being Ruled* (London: Chatto & Windus, 1926).

and a Right-wing transvaluator of all values.

Interestingly, the idea of *The Apes* comes from the dilettantist perquisite of thousands of amateur painters, poets, sculptors, writers, and the rest, themselves all part of a monied bohemia, who crowd out the available space for genuine creatives like himself. The cult of the amateur, however, would soon be replaced by the general mélange of entertainment and the cultural industry which has probably stymied a great deal of postwar creation that Lewis never lived to see.

Counter-Currents, July 21, 2011

WYNDHAM LEWIS' *TARR*:
AN EXERCISE IN RIGHT-WING PSYCHOLOGY

Wyndham Lewis
Tarr
London: The Egoist, 1918

Wyndham Lewis' novel *Tarr* (an anagram of both "art" and "rat") appeared first in 1918 as the Great War was raging, and it remains one of the great exercises in hard-boiled psychology. Most behaviorist prose tends to be shunted aside into genre fiction such as adventure and perhaps the *noir* detective novel. *Tarr* is unusual in that it represents a fusion of high-grade literary fiction and the sort of psychology which animates the characters in Ayn Rand's *The Fountainhead* — such as Dominique Francon, Howard Roark, and Gail Wynand, for instance. Critics at the time — if not seduced by literary Modernism — spoke of a tough-minded work in which the main characters mean to "have their cake and eat it!"

The action revolves around five main characters, the eponymous artist Tarr, the radical bohemians Kreisler and Soltyk, and the two women, or items of love interest, Bertha and Anastasya. The esteemed critic Rebecca West once compared Lewis to Dostoevsky on the basis of this novel and said that its character was Russian rather than English because of its undue interest in the human soul.

The characters are multidimensional and fervid in the expression of their desires — particularly their intellectual ones. Everyone strives not to have liberal or love-oriented reactions to things — with the sole exception of Bertha . . . although she has to shape up, too, when she is raped or sexually assaulted by Kreisler, the German artist.

The central part of the novel — from about a third of the way in until just about the end — belongs to Kreisler. He is a distrait and semi-psychopathic individual — who is doubtless an amalgam of eastern and central European bohemians whom Lewis

met during the early part of the twentieth century. Much of *Tarr* is actually based on his own life. Kreisler decides to "break out" of civilized constraint, given the license which bohemia affords, and during the course of this he is found to be highly destructive indeed, in that Bertha is raped and Soltyk killed in a duel in the woods that goes wrong.

Most critics have compared Kreisler's personality to Hitler's and accused Lewis of a terrible premonition or the possession of an occult sense . . . given that the book was written between about 1909 and 1918. It would be much more accurate to accuse Lewis of possessing magisterial antennae—in the matter of the chaos, moral and otherwise, that lurks in the undergrowth of bohemia.

This is especially the case with that wide penumbra cast by those characters who are not really artistically creative, but who feed off the arts in an attenuated or prescriptive way. Lewis was always very alert to the non-professional and amateurish in the arts—whether it can be attributed to a penniless or a millionaire bohemia, of the sort which he satirizes in *The Apes of God*.[1]

With the exception of a few minor bohemians who do not appreciably develop the plot—mostly English expatriates living abroad and acquaintances of Tarr—the main characters are all hard-boiled in the way that I have described. The sole exception would be Bertha. All of the others are carnivorous raptors who feed off the psychic carcasses of those around them . . . for the articulated psyche is closer to that of soldiers or military personnel than to an accepted portrayal of artistic types. The objective method for handling human beings—wherein they are viewed from outside-in, as well as in a hard-edged, cowboys and Indians, striated manner—all contrives to bring about this effect.

Although Ernst Jünger's *Storm of Steel* did not appear until after the Great War, the mental atmosphere of this book is remarkably similar. Wherein a description of a meal between

[1] Wyndham Lewis, *The Apes of God* (London: Nash & Grayson, 1931). See also chapter 5, above.

Bertha and Tarr, for instance, becomes an instance for all-in mud-wrestling—all of the combativeness remaining emotional and linguistic.

Tarr, as a book, also indicates the tyranny of originality, for all of the characters disconcert by dint of their inability to say anything unoriginal. One of the "shocking" plausibilities of this fiction is what it tells you about normal relations—namely, how boring they often are! Try and have a *Tarr* day, in which everything you utter to everyone is fresh and aggressively original, and you'll find yourself dismissed as a monster by the end of it.

All of the characters, particularly Kreisler, are monsters who lap up life's cream with abandonment and gusto. All of them (minus Bertha) live in accordance with Nietzschean maxims and in accord with Lewis' Nietzschean credo and essay, "The Code of a Herdsman."[2] This essay is difficult to sum up, but it essentially involves never repeating yourself, wearing masks in front of the majority of people, never going back to repeat your mistakes, and making of daily life a theater of cruelty, to use Antonin Artaud's felicitous phrase.

All of this strikes liberal critics as callow and adolescent, but it actually betrays a deeply fascistic register of the emotions. It is very rare for a novel to be written from such an illiberal vantage point, in a literary and metapolitical sense. For nearly all novels, poems and plays proceed from the premise that all you need is love (The Beatles' anthem which made the sixties its own). Nonetheless, the only characters—in liberal fiction—who evince poor morality in their day-to-day conduct are the villains. This is one of the reasons for contemporary transgression—namely, the fascination with evil and negativity because such persons seem to be the most alive. It is the Aleister Crowley phenomenon writ large, if you will.

A key example of this can be found in Iris Murdoch's *The Philosopher's Pupil*, a book in which everyone is soft, decent, moral, Quakerish, and liberal-minded, with the sole exception

[2] Wyndham Lewis, "The Code of a Herdsman," *The Little Review*, July 1917.

of the Russian philosopher, who comes across as twice as alive in relation to the other characters. In *Tarr*, all of the personalities, even the conventional German romantic Bertha, betray the fascination for illiberal qualities always manifest in the liberal breast. Surely the secret attraction, particularly in art, that liberals have for anti-liberal intellectuals is a love that dare not speak its name.

Counter-Currents, August 18, 2011

Ezra Pound[*]

Ezra Pound had a long life and was eighty-seven when he died. He was born in 1885 and died on the first of November 1972. I'll start by reading a poem that Pound wrote about the First World War and its effect upon that generation, which was known as "Hugh Selwyn Mauberly" and was written in around 1920. Part four of these inter-connected stanzas that make up the work:

IV

These fought in any case,
and some believing, pro domo, in any case . . .

Some quick to arm,
some for adventure,
some from fear of weakness,
some from fear of censure,
some for love of slaughter, in imagination,
learning later . . .

some in fear, learning love of slaughter;
Died some, pro patria, non dulce non et decor . . .

walked eye-deep in hell
believing in old men's lies, then unbelieving
came home, home to a lie,
home to many deceits,
home to old lies and new infamy;

usury age-old and age-thick
and liars in public places.

[*] A lecture to the 33rd New Right Meeting, London, Saturday, June 11, 2011. Transcribed by D. B.

Daring as never before, wastage as never before.
Young blood and high blood,
fair cheeks, and fine bodies;

fortitude as never before
frankness as never before,
disillusions as never told in the old days,
hysterias, trench confessions,
laughter out of dead bellies.

V.

There died a myriad,
and of the best, among them,
For an old bitch gone in the teeth,
For a botched civilization,

Charm, smiling at the good mouth,
Quick eyes gone under earth's lid,

For two gross of broken statues,
For a few thousand battered books.[1]

That's one of the more powerful and direct poems, or part of an overall poem, written by Pound who was highly disillusioned by the Great War and the slaughter which eventuated. Indeed, it led further to his break culturally with this country, which he lived in from about the turn of the twentieth century.

I think to give the talk some spine, it's best to adumbrate and look at the chronology of Pound's life. You have his birth in the United States to an establishmentarian family with Republican political connections, a quite prosperous family, in the 1880s. You have the move to scholarship and to study English literature and medieval literature in particular, an obsession with the troubadour tradition and the poetry of the late Middle Ages and a certain suppressed, erotic and/or other currents in European

[1] Ezra Pound, *Hugh Selwyn Mauberley* (London: Ovid Press, 1920).

art. You have the move to Europe and teaching, at polytechnic and various rag-bag institutions, the writing for small magazines and small poetry journals, the befriending of almost every poet and/or artistic intellectual who came to prominence during that period, Pound being a sort of unofficial clearing house and university for culture. The disillusionment in the wake of the Great War. The returning to the Continent thereafter. The living in France from 1921 to 1925 and subsequently Italy from 1925 until 1945. The gradually increasing political radicalization throughout the late twenties, thirties, and forties. After all he was living in Mussolini's republic.

After 1945, imprisonment by the American authorities, the option to execute Pound for treason to the American republic as designated, the option of life imprisonment, both of which were very real possibilities. Don't believe the rather tendentious and journalistic comment of the present time that says that Pound was really in no danger: the Americans would never have put one of their foremost poets to death. There was a very real prospect, of both execution or life imprisonment, probably a slightly greater prospect of the second. In the end, of course, he was institutionalized at St. Elizabeths mental hospital between 1948 and 1958. He then returns to Italy in 1958, through to the end.

So you have that spine of the life, which—given that it was quite a complicated, diverse life—is best to keep in mind.

Why is Pound regarded as an artistic revolutionary? Why is he inescapable from poetic Modernism in the twentieth century? Why hasn't he been dumped and binned because of his political affiliations? The reasons are essentially his concern with purity in language and the belief in the consolidation of literary forms and the compression of ideas into a smooth and unemotionally slithered diction which he called "Imagism" and which was to affect most of the poets of his era including W. B. Yeats, whom he befriended. I think Olivia Shakespear, who was a flame of Yeats, had a daughter called Dorothy who Pound later married. Pound was always rather complicated in his emotional and private life entanglements. He essentially had two families. He sort of had a mark I wife, Dorothy Shakespear, and a mark II wife, Olga Rudge and had children, Omar and Mary, by both. There

are also various other mistresses as well.

Pound once boasted that he'd been in Paris for three months and had not yet acquired a mistress when he already had essentially quasi-bigamist relations with two women and two family groups. So this is the sort of attitude that he had in this area to which in some ways might not have given them that great an importance because artistic, cultural, intellectual things always came first to Pound.

It's important to realize that the culture that grows up after the Second World War is completely distinct to the culture which existed before it. Poets were "rock stars" and were treated as such in the immediate pre-war period. Their doings, their mistresses, their outrageousness, their living against the conventions of bourgeois society were all considered to be integral to the poet's art.

Pound advocated a revolutionary poetics that gradually grew upon him from the first decade of the twentieth century on and was associated with poets like Hilda Doolittle (better known by her initials H. D.). Virago published Hilda Doolittle's poetry. Amy Lowell, and various other people. He was also associated throughout the century with very, very major writers who would later campaign against this execution and imprisonment, whatever they thought of his political affiliations, people like Robert Frost and, above all, Ernest Hemingway.

Hemingway's very planed-down, minimalist style, this sort of adoption of a Shaker diction in literature—Shakerism being an American Protestant cult where everything is simplified down to concrete essentials. They are most famous for their furniture. Shakers used to dance with each other rather than have sexual intercourse, men and women, which is why their sect died out!

Pound was very much a product of the Protestant north of the United States and remained, in a sense, a proud Yankee of independent birth and tradition. Many of his political positions are actually based on preceding incarnations of the American republic, and this becomes increasingly evident during his life and during his work. The middle and latter stages of his career are dominated by *The Cantos*, which is an enormous poetical

book, published in a series of stages and including fragments which were published after 1969 as a sort of addendum to the same.

Now, *The Cantos* of his middle and late career are the books like *Cathay* and so on, are part of his early period. But what you see in all of his work is a concern with purity of tone, purity of pitch, solemnity and dignity of diction, the planing down of language, and in some ways a slightly Eastern use of Western language which led him to explore Japanese and Chinese literature at a time they were virtually unknown outside tiny Siniological specialties in specialized university departments.

Pound's poetry is very academic at one level and visceral at another. Philip Larkin once criticized Pound in a post-War way by saying he made poetry out of literature rather than out of life, and it is true that Pound's poetry is fiendishly difficult. *The Cantos* explores fifteen languages, multi-dimensional realities, the idea of a hell that we're all in, a group of people that wishes to transcend that and find, if you like, a terrestrial paradise, and enormous amounts of economic and political lore, particularly in relation to the Social Credit theories of Douglas that transfixed Pound from the 1920s onwards and led him to believe that solutions to Western economic privation in the thirties were ready and were to hand.

Pound basically believed in a sort of cultural organization. He believed in telling people what to write, how to read, what they should be reading. He managed to make sure that many of his associates were published and were put into galleries. He was extraordinarily important in the launching of the career of Wyndham Lewis and in later theoretical and linguistic turns taken by W. B. Yeats. He launched a large number of poetical magazines which wouldn't have existed without him.

Major works in the twentieth century would never have been published without Pound either as an editor or as a midwife, or as a publisher's assistant or as somebody who even paid for the thing to be published in the first instance. "The Waste Land" by T. S. Eliot and most of T. S. Eliot's early poetry would not have been published without Pound's intervention. Pound believed Eliot had modernized himself and got rid of Romantic and what

Pound considered to be effete diction. He planed-down language to a Modernistic absence of excess. *Ulysses* by James Joyce would probably not have been published without Pound's intervention. Wyndham Lewis' *Tarr* would not have been published without Pound's intervention. So Pound was extraordinarily important in fostering other talent.

Artists are extraordinarily reluctant to support other artists because they're always involved in competition with each other, and there's a degree to which Pound was very unusual in his underground university attitude towards culture. This also went with his anti-democratic or elitist views. Pound basically believed in the absence of what has come to pass. He believed in a hostility to mass society, to mass entertainment, to mass infotainment, for the pop-culture which emerged in and around the Second [World] War but was preceded by the jazz age in the 1920s as a sort of precursor of same.

Decadent mass culture, in a sense has three variants, the 1890s, an upper-class version of it; the 1920s, a bourgeois version of it and a blow-out period after the excesses and privations of the Great War and thereafter; and the 1960s, when these mass counter-cultural energies become both mass bourgeois in orientation and also become proletarianized.

So what has actually occurred, Pound opposed from the moment of its inception. Pound believed that artists and writers and intellectuals and those associated with them had a mission to raise the level of the masses and to raise the level of mass culture. The artistic orientation of culture was a mold that the jelly of society should be made to fit. This led him in opposition to the idea that life is economically based, and that all that matters is economic preferment, and that material good and material success is all that's important. And, of course, during this period the rise of commercialism—which now accedes to a totalitarianism and is all around us—was that which Pound and many other writers of the Right or the radical Right laid into.

Pound was part of a generation that believed that Europe was dying and will either continue down to death or would be reborn. He hoped for the latter, and he saw in Mussolini's time of politics an adoption of the mechanisms and modalities of

Social Credit.

Now, Social Credit is an alternative set of economic theories, put forward by Major Douglas. Some compare it to Keynesian economics, although Keynes violently repudiated that. The criticism of both Douglas and Keynes, that their systems are inflationary, was held by Douglas of Keynes and Keynes of Douglas! Interestingly, these are not just theories because there is an attempt to implement these theories. In Alberta there was an attempt at a Social Credit regime. Social Credit ideology cannot just be dismissed as fanciful, beyond Left-Right posing and a desire to put poets in charge of the national economy.

I remember the Nicaraguan Sandinistas put a poet in charge of the national economy after they achieved power in that small, Latin American society. The economy subsequently collapsed. Hostile critics in *The Economist* and other journals blamed this on putting a poet in charge of the national finances. The Sandinistas blamed it, of course, on widespread sanctions which the United States was then inflicting on a tiny, impoverished Latino society.

Nevertheless, Social Credit *is*, in all probability, a reasonably acceptable sketch for an alternative type of economics. Pound invested it with holy writ and really did believe that there was the prospect of building a Social Credit society where money served the consumer and served the producer, and where the middleman based on usurious, interest-bearing profit without work or prior motivation, could be cut out. This drew both Douglas to a minor degree and Pound in a much more lurid, and extravagant, and artistically extreme way into what we might call politely the rejection of philo-Semitism. In Pound's case it became more and more lurid and more and more extreme as the thirties and forties continued.

Pound was a brave man and was prepared to suffer for his ideas and was driven to a certain extent, if you consider that he was, in many ways a one-man dynamo because he contradicted the establishment into minor elements of which, in the United States, he'd been born himself. On most major fronts in the twentieth century he opposed the literary and cultural values of the pre-Second World War era and post-First [World] War establishment. He opposed neo-Edwardianism and traditional Ro-

manticism in verse and sought for a modern alternative. He opposed economic and social doctrines which were widely prevalent at the time. He had a look for certain forms of authoritarian socialism in socialist and alternative magazines like *The New Age* which he wrote for in the second decade of the twentieth century edited by the occultist or occult-interested writer A. R. Orage. He explored ideas of re-evaluation and currency reform and economic transformation of Western societies, to get rid of the merchant or to get rid of the trader and to get rid of the banker and to get rid of the financier as the major arch or linchpin for that which existed. It's not that these societal models and roles didn't have any veracity whatsoever, it's that Pound believed that they should not be central to a culture or a civilization otherwise the values inherent in a culture will rot away.

"Usury" is what he used to describe this kind of debt-based finance capitalism, which is the system that prevails, which is the system which has worked/not worked, which has staggered on through the twentieth century with recurrent crises, seeing off its state socialist, authoritarian socialist, and in some respects its social democratic rival models.

How realistic the models were and are is difficult to determine. Probably Douglas' solutions would be inflationary as neoliberal and libertarian and *laissez-faire* economists — re-directed and come around again via the Austrian school and the Chicago business school — would attest. But there is a degree to which these theories have never been properly applied, and even if Keynesianism is in some ways a diluted or differentiated version of Douglas' ideas, these ideas were used to pilot the Western economy through most of the fifties, most of the sixties, and most of the seventies. They then fell into disuse and were upturned by the Thatcher and Reagan economic and political revolutions, or partial revolutions, of the 1980s.

Pound lived until 1972 and advocated maximal reform in the 1920s, thirties, and forties. Pound was the most politically active poet since William Blake. In an average year he wrote a thousand letters to various administrators, statesmen, and senior politicians. He was always berating politicians, and he always sought personal contact with them. Just as with the artistic

community when he arrived as a young student American immigrant in and around the latter years of the first decade of the twentieth century, Pound went directly to source. If he wanted to meet the putative Imagists like Amy Lowell and Hilda Doolittle, he would go and do so. If he wanted to meet W. B. Yeats and become his secretary then he would go and introduce himself and offer his services as a putative amanuensis. If he wanted to meet revolutionary artists like Wyndham Lewis, he would go and do so.

There was a cafe/bistro run by a Hungarian restaurateur in New Oxford Street called the Eiffel Tower which was the restaurant where they all used to meet. After Imagism and Amy Lowell's sort-of cannibalization of that idea, Pound moved away from that and towards a different conception of art called Vorticism which he developed in association with Gaudier-Brzeska and Wyndham Lewis. They used to meet in the Eiffel Tower, and there's a well-known painting of the Vorticists with Pound in the corner with a cravat and earring and the usual sort of post-Raphaelite look if you want to put it in that way, Lewis dominating the whole group with his enormous Spanish sombrero and cape, and various of the other artists and writers who were associated with that tendency of opinion.

Blast—which was meant to be aggressive rather than passive and was meant to be expressive and anti-romantic—didn't really survive the First World War but was an enormous magazine with pink covers and Modernistic abstractions and militaristic themes on the cover and was as big as the London phone directory. It was an enormously thick volume in which various tendencies were blasted or alternatively blessed.

Now, Pound became the most notorious poet of the twentieth century through a concatenation of forces. Certainly, on the 26th of July 1943 he was, *in absentia*, indicted for treason by the American government, and this was for broadcasts which he made for Mussolini on state radio. The Italians were reluctant to allow Pound on the radio. He had to fight for quite a long time until "they allowed me near that damn microphone!" as he would have said. When Pound got into the studio, Pound's voice was quite peculiar. The BBC occasionally play some of Pound's cyl-

inders, I suppose, or pre-33-and-a-third sort of 78 recordings, cylinder type recordings which were taken down by the University of Pennsylvania which was the listening station of the United States government to foreign broadcasts.

Hoover ordered a special file to be created on Pound, "this traitor," who he intended to deal with after the Second World War. The passion that the Pound case involved is difficult to understand in contemporary terms. Arthur Miller wrote a long article in which he speculated upon the tortures he would like to see inflicted on Pound prior to execution, and this was published in the published prints. The emotions which were generated by "the traitor Ezra" who was described by Miller as "worse than Goebbels" and "who knew how to appeal to every American strand of prejudice." Most of these broadcasts were never heard. But they were certainly heard by the American elite and by the American cultural elite.

The irony is that Pound had so many friends, culturally from Hemingway down, that he was awarded the Bollingen Prize by the Library of Congress immediately after the Second [World] War, which caused absolute outrage in the United States and led one congressman to describe it as "giving a prize for a man who uses words as maggots." So America has always dealt with those who it believes to be treasonable in a very straightforward way, primarily by stringing them up and by a "rope party" as it is called. Pound fell just short of such a rope party. Had it not been for his lawyer campaigning for an insanity plea immediately post war, he'd have probably faced life imprisonment and had it not been for the enormous number of prominent artists and writers, people like William Carlos Williams, people like e. e. cummings, people like Robert Frost, people like Ernest Hemingway, many of whom had no time for Pound's political views. If it had not been for them campaigning on his behalf, he could well have had a much stickier end.

Pound broadcast until the Americans invaded Italy after Operation Torch which saw the organized landings in Sicily and the Southern toe of Italy and general movement Western and Allied armies up against German and Italian troops, aided and assisted by partisans, most but not all of whom were communists. Pound

was arrested by partisans, and he slipped a copy of Confucius or a small volume of Confucius' thought—extremely socially conservative Chinese thought which had always influenced Pound, both poetically and politically—into his pocket. He probably expected to be shot. The partisans had killed the Mussolinis[2] a day or two before. But interestingly the partisans seemed to know who he was and knew that American intelligence wanted to interview him.

The interesting thing is that he was released initially, into the care of his family, and was then taken back into American custody. The second phase of American custody was the most climactic because in Pisa, he was put in the "death cells" as they were called. The death cells were six-foot-by-six-foot steel cells. Pictures exist on Wikipedia pages devoted to Ezra Pound, and they're worth looking at if people have a minute to bring them up. He had little water, few toiletries, there was no belt allowed, there were no shoelaces allowed—threat of suicide, through the bars of the cage.

These penal colonies and these death cells were primarily pursuant to struggles inside the United States army, particularly racial and political struggles. Whenever the US has gone to war prior to the accession of civil rights in the late 1960s you have struggles with all American armies. It goes without saying that the bulk of the prisoners in these maximal and ultra institutions for infractions of American rules and military disciple would be African-Americans, many of whom were on death row, waiting to be hanged by the US Army internally.

It is not an accident to suggest, as certain black nationalists in the 1960s would have suggested in the United States, that many African American troops were at war with their own army, and the war, from their point of view, was not against Germans or against Japanese or against Italians or against people who were fighting along with the Axis powers of other nationalities but was primarily against the US government. Most African-Americans always oppose American wars abroad by virtue of

[2] Probably referring to Mussolini as well as his mistress, Clara Petacci.

the fact they regard, like Obama's wife, their own country as the chief enemy.

Pound was put in this cell for two-and-a-half weeks and gradually either went partially mad, or did go mad for a short period. He was in extreme heat. He was denied all cultural stimulation. The guards were told not to talk to the prisoners. The only individual you could communicate with was the chaplain. There is a lot of evidence that Canto LXXXVI was started in the Pisan cells, because he started the Pisan Cantos, one of the most famous sections of *The Cantos* overall, in the death cell, which shows a mental resilience and a commitment to culture even in the harshest conditions where he either faced insanity, death, being left in the death cell until there was literally nothing left. It was only when he was interviewed and assessed by a psychiatrist that he was taken out of the death cells and put in medical confines. He was then interviewed by J. Edgar Hoover's personal representative who'd opened a file on him in 1943 pursuant to the treason trial which would occur.

The attempt by his literary friends to have him declared insane was essentially a ruse or a cultural route that was adopted primarily to save his sanity and his life. Whether Pound actually crossed the line into partial insanity at certain times, at St. Elizabeths where he was incarcerated in a mental institution for ten years, between 1948 and 1958, is difficult to determine. Certainly, Pound was driven, and he once said that Wyndham Lewis, his old friend, was pursued by the furies. But Pound himself was in certain respects a man who was pursued by the furies.

The Cantos, which is as thick as a telephone directory, which is published by Faber and Faber in Britain, is a strange work because it has no ultimate plot or overall structure, rather like Pound's work, which tends to be a cluster of heightened images, often pared down, involving enormous cultural resource of language whereby one idea suggests another one, somewhat effortlessly, and where you, rather like with Blake, realize that an internal world, an internal soundscape in language, a visual world in many ways, and a highly cultured one is being illuminated in tropes and in artistic configurations.

That's the only way really to read Pound. It doesn't have an

obvious narrative sense. It all associates with a need for renewal in culture, the extraordinary importance of the troubadour, the high medieval and classical tradition of the ancient world, the importance of culture to be raised over money in all areas of national life, the importance of the past in the present and the future, but the commitment to the future and the commitment to an explicitly modern future, but not the modern future that we live in now. Pound's growing disgust at the forces which he believed held back art and civilization and were planning for a new war.

One of Douglas' ideas, much more radical than Keynes in this respect, is that a debt-laden economy — which needs endlessly to spend in order to produce and then clear more and more debt which in turn will be spent through in a circular way — leads to war. He believed that the control of economies by bankers and financial capitalist institutions and the subordination of industrial and agricultural productivity to same will lead to war, what the extreme Left in the 1960s called the welfare/warfare state. These are sorts of statements which were made by Marxists and Frankfurt School intellectuals like Herbert Marcuse in books like *One-Dimensional Man*, in the late 1960s.

Now, radical Right and extreme Left share certain assumptions or share certain ideas if they radically critique finance capitalism, in particular, and the nature of the contemporary economic order. Pound was never an orthodox conservative and was essentially opposed to liberalism, except in the humanistic sense, except in the sense of a wide and deep educatedness. Other than that, he was opposed to liberalism in politics. He believed in enlightened aristocracy and rule by the talented few. He was opposed to liberal enlightenment views in culture because he believed in a culture-bearing strand or elite which is fed down into the masses and tried to raise them up to the level they could reach given their natural aptitudes and abilities. And he was also opposed to money choosing the politicians that one has.

In most Western societies you have two blocs, as everyone here knows, one representing bourgeois electoral power, one representing working-class electoral power. They occasionally

overlap in the center, but they basically vie with each other to manage the system best as boards, but increasingly are powerless in relation to money which seems to determine their ideas, their foreign policies, and even the personnel who run these parties. It is increasingly difficult to say whether contemporary politicians actually run these societies, the Left-wing concept of the ruling class that doesn't rule, the sort of rudderless ship, a system that is a process in and of itself, and developments which occurred after Pound's death.

What he critiqued in the 1930s, particularly with the Roosevelt administration which you could argue that by the New Deal had moved to Keynesian demand management and to certain forms of radical economic activity and initiative, very unusual for an American regime, which might be to Pound's liking. But Pound saw a poisonous relationship between the United States and the rest of the planet. While not, strictly speaking, an isolationist, Pound was a European American in the most radical of senses. Pound believed that American culture was an extension of European culture, not the other way around, and he also believed that Americans should contribute to Europe and to the glory and continuity of European culture as represented by the still living and extant cultural spaces of Italy and Greece.

A romantic of the European south, Pound believed that the task of great writers and intellectuals was to lead people and was to instill in people a belief in the glory of their civilization, something almost all contemporary artists have given up on.

Pound remains uniquely controversial in twentieth-century letters, and no matter how many little magazines he founded, no matter how many poets he led to being published, no matter how many artists he got into galleries, no matter how important his own work, the politics he became associated with is what has doomed him in the eyes of the culture-bearing strata. Although there's a degree to which Modernism in letters, in the English language at any rate, cannot exist without him. There is a degree to which Pound remains cardinal to the poetical experience in the twentieth century. This is why any modern literature course in any British or American university or further afield has Ezra Pound as a key item within it. But Pound can only be talked

about in hushed tones and in tones which attempt to apologize for his past, liberally, revisionistically explain away his past, or honestly confront his past as in John Tytell's biography of Pound,[3] without necessarily belaboring the criticism too much, because academics can get away with a certain specious objectivity. Tytell's book is quite interesting actually because it is a liberal confrontation with Pound which doesn't duck the political questions at all. He also wrote a book on the Beat generation.[4]

One of the most famous biographies of Pound, of course, is written by Eustace Mullins,[5] the quite well-known Right-wing currency reform advocate, alternative economics, conspiracy theorist, and American writer in the post-war era. These friendships Pound had with John Kasper and with Eustace Mullins would be held against Pound and were indeed used as a way to prevent him from leaving St. Elizabeths mental hospital until 1958.

Ernest Hemingway always campaigned for Pound's release, gave him a thousand pounds on the moment he got out of St. Elisabeths and went back to Europe. When Pound returned to Europe, the first gesture he did when he got off the boat was to give, in front of waiting journalists who were there to receive him, the Fascist salute and said that "I've left America, and America is an insane asylum. Everyone in America is mad, so by leaving America, I've left an asylum!"

So, anti-Americanism didn't begin with Pound, and it certainly didn't end with him, and yet he would proclaim himself to be a proud American, loyal to republican and federalist ideas which go back to the founding of the republic. The belief in honest work, the belief in standards of family and behavior, the belief in a post-European culture and identity in the Americas, a belief in hard work, a belief in the frontier ethics, a belief in the

[3] John Tytell, *Ezra Pound: The Solitary Volcano* (New York: Doubleday, 1987).

[4] John Tytell, *Naked Angels: Lives and Literature of the Beat Generation* (New York: McGraw Hill, 1976). Tytell went on to publish three other books on the Beat generation after Bowden's death.

[5] Eustace Mullins, *This Difficult Individual: Ezra Pound* (Hollywood, Cal.: Angriff Press, 1961).

lumberjack sort of ideal of the United States which is not corrupted and polluted by fiscal capitalism. In some ways he wants a simple, ruralist idealized US, which is like a machismo version of *Little House on the Prairie*. In actual fact, there's a degree to which William Pierce's ideas at the end about the sort of American he would like are very similar to what Pound advocated for his own society.

One of the very interesting paradoxes of contemporary life is that America is the most post-modern society, the most hyper-real society, the most fiscally based and fiscally driven society, the society that dominates all the others even to the degree that communist China and India, despite their new preeminence, are basing their models upon the American model.

This society is so Americanized—with the sole exception of not speaking with an American diction and using technically the American form of English—to the degree we have become an America here. This is the fifty-first state without almost any doubt, and our culture is so seamlessly intertwined with that of the United States that it is even regarded as slightly blasphemous to say so because it is so ingrained that people accept that without thinking.

Yet, the most radical criticisms—by people like Lawrence R. Brown, Revilo P. Oliver, Francis Parker Yockey, Pound in his book *ABC of Economics*, *How to Read* (and how to write, and who one should be reading), *Jefferson and/or Mussolini*, and many of his non-fiction works[6]—he wrote an enormous amount of journalism and an enormous amount of non-fiction prose to go with the poetry—all of these works are produced by Americans. It's as if America has a radical cultural split between those who accept everything that Americanism is in its contemporary terms and those Americans who reject Americanism and claim to be the most American of all.

It's important to realize that the most extreme indigenous, bluegrass, socially conservative politicians in the United States—

[6] Ezra Pound, *ABC of Economics* (London: Faber, 1933); *How to Read* (London: Harmsworth, 1931); and *Jefferson and/or Mussolini* (London: Nott, 1935).

people like David Duke and so on—are those ones that advocate the end of an American empire and isolation. Even more moderate and slightly more credible candidates to a certain extent like Patrick J. Buchanan. And one of these candidates always stands in every presidential election on the margins. They get two percent in certain states and so on. Most people who would otherwise vote for them vote Republican, given the internal ethnic balance and complicated politics of the US *per se*, where the Republicans have become the repository for white votes. It's quite clear, President Obama was elected because a third of the society, in one way or another, looks the way he does. America has changed out of all recognition in the last thirty to forty years, something which largely Pound didn't live to see.

But Pound's predictions in relation to what would happen in the world—recurrent wars, recurrent crises, recurrent instabilities for international fiscal capital based upon debt and usurious inheritance—is largely true now as much as when he talked about it in the twenties and thirties.

Pound was unusual in that as an artist he should have no right to talk about these matters—about which he could be presumed to know little—cross the margin, cross the line into politics. One thing about artists is that they will always choose extreme or radical political formulations if they cross the political line, because moderation doesn't come naturally to them. Also, thinking as an end in itself, politically—whereby one basically looks at a corpus of ideas and if necessary pushes the latent ideas within that system to the most radical margin or edge—is inevitable for people involved in artistic and intellectual life.

This results either in the idea that people think intellectuals make incredibly bad politicians or a cult of anti-intellectuality amongst politicians, because if you thought out logically the semblance of logic that exists in your own programs, you might be invited to adopt radical solutions that would make you unelectable or would not pass various liberal filters in the media and elsewhere when you are asked about your own opinions. Most politicians, after all, lie about what their real opinions are, increasingly don't have any, increasingly think that politics is a vehicle for themselves to get on and run against the interests of

the people in the bloc that they were put there to represent in the first place, and this is considered to be normal politics .

Milliband is now re-engineering new-old Labour to be a party which he is and isn't proud to lead as he seats the liberal centrist votes that will bring Labour back. Cameron spent his entire time as an opposition leader denying that he was a Conservative and saying that he was an upper-class liberal chap with terribly modern ideas really that didn't amount to much, that just happened to wander into the leadership of the Tory party. This is how our contemporary politicians behave.

People like Pound are so extraordinary because they have no concern with that sort of tendentiousness at all, and this makes them either deluded idealists of the first water, from the perspective of practical men, or refreshing idealists who push the envelope and who believe the truth lies in the margins, believe that truth lies at the extreme, at the outlet in mathematics. The arrow that crosses the circle is furthest out, and X, the point the line goes through the circle, is the most radical formulation of a proposition that you can have.

Now, Pound recovered gradually and used St. Elizabeths hospital as a sort of moral university. Most of his family—his two families, if you like—visited him there. A large number of writers and intellectuals visited him there. Wyndham Lewis once complained that "Your strategic initiative in taking up residence in a lunatic asylum is not healthy!" Although it was quite clearly the strategy which enabled him to survive and prosper in the post-War world.

I'll read another poem which is about usury and which is a very famous poem, and I shall attempt to read it in the way Ezra Pound would have read it, which may, or may not, be amusing![7]

One thing that always works with Pound it to put it into an American diction because—although it's said the British and Americans are a people divided by the common use of the same language—there is a degree to which the poetry does come alive when you put it into that American diction. Just on a technical point, American language is often more archaic than British Eng-

[7] Bowden's reading of Canto XLV omitted due to copyright.

lish, because it is more based on the Authorized Version, and it can at times have certain primal qualities. It's no accident that a great number of the foremost writers *in English*, in our general language, have been Americans. But they've been Americans who have sought out the European destiny and believed that they should come here. Wyndham Lewis was Canadian born. Ezra Pound was a Yankee American. T. S. Eliot became more English than the English but was, of course, an American by birth. For all of them . . . There's a large number of people: Amy Lowell, Anna Kavan,[8] Djuna Barnes, Hemingway, and so on, of a slightly lesser sort. Hemingway is actually slightly interesting. Hemingway always supported Pound, and Hemingway said, "In a thousand years, if literature is still read, Pound will be there."

When he was asked about his relationship with the segregationist, John Kasper and Ezra Pound . . . Kasper would later be jailed for the bombing of a school, when there were no children there, which was desegregated and who ran a radical Right bookshop in Greenwich Village of all places! An area that's open to alternative ideas.

One of the interesting things about the sort of radicalism Pound represented is that many people would have thought it was Left-wing for quite a while, particularly the alternative economic ideas, the writing for socialist magazines like *The New Age*, and his association with Dorothy Shakespear.

When I was a young man I went to Paris for a couple of weeks, and on the left bank there is Dorothy Shakespear's bookshop called Shakespeare and Company, which is the most famous English-language bookshop in Paris.[9] It's a stone's throw away from Notre Dame—I think it's in the Fifth Arrondissement—and you can almost see the cathedral from the bookshop.

[8] Anna Kavan (Helen Emily Woods, 1901–1968) was a British national born in France and raised in Europe and the United States.

[9] Shakespeare and Company (with an "e") was not founded by Dorothy Shakespear but by Sylvia Beach. Dorothy Shakespear and her husband Ezra Pound frequented the bookshop in the 1920s. Shakespeare and Company was closed in 1941, and the shop Bowden visited was opened by George Whitman in 1951 as Le Mistral then renamed Shakespeare and Company after Beach's shop in 1964.

It's a very shambolic sort of bookshop, with books piled absolutely everywhere. It was run by a very aged, bearded Trotskyist in 1982, I think, when I was there, and he said, "You'll be staying for tea?" because everyone who was there was invited for tea, and you went upstairs. So in a sense it retained its bohemian qualities which it doubtless had in the era of Dorothy and Ezra. No French books were sold there really. It was all in English. Kilometer zero, right in the center of the city. Shakespeare and Company, kilometer zero, every book stamped with that particular marker, round cylindrical marker. A lot of the books even hail from the thirties, by Miller, by Hemingway, and others are still on sale, some of them in original binding.

Now, Dorothy Shakespear's Egoist Press and the journal *The Egoist*, which Pound helped her with, published Lewis' *Tarr*. I think may have published Joyce's *Ulysses* as well. So Pound was always at the forefront of the radical use of language, no more so than in *The Cantos*.

And with the audience's indulgence and permission I shall now read the beginning of *The Cantos*. Pound is very difficult. Pound is very difficult to read. Pound relies upon an education which almost no one in Western societies is now given, even at the most elite level. But my view is that is a wrong way to read Pound. Most people they come across in the third line a cultural association which they don't understand, maybe from the classical world, and they think "This isn't for me. I'm on the third line, and I'm already lost," and they put it aside. But in actual fact, my view of writers like him, who use other cultural forms to think through, it's a shorthand for their own thinking, is not to be bothered about not getting the cultural reference, you continue with the work itself. So I would advise anyone to get Pound out of their local library and to have a look, liberals say, irrespective of the politics, and irrespective of the political radicalism.

It is noticeable that nearly all political articles about Pound such as the excellent article in Kerry Bolton's *Thinkers of the Right: Challenging Materialism*[10] doesn't really concentrate on the

[10] Reprinted in Kerry Bolton, *Artists of the Right: Resisting Decadence*, ed. Greg Johnson (San Francisco: Counter-Currents, 2012).

poetics, which is very difficult and very technical. Liberals would have loved it if there had been no politics at all and no political overlay.

Here's the first part of *The Cantos*, Canto I.[11] Now, obviously that particular beginning of *The Cantos* is based on Homer and is based on a transcription or a literary transliteration of same. Many of his translations—from the Provencal, from the troubadour tradition, from Japanese and Chinese art, from medieval poetry, romance and courtly love poetry, and Anglo-Saxon literature, for which he had a great love—were very important in an era where many of the great poets had moved away from translation.

Pound's academic translations are still controversial. Many academics think he made many mistakes, and the translations are not literal, and probably in terms of language use that's true. But certain Chinese writers have pointed out the extraordinary idiomatic quality of Pound's translation, his ability to enter into the spirit of the artist he's translating and do something called mimesis, whereby you actually ventriloquize and adopt their voice, so you leap dictions, and this led to his celebration of the ideogram.

In Japanese poetry there's the concept of the haiku whereby you put things in so concentrated a manner, that really you compress a life or a momentous incident into four or five lines. It's the idea of adding power through compression. Pound wants to have the power, due to the compression of the language which he's used.

Ezra Pound, a life, 1885 to 1972: I would say that Pound delivered up his entire life for what Western civilization should be. He chose the most controversial political side that was then in existence and which he could have chosen. He thought little for himself and thought only for the civilization of which he was a culture-bearer. Pound is an example in a modern world of crass materialism and levelling absence of distinction, particularly intellectually.

[11] Bowden's reading of Canto I omitted due to copyright.

What is unpalatable about Ezra Pound is his opposition to the shibboleths that now dominate us: the belief in equality, the belief in mass uniformity, the belief that certain ideas are "out of order" and cannot be accepted, the belief that certain political and cultural trends are so unacceptable that they shouldn't even be discussed at the tertiary or university level. These are the things which Pound rebelled against all of his life.

The other interesting thing—in a period when someone who I've spoken of in these meetings before, Bill Hopkins,[12] who has died recently, at approximately eighty-three years of age—is Pound's link to the most eternally minded and important artists and intellectuals of his time. The radical Right is regarded as a trajectory that has no connection with civility, or with art, or with culture. It is a tendency connected to thuggery in the mass mind and in the mass media mind. Whereas here you have exemplars of the civilization, people amongst the most significant individuals in their society who in the end, ended up put in the death cage, in an American penitential death cage, for the views which he espoused as a free man on Italian radio.

So Pound was prepared to die and was prepared to suffer for his beliefs. His weren't the crazy views of an intellectual who thought he could put the world to rights. They were beliefs that he was prepared to die for. And if people are prepared to die for things, they are prepared to live for things.

The West is in a very rocky stage at the present time, and although there is some evidence Pound became very depressed at the end of his life, there is still hope, and there is still a fortitude that exists here among Western people that a change in the next twenty to fifty to seventy years is possible.

My view is that one thing that people should always look at are the elite artists and intellectuals who have aligned themselves with European renewal. Educate yourself, read for yourself, read, and make decisions for yourself, turn the television off, and look at this sort of material.

Ezra Pound is an example of Anglo-American intellectuality

[12] Bowden's speech and writings on Bill Hopkins are collected in *Western Civilization Bites Back*.

and poetic resourcefulness at a very high level. Even the critic George Steiner once said of Pound that he had an extraordinary ear, this *ear* for language. Pound believed that artists were the antennae of the race—the antennae of the race—and they were there to lead other people towards a greater understanding of what it is to be human, a greater understanding of what you're going to experience before you die, when you wonder whether your life has been worth anything or not. These are the sorts of areas that Pound wishes to reach into.

So I would ask people to admire this man, not just because he had a political affiliation that people in this room would find much more acceptable than your average representative of Radio Four culture, but also because he's an elitist of the best sort and a mind of the best sort that we rarely see today. A polymath, who was unafraid, and he walked in a manner that led people to recognize that, irrespective of his Americanism, this man was a European. Here goes a man, here goes a great European American. I give you the memory of Ezra Pound, 1885 to 1972.

Thank you very much.

Counter-Currents, August 29, 2014

T. S. ELIOT:
ULTRACONSERVATIVE DANDY

For a brief period in the late 1990s, there was an attempt to demonize T. S. Eliot as an anti-Semite. This opinion was most ably canvassed by Anthony Julius' *T. S. Eliot, Anti-Semitism, and Literary Form*,[1] but the attempt failed, and Eliot's reputation as a poet now stands even higher than ever.

Thomas Stearns Eliot's most controversial book was the collection of essays drawn from a series of lectures he gave in 1934 called *After Strange Gods: A Primer of Modern Heresy*.[2] In this book, Eliot argued for an organic society—primarily from a Christian perspective—and he took a decidedly non-philo-Semitic position, considering that the more organic the society, was the better its prospects.

It seems an utter travesty, at this date, that the most famous English language poet of the twentieth century should be treated in this way. For the interesting things to say about this fey, classical, and austere man have little to do with this (or his marriage to Vivienne Haigh-Wood in 1915) but, rather, revolve around his contribution to literary criticism. In this regard, his development of the idea of a tradition within a writer's *oeuvre* proves crucial—witness his own distancing over time from the thesis of "The Waste Land" and "The Hollow Men" as he turned to Christianity, metaphysically speaking. The idea of not seeing works in isolation but from a whole perspective is very interesting in a deeply conservative way.

This further ramifies with Eliot's coolness and classicism in the arts—if compared and contrasted to his hostility to the Romantics, particularly a Left-wing revolutionary like Shelley. (Eliot would have had no time for the literary prognosis of the Trot-

[1] Anthony Julius, *T. S. Eliot, Anti-Semitism, and Literary Form* (Cambridge: Cambridge University Press, 1995).

[2] T. S. Eliot, *After Strange Gods: A Primer of Modern Heresy* (London: Faber & Faber, 1934).

skyist Paul Foot in his *Red Shelley*.) Nonetheless, for him, poetry was a codification but never a standardization. It was an escape from emotion through distancing—rather than an achievement of emotional excess through revelation. All of this led to his espousal of the metaphysical poets—Donne, Vaughan, Marvell, and Thomas[3]—as he praised their use of metaphysics in poetry to provide a unified sensibility.

Possibly Eliot's most famous literary idea was the objective correlative—whereby he sought a general, and culturally relevant, explanation of works which transcended personal responses to them. This involved a semi-objective as well as a subjective reading of the text. A piece attempts to mean what it says, but it also indicates states of mind and experiences which are factual and that can be essayed without being unduly personal about literature.

This hunt for a more general meaning indicates a social vision for art in a man whose own work is very abstruse and 'difficult' to understand. This is particularly true of the early poems such as "The Love Song of J. Alfred Prufrock" (1917) and "The Waste Land" (1922) but changes somewhat after "Ash Wednesday" in 1927.

If we might turn to the poetry now: "Prufrock" begins with a stream of consciousness which is typical of early Modernism—although much of Eliot's early poetic vision owes something to his discovery of Arthur Symonds' *The Symbolist Movement in Literature* in 1908. Prufrock begins with comparing the evening to an etherized patient upon a table which was considered scandalous at the time when Georgian poetry was all the rage. There is even a hint of the right-wing nihilism of Gottfried Benn in early Eliot. In "Prufrock" he deals with a disappointed life, states of physical and intellectual inertia, and the absence of both carnal love and spiritual progress.

In October 1922 "The Wasteland," edited extensively by Ezra Pound, made its appearance and extended the analysis, amid many other concerns, to his failing marriage to Vivienne, both of whom were suffering from nervous and mental disorders at the

[3] Probably the dramatist Thomas Middleton (1580–1627).

time. The poem definitely chimes with the post-First World War disillusionment of an entire generation.

"The Hollow Men" in 1925 confirms and extends this triad of despair until his conversion to Anglicanism from Unitarianism in 1927. This event was definitely the key metaphysical moment in this very fastidious man's life. The hunger for meaning and a dormant metaphysical purpose came out. For, in his conversion or re-conversion, Eliot illuminated the idea that life is spiritually barren and meaningless without an over-arching quest, sensibility, or teleology.

Certainly once his conversion is definite, the pitch of Eliot's life and his poetry (above all) takes a decisive turn. "Ash Wednesday," the "Ariel" poems, and the "Four Quartets" (for which he was awarded the Nobel Prize in 1948) are much more certain in their direction, as well as being more casual, melodic, and contemplative in their creative method. Although secular literati remain discomfited by these poems' transparent religiosity. This is nowhere more apparent than in the "Four Quartets" which is immersed in Christian thought, traditions, and imagery.

Much of his creative energy after "Ash Wednesday" went into writing plays in an attempt to broaden the poet's social role — all of these pieces were verse dramas. The whole point of *Sweeney Agonistes* (1932), *The Rock* (1934), and *Murder in the Cathedral* (1935), dealing with Thomas à Becket's assassination, was to bring a larger or wider audience to a conservative purpose for Christian poetry.

For Eliot is that rare thing in twentieth-century literary art — an ex-nihilist, someone who reverses the positions of Dostoevsky's *The Possessed* (without the enervation) and wanders back towards C. S. Lewis, Belloc, and Chesterton. I think the key point about these partial dandies and Right-wing conservative intellectuals is their belief in belief . . . For, without the prospect (even in its absence) of metaphysics, life had no ultimate meaning for them, or for us. Almost everything else about them is incidental to this truth.

Counter-Currents, July 29, 2011

T. S. Eliot*

Thomas Stearns Eliot was born in St. Louis, Missouri in 1888 and died in 1965. He was awarded the Nobel Prize for Western literature in 1948, and his career in many ways is an elixir of Modernism in the arts, certainly early on. In the late 1990s, there was a concerted attempt to demonize Eliot based around a book called *T. S. Eliot, Anti-Semitism, and Literary Form*, which was produced by somebody called Anthony Julius. There was a large-scale media correspondence created by this book. BBC debated it on channels that liberals listen to, such as Radio 4. Was Eliot an anti-Semite or did he reject philo-Semitism, as I call it, a bit too nakedly? There's a degree to which Eliot certainly went through a radical phase in the mid-1930s after his reconversion within Christianity in 1937 from Unitarianism to Anglicanism, which in many ways was the key metaphysical moment of his life.

One thing that always happens with all those who gain any degree of prominence is that there's a general academic response to them obviously, but to one side, there's an attempt to feed off them in a sort of collateral damage way of literary criticism. This relates to two areas: their private lives and what can be said about it, particularly in a detrimental way, which is either tittle-tattle or the sexual politics of their life, biographically speaking, and we'll come to that in relation to his first wife, Vivienne, in a moment. Or, secondly, whether there's political incorrectness, whether you can harvest the fact that the person concerned, in some way or other, had views that are unacceptable. The remarkable thing is that before people started guarding their most private and intimate thoughts—particularly if they were of some cultural or educational level in the last twenty years, after the advent of what was called political correctness—a vast range of people, from Marx onwards, have rendered extraordinarily incorrect statements privately and in diaries and in written rec-

* A lecture to the 34th New Right Meeting, London, Saturday, August 6, 2011. Transcribed by V. S.

ords. And Eliot was no different.

His most notorious publication, which was never republished, was a book based upon the transcript of a lecture, I think in 1934 or 1935, *After Strange Gods: A Primer of Modern Heresy*. Now, this book argued for an organic society with the fewest number of foreigners. It was largely done from what you might call a Christian national perspective, given his conversion to High Church Anglicanism. Eliot remained High Church and semi-Anglo-Catholic by adoption. But as a man, psychologically, he remained a Puritan, and he always had a strong streak of puritanical New England diffidence, which in some ways probably prevented him from leaving the area that we could call ultraconservatism.

There's a website in the United States called *Counter-Currents*, and I've written an essay in the last couple of weeks on it called "T. S. Eliot: Ultra-Conservative Dandy," and there's a degree to which this is what I consider Eliot to be.

The most important element in Eliot's life isn't accusations of incorrectness about this sort of matter played by Julius or whoever else, but is the quasi-nihilism of the early poetry, which maybe poetically is the best poetry, in comparison to the later belief and the metaphysical plunge or the re-plunging back into a considered form of identity and the identitarian politics that inevitably goes along with that.

Now, Eliot worked in a bank for a short period between 1917 and 1925. After that, he worked for Faber and Faber in Camden. He married Vivienne in 1915, and one of the other areas where Eliot has been attacked posthumously is his relationship with his first wife, Vivienne Haigh-Wood. There was a well-known play called *Tom & Viv* in 1984, and this was followed up by a film of the same vein, *Tom & Viv* again, on the screen in 1994. This is part of the concerted feminist attack on various writers who retain some prominence in the twentieth century. The idea that they were bad to their spouses, that they drove them insane, that they were responsible if not for wife-beating and that sort of thing — we're dealing with people of a certain cultural level after all — then the moral and linguistic equivalent of same.

This is particularly true of Ted Hughes and his early poetic

wife, Sylvia Plath, who committed suicide, of course. And there have been extraordinary attempts, including a very back-handed and misguided one to partly dig up the Plath grave, by feminist devotees largely from the United States. This was part of the extremist second wave of feminism, which is very much part of the 1970s.

You notice that academics feed on writers in two main ways. One is just general biographical and academic approaches within the tolerated bounds of opinion, academically and otherwise. The other is this attempt to suggest that there are dark, willful, abstracted, incorrect, pseudo-Satanic elements to them that need to be revealed, such as a belief in an organic Western society with as few foreigners as possible, the belief that not all Semitic influence is for the good of the general population, the belief that men and women are genetically and biologically different and psychologically and emotionally so and in some ways need to be treated differently in relation to legal conduct.

Now, Eliot's poetry has this enormous bifurcation between his pre-conversion experience and post-conversion experience. The early poems such as *Prufrock and Other Observations* in 1917 and thereafter and "The Waste Land," one of the most famous poems of the twentieth century, and "The Hollow Men" in the mid-1920s very much despair at life, at existence. Don't just incarnate the disillusionment of the post-Great War generation, which suffered a catastrophic loss of faith in relation to Western traditions and structures at that time. It wasn't just a generational clash between those who had fought in the war and those who had ordered the bloodbath; it was a general and conceptual retreat from many hitherto adopted Western attitudes.

There's an interesting parallelism between Eliot and what you might call an amateur poet, Enoch Powell. Enoch Powell had a prior belief system before his conversion/re-conversion to High Church Anglicanism, and that was Nietzscheanism, which strongly influenced Powell when he was a younger man. Powell wrote poetry throughout his life, and volumes of it are available on the internet. Now, when I say a re-conversion, I am working on the premise that before 1950, certainly before 1960, we were living in a largely Christian society, at least in terms of its self-

conception. Thereafter I make the judgment that we are beginning to live and now most definitely do live in a post-Christian society. So, when I talk about reconversion, when somebody *recommits* to a doctrine of metaphysics such as Christianity — revealed Christianity, of one of the major departments, Protestant, Catholic, Orthodox, or one of the major sections or sub-sections within that — they are basically *going back* to prior Western structures. Maybe not the structures I would choose in an ideal world, but they are going back to that which existed before them.

Tradition was very important to Eliot, who had another career as a literary critic and another career as a playwright, particularly in and around the Second World War. Eliot always sought a social role for the artist, which clashes slightly with the nihilism and despair and inner despondency of perhaps the greatest verse, which he wrote early on in his career. I'll just read a few things which I have with me in the Faber and Faber edition of the *Collected Poems 1909–1962*.

Eliot, of course, worked for this firm from 1925 onwards apart from a few outtakes as a professor at Harvard wherein he largely lost contact with Vivienne, partly deliberately. Vivienne was the first wife who declined into mental illness and lived the last nine years of her life from the mid to late thirties to about 1948, I think, or maybe '47 in an insane asylum in Hampney in Stoke Newington, The Northumberland Institute.

"The Love Song of J. Alfred Prufrock"

Let us go then, you and I,
When the evening is spread out against the sky
Like a patient etherised upon a table;
Let us go, through certain half-deserted streets,
The muttering retreats
Of restless nights in one-night cheap hotels
And sawdust restaurants with oyster-shells:
Streets that follow like a tedious argument
Of insidious intent
To lead you to an overwhelming question . . .

Oh, do not ask, "What is it?"
Let us go and make our visit.

In the room the women come and go
Talking of Michelangelo.

 The yellow fog that rubs its back upon the window-panes,
The yellow smoke that rubs its muzzle on the window-panes
Licked its tongue into the corners of the evening,
Lingered upon the pools that stand in drains,
Let fall upon its back the soot that falls from chimneys,
Slipped by the terrace, made a sudden leap,
And seeing that it was a soft October night,
Curled once about the house, and fell asleep.

 And indeed there will be time
For the yellow smoke that slides along the street,
Rubbing its back upon the window panes;
There will be time, there will be time
To prepare a face to meet the faces that you meet;
There will be time to murder and create,
And time for all the works and days of hands
That lift and drop a question on your plate;
Time for you and time for me,
And time yet for a hundred indecisions,
And for a hundred visions and revisions,
Before the taking of a toast and tea.

 In the room the women come and go
Talking of Michelangelo.

 Now, this was written 1917 and onwards before Pound became involved in his poeticization. "The Waste Land," which followed in 1922, was heavily influenced by Pound and was edited by him. There is this quote in Latin and Greek at the beginning of the poem where he basically talks about being honored by the greater craftsman because Pound certainly imagized the poem and cut it down and made it more sheer and not less com-

plex, but probably starker than it might otherwise have been. "The Waste Land" is probably the greatest expression of despair in the twentieth century, and despair underlines quite a lot of Western artistic attitudes in the twentieth century.

It's interesting to notice, metaphysically, in a high philosophical sense, why there has been such a current of despair in Western art in the twentieth century. As Pound said, artists and writers of some quality — we're talking about after their death, anyway — are the antennae of the species. There is something in the aether of contemporary modernity and postmodernity which is uniquely despondent for those who care most about civilization and where they believe it's going. So, if you have the idea that artistic individuals are insightful at a higher level than the general mass of the population, it's inevitable that they will imbibe many of the energies, pro and con, fulfilling the presence and the absence of the metaphysical space.

Don't forget that the religion that people were taught to believe in for the better part of one-and-a-half to two thousand years is partially collapsed during this period. Western identity has largely collapsed during this period. And if faith and identity go, and if knowledge in terms of what once was feeds through into the present, which determines what one will be, you can understand why many writers and artists have taken the perhaps easy consolation of despair.

Although never riding roughshod in the sort of Left-nihilist terrains like Beckett, Sartre, and others of the existentialist school in the middle of the twentieth century, someone like Eliot incarnated many of their attitudes earlier on, prior to his conversion or re-conversion from Unitarianism to Anglicanism.

I think it's extraordinarily important actually that Eliot made a metaphysical choice, because it's a choice that everyone has to make in this life in relation to the ultimate answers. We've heard political talks earlier on this afternoon, but politics can only go so far in answering what life is about, particularly as one gets towards the phase of life when death begins to approach.

Religion ultimately gave the consolatory answers to what life's meaning could be for most people. In the twentieth century, religion for thinking and reasonably sensitive people has

been replaced by art, and it's no accident to my mind that despair has become the currency of a large amount of the creative superstructure of Western thinking. People can say, "What use is it for these considerable talents, whatever one thinks of individual artists and writers, to retreat into the possibility of despair? Isn't it the job of artists to ennoble, to glorify, to build up, to create structures that can be looked up to?"

This is why hierarchical elitism is so important, because if there is nothing above you, then there's nothing to look forward to, there's nothing to transcend to, there's nothing to abide by that is beyond and outside one's often quite trivial concerns. The mass of people today live completely buried in their trivial concerns, and most forms of culture are forms of entertainment. Eliot represented one of the last generations where the more classical and restorationist attitudes toward culture prevailed.

After the conversion to Christianity in poems like *The Ariel Poems* and "Ash Wednesday" and the "Four Quartets," for which he was largely awarded the Nobel Prize in 1948, Eliot's diction and his poetry changes quite considerably. It becomes more causal, becomes more melodic, becomes more semi-Romantic, although he resisted Romanticism in poetic diction. Eliot's a Classicist. Eliot is a New England Puritan in a very complicated way. There's a poetic neuroticism to him, particularly in the early verse, but there's also a deep New England Puritanism, but never philistinism because you're dealing with a highly complex individual. Born in St. Louis, Missouri, he once said that his heart was British, but his sensibility and intellect were American, and that Anglo-American hybrid or hybridization very much fulfills the nature of his vision.

Towards the end of his life he became increasingly important even in the politics, if one can call them such, of the Anglican Church. He was asked in the late 1940s by the Archbishop of Canterbury to serve on panels that discussed the theology, particularly of the more Anglo-Catholic chapter of the Church, and he also was involved in 1963 in revisions of the psalter in collaboration with C. S. Lewis in committees to re-examining church doctrine, morals, and textual exegesis. So, Eliot threw himself into Christianity and threw himself into the idea that a Christian

community should be what this country *had to be* in order to reach the redemptive view of itself. This may not be to everyone's taste today, but there's a degree to which this mattering to Eliot that something should matter was crucial to his later developments as a poet and a playwright.

Eliot had a parallel career as a literary critic. He developed several important critical ideas, from a highly conservative and individual standpoint, which have stood the test of time and have had great influence. He influenced New Criticism in the middle of the twentieth century when it was characterized by I. A. Richards in the United States and F. R. Leavis here on this side of the Atlantic and was characterized very much by the developments at Cambridge University amongst other places.

Eliot's ideas were very much of the vogue that there has to be a response to art and a response to higher things which isn't purely personal. We live in a world where everyone has a subjective response. They like something, they dislike something. They intensely like something, they intensely dislike something. They're completely indifferent, or whatever else. Eliot developed a concept which he called the objective correlative, whereby the words were not completely evaluated by "me likes, me doesn't likes" sorts of vocabularies.

This involves the idea that there is a background or tradition within an artist's conceptuality. In other words, the man who wrote "Ariel," the man who wrote "The Rock"—a collected and collaborationist Christian piece in 1934—was quite different to the man who wrote "The Hollow Men" and "The Waste Land," and yet the poetic diction of the one and the other are interrelated, and all of them have to be seen as part of a career, part of a progression from conscious adult life towards death.

So, this idea of a tradition within an *oeuvre* rather than just relating to tradition as it comes down to one in relation to the Georgian and post-Andersonian poetry that was written earlier in his career and, of course, against which he was a rebel. In "Prufrock," there is a comparison between the evening and a patient who is being anaesthetized or etherized and is lying on the table. And that was regarded as quite a shocking and incorrect image at that time when Georgian poetry and neo-Romantic

idealism were the way in which things were configured.

There's a nihilism at times to early Eliot which comes close to Gottfried Benn and this sort of school which is associated with the Right not the Left. It's important to realize that not all despair in culture is Left-wing. The Left wants to pull down and therefore often adopts an antagonistic attitude towards nearly all prior forms. The more extreme the current of the Left, the more extreme becomes the destructive urge. There's even a spiritual dimension to this in occultistic terms whereby the Left represents the destructive and chaotic side that wishes to arrange and extend the limit of chaos prior to the prospect of reconstruction. The idea that destruction is a creative passion.

There's an interesting story about the anarchist Mikhail Bakunin who was, if you like, the founder of a movement that lies to the Left of Marxism and was a rival to the attentions of the extreme Left in the nineteenth century. Don't forget: extreme Leftists would have tiny little meetings like this in the nineteenth century totally ignored by the general culture. Yet their ideas in the twentieth century were to dominate much of the hinterland of the planet. This is from E. H. Carr's biography of Bakunin.[1] Bakunin once passed a gang of rascals and ruffians who were destroying a house and were burning it to the ground, and he got out of the coach and joined in the destruction. He raced about! Don't forget that he's an aristocrat. He raced about putting his cane, feral, through things and stamping on pictures and throwing things out of windows with the other ruffians, who just accepted that he was one of them because he joined in. When the conflagration had ensued, and most of the mansion or whatever it was had gone up, Bakunin was asked why he'd done it, and he said, "Because it's there." That's an ontological prerequisite, a very extreme Left-wing attitude. You want to destroy things because they are *there*. The reason you want to do that isn't pure nihilism, because the bulk of it is the notion that it's a perfect society that can replace that which is destroyed.

The reason why Right-wing meetings are, in the past when they had the numbers, ranked by the extreme Left—and almost

[1] E. H. Carr, *Michael Bakunin* (London: Macmillan, 1937).

everyone over a certain age in this room has had experience of that — is because they see in their most radical opponents on the other side the germ, and more than the germ, of everything that they most dislike. They see the maximum form of essentialism. They see the maximum form of the belief in the politics of identity, when they believe in the politics of non-identity. This means that people like Eliot, people like Pound, people like Lewis are anathema and always have been to the extreme Left that took over much of the academy from the late 1960s. Although in funny ways, one is surprised that Pound and Eliot have not been demonized more.

The reason that they haven't been, as I discussed in the Pound lecture last time, is because they are crucial to Modernist writings and the arts in the English language. If you took Pound and Eliot out and basically corralled them into the zone where Lewis is largely, but not exclusively been left, as politically incorrect, as essentialist, as "racist," "sexist," "homophobic," not philo-Semitic, inegalitarian, hierarchical, religious, prior metaphysical, and all these things which you're supposed not to be, you wouldn't have much left of Western writings in the twentieth century. That's why they've survived, because they can't be taken out. All you can do is essentially throw brickbats at them from one side of the cultural space.

There's a lesson here and that is that despite the demonizations — particularly of Pound and to a lesser extent Eliot who made peace with the establishment after the war and partly adjoined it from a radically conservative to ultra-conservative perspective. Eliot's a less sexy person to talk about from the perspective of the people in this room and the traditions that a group like this could be said to feed upon, but that doesn't mean that he shouldn't be looked at and, if you like, is to the Left of Pound and Lewis by quite a considerable way, and yet in actual fact he's still to the Right of most other tendencies that exist. I think it's just a truthful statement with which he would largely agree.

He certainly wrote some poems after the Second World War (1939–1945), which praised the war and are regarded as a sort of establishmentarian coming home. By that time he wished to en-

ter the bosom of the Anglican establishment which until the 1960s was still very culturally important as a guiding post for the accepted and received wisdom of society. Anglicanism has declined to such a degree, and is such a dog's breakfast now, that there's a degree to which one can often make a mistake of belittling its importance earlier in the century when the Church of England was a power in the land. Now it's a pathetic, broken-backed organization with almost no power at all which is dwindling with every year that passes. It's amazing to think that it once was *the* metaphysical engine of the English people and that a considerable part of our people invested quite a degree of talent, power, and moral energy in that particular structure. When things die, they go down quickly. But, to view the thing dialectically, the quicker things go, the more of a space is created for something else to emerge. And something always will emerge.

Somebody spoke to me earlier on about this society and its current status. This society in which we are now living under and in is the hegemon of the liberal vision that has grown up over the last two centuries, but particularly in the last fifty to sixty years. We are living in the eye of the storm. Almost all of the values that people in this room hold are inverted in relation to the mass society and vice versa. This means that we are living through the eye of the tiger and the eye of the storm. Liberalism has never been more powerful in a Left liberal, secularized sense. Eliot uses the term "liberal" as shorthand for all sorts of other terms that could be used. We are now living in the apogee of the sorts of ideas that used to meet secretly and semi-Masonically at the beginning of the twentieth century when small little circles like the Bloomsbury Group, who used to meet in and around this area. Bloomsbury, the university district of London University, in Senate House just behind us and so on. A lot of history in this area.

These tiny little groups said to almost recognize each other with strange little handshakes and little nods, winks, and so on. You have to remember the pressure these people were under psychologically in the 1920s and the 1930s. Everything that they liked was detested by the mainstream. They were in favor of atheism. They were in favor of dehumanization. They favored it

in a different way because mass immigration hadn't come about then, but they were in favor of various forms of multiculturalism as it would have been defined in that era. They were in favor of homosexuality. They were in favor of the decline of the marriage bond. They were in favor of alternative lifestyles and relationships as a norm. They were in favor of drug usage and its privatization, if you like, in terms of the moral space. They were in favor of all of the things which have come to pass, with the possible exception of euthanasia. Absence of the death penalty, absence of military service, absence of an organic, collective, and coherent vision of a society. A particular type of upper middle-class power, maybe, in socio-economic terms, a form of radical Keynesianism dominating the social and economic space, which is complicated because all sorts of different groups were aligning with that sort of idea. Although Keynes was a part of the Bloomsbury Group, that wasn't their original formulation.

But we're living now in an era where all of those ideas are semi-totalitarian. Indeed, they are so pervasive that they're almost totalitarian. Eliot, Pound, Lewis, and the others—the men of 1914, which is a long time back now—were living in a last gasp of the society that culturally came to an end in the 1950s. If Eliot dies in the mid-1960s and a stone is put up to him in Westminster Abbey two years after his death, we are living in a society which is the opposite polarity to that in which he and the other men of 1914 grew up.

There's a degree to which if somebody like Eliot, with some of the attitudes which he had, particularly written in the earlier material, were alive now, he would receive no attention at all or would be retrospectively completely demonized and would be regarded as a demonic influence both for the Christian conversion and for the Right-wing elements in the prior nihilism which exists before it.

He was a literary critic, had to deal with certain other areas. Eliot disliked Romanticism in art and was essentially a Classicist. There is a frigidity to Eliot. There is a prudery, in a way, despite the subject matter of some of the early poems. There is a New England fastidiousness. It's probably one of the many reasons why he didn't go out beyond the radical conservatism that

he believed in quite strenuously.

In "The Waste Land" and in "The Hollow Men," there is a scintilla of the possibility that he's opposed to the Versailles Treaty, which, of course, is the Woodrow Wilson-inspired belief in all nations cooperating, except if part of the opposition forces in the 1914–'18 war.

We see in Pound and Eliot's generation the belief that the Western world can revive, that Spengler's doctrine of the decline of the West in 1918 and thereafter need not be fulfilled. Whether they favored a form of Caesarism to come up from below and rescue the West and its impasse socio-economically in the 1930s—or whether they believed in forms of classical and restorationist conservatism, with an existing elite toughening its game and imposing upon society a vision more congruent with structures in the past, which would have been Eliot's cultural vision—is neither here nor there.

But all of them represent in some ways the last flowering of a particular type of Western intellectuality the likes of which you don't see in the post-war period. In writers and artists who are prominent in the post-war period—John Fowles, J. G. Ballard, Anthony Burgess, with a mild exception in Burgess' case who wrote *A Clockwork Orange* amongst many other things, and these sorts of individuals—you do not see the degree of Westernization that you see in Eliot, you see in Pound, you see in Lewis, and you see in some of the others.

We're living in a state where the unconscious of the Western world doesn't really have an outlet except in the artistry of those who in some ways were morally defeated by the progress of the twentieth century. It's quite clear that certain forces of direct Western renewal were defeated in the middle of the twentieth century, and we are living in almost all areas of life with the consequences of that.

Eliot's retreat into Christianity, if you wish to regard it as such, is his attempt to deal not with that Event, which of course comes after it, but with the spiritual malaise that preconfigured it. The purpose of life, the meaning of death, the prospect of family, the tradition out of which we come: all of these are now up for grabs in a world that's changing with its kaleidoscope with

extraordinary speed and rapidity. The point about Eliot's later Christian poetry is its stillness and its belief in a center and its belief in a return to essence.

In contemporary theory—which if you do an arts course in a Western university today, you will experience quite a bit head on—all the beliefs that are identity-focused are regarded as essentialist. They are regarded as reactionary. They are regarded as that which should not be occasioned. Anyone who does any course across the arts—and in the -ologies that were referred to earlier on, such as sociology, anthropology, the application of economics to social and personal life, psychology, social psychology and so on and all the liberal arts subjects with the exception of the classics—will come across the fact that belief in the prior identities of the West, belief in the religions of the West, belief in the higher philosophies of the West, most of which of course come from the Greeks in one form or another, is anathema. Everyone is taught to be critical, but no one is taught to believe anything. This is why belief, and belief in belief, are of crucial significance culturally and even anthropologically.

When people cease to believe in anything higher and above themselves, they render themselves open to the prospect of slaughter, in my opinion. Therefore, it's very important if there are prior artists in the tradition to go back to the prospect of the existence of identity, even in attenuated forms.

Eliot married again towards the end of his life after the death of his first wife, who clearly went insane. Eliot suffered from various nervous and psychological problems early in life, but they seemed to clear up later in life. There are some who think the later work is weaker than the earlier work, but that in some ways, as always, is a matter of taste—although Eliot regarded taste as a dubious criterion in terms of cultural analysis.

One of the groups that he brought back into prominence was the metaphysical poets: Vaughan, Donne, Marvell, Thomas,[2] and the others. He wrote about the metaphysicals extensively just as he wrote about Greek tragedy extensively. He had the

[2] Probably the dramatist Thomas Middleton (1580-1627).

idea that the metaphysicals were useful because they pooled together an entire sensibility in earlier British and English literary poetics. This was the idea that you had a unified sensibility, which some people just regarded as another name for metaphysics, just as they regard objective correlative, another of Eliot's formulations, as a metaphorization for the belief that there are objective standards through which to view culture.

Eliot certainly did enter the establishment in his final years. Wyndham Lewis once said of Eliot, "He's kicked up around himself a death-knit and rather smug concept of cult." And there is a degree to which he did enter into the higher reaches of the Anglican establishment and in many ways compromised with the outsider's vision of his earlier art. But that's almost inevitable given the fact that he's a conservative and given the fact that the society that existed in the 1950s and 1960s viewed from a High Anglican prism wasn't so far away from what Eliot thought of as a reasonably tolerable and good society.

Eliot regarded himself as an American mentally and British emotionally. He once said, "I'm American in my mind and British in my heart." And he was very much a part of that Anglo-American generation that viewed this country as seamlessly: England-New England, New England-England. You go back to Henry James, there's a whole species of Anglo-Americana that thinks of itself in this way. That sensibility, given the change in American art, life, and letters congruent largely but not exclusively with the demographic changes in the United States, which are *enormous* . . .

President Obama's presidency is just symptomatic of the extraordinary changes which have occurred in the United States, which have de-Europeanized it culturally, intellectually, sociologically, and in other ways to a quite incredible degree. No one who ever goes to the United States now should doubt what Obama's victory means. It's just a codification. It's just a simplistic statement of the changing nature of the identity of the society.

The society that Pound and Lewis — who was born on a yacht off the Canadian coast and spent his first six years in the United States — and Eliot grew up in, that Anglo-Americana has not gone forever, but it exists in a very reduced spectrum. If you

look at the art that is produced in the United States now, it bears no relation to the sort of hieratic, puritanical disciplines out of which somebody like Eliot came.

One is often asked with figures as difficult, abstruse, and elitist as Eliot what the point of them is. The point is that they are transcendent figures. The point is that they look upwards. The point of all life is to look upwards in the prospect of something which is above you. Whether you believe God is above you, or you believe some other force is above you, or you believe the gods are above you, or you believe your ancestors are behind and above you, or you believe that the prospect of something else may exist, or you believe in philosophical verities that give three-dimensional meanings to death, to sexuality, and to other things, you've got to look above you.

Mosley once talked about endless, varied, and revivified forms getting higher and higher. That's a Platonic idea, a neo-Platonic idea of the prospect of an archetype or an idealism that one can only approximate to. These may be in many ways highfaluting and airy-fairy judgments. In comparison to the majority of people out there, they are completely meaningless. But they have a deeper and more archetypal meaning to my mind, and this is the fact that without such idealism all you get trapped into is mediocrity and opportunity.

Much of the opportunism which has been decried by speakers earlier this afternoon is due to the fact that there is no higher vision there to articulate. It's not just having a hardcore nationalist political view, in my view. There is also no higher vision there. There's no philosophical goal in there. Metapolitics is the idea that there is something more to politics than the distribution through power and odd companies of how British Gas operates in the post-privatized world.

If you believe that politics is more than that sort of zero-sum game, you have to have some higher metaphysical vision which is grounded in things like religion or art. This is why our group feels so vulnerable in relation to many other peoples who have kept cardinal forms of identity, often very simplistically, but they have kept them. Once a people loses its ability to recognize its own side, its own semiotic of being, it's finished as a people,

unless things get so bad that there's a return to forms of identity by looking at the very small vanguard of people who haven't given up on them.

In terms of the Right, you can have a very low view of the Right, or a sort of low version of Right-wing ideas, or you can have a very high version of Right-wing ideas. If you have the very high version, you end up almost speaking to yourself. If you have the very low version, you face complete demonization by the forces of media power which exist completely against you. I personally think that, in this moment of maximum difficulty for our way of looking at things, it's important to pitch the level as high as possible, partly in relation to the baton that you're going to hand on.

Without the belief that men like T. S. Eliot can exist, there will be no future for our people, defined as Caucasian people all over the world, particularly of Anglo-Saxon ancestry. Because we are all over the world. We're increasingly not here, even though we are here, but we are all over the world. One of the primary things that we have to do is adopt a worshipful attitude towards our higher creators.

I am not arguing for a surrogate religiosity of culture, but I think that something which mildly approaches it is necessary. If people give up on the highest things that their people as individuals have created, they are opening the space for themselves to be destroyed in the future by people who will not give up on their greatest gifts.

Pound, in an extreme moment of disillusionment at the end of the Great War, talked about a botched civilization and an old bitch of a civilization gone in the tooth and the generation on all sides, including our own nationality of course, that had been slaughtered for a few thousand books, for a few old Greek statues. The First World War was reckoned to be the end. It was reckoned to be the nadir of nadirs. It was reckoned to be the moment when the West came home to itself in the most violent and dispirited of ways. No one claimed that they had a great victory after the Great War who had experienced the industrialization of death that that conflict represented. And yet within a couple of decades, of course, a second war — one of the most vio-

lent of conflicts that has ever convulsed the planet—was itself to break out, followed by atomic weaponry that froze power between the blocs.

Our role in this group and in those like it across Europe and North America, is to keep alive the idea of high culture that is aware of itself and aware of where it comes from. GRECE in France and other groups always try to pitch the level as high as possible, and they have created a space for organizations like Front National, which in many ways disagrees with it on all sorts of cardinal points. But the point is to create the space for the prospect of metaphysics, for the prospect of higher philosophy, for the belief that belief is possible. Our people face the dilemma, of course, that many instinctively don't necessarily want to go back to Christianity. But nothing else appears to be tolerable for them, so we live in this post-Christian void.

Eliot had the courage, possibly of the Puritanism of his New England forebearers, and he actually chose belief. How deeply did he believe in the Anglo-Catholic re-immersion that he engaged in from middle life onwards? One doesn't know. Certainly, the conversion, or the re-conversion as I call it, seems to be pretty absolute. There's nothing fundamentalist about his religiosity, because it's too fey, too complicated, too non-linear, too mosaic, too modern, too partial to his own sense of self to be something ridiculously constricting.

But I feel that the absence of a prior religiosity or a prior philosophy of life which is congruent with it is a key affliction for our people. A key affliction. It's something that weakens us particularly in relation to those that may in one moment in the future, as Enoch Powell had said, come to conflict with us generally throughout the future of this island. I personally believe that emotion in high culture, even partially, is vitally necessary to keep yourself morally and intellectually clean for the future.

Eliot's plays received quite a lot of comment and were widely performed in the commercial West End up until his death in the mid-1960s. The key play is the murder of Thomas Becket in the cathedral, *Murder in the Cathedral*. These plays are an attempt to widen the poet's vision. Eliot always believed that just to talk to a small number of cultural collaborators via small political jour-

nals and magazines was never enough, that you needed to transcend that, that the poet needed to have a social role. And playwright—because, of course, there are verse dramas—is the social role of a poet. Notice that the sort of plays that Eliot wrote—very different from the social commentary of someone like Rattigan, a contemporary—are decisively different from what followed.

British theater changed out of all recognition in the 1960s when a whole generation of essentially culturally Marxist playwrights came up. Eliot, although *Murder in the Cathedral* is still performed, has become very unfashionable in the generation of Edward Bond and Trevor Griffiths and Arnold Wesker and Hare and Howard Brenton. These are the people who took over the theater in the 1960s, seventies, and eighties, particularly the state-subsidized theater which came out of the Arts Council and the big national corporate bodies that Labour created post-war, post-Festival Britain, and which the Tories have never understood how we should deal with.

It always amazes me—this is an aside which has little to do with the topic of this talk—how when Margaret Thatcher was leading this country in what Leftists would regard as an extreme Right Tory direction, however you choose to define that, a play was put on at the National Theatre which consisted of her execution. This was called *The Unkindest Cut of All* by Howard Brenton with an all-female cast in which a Tory harridan Thatcher lookalike was guillotined on the stage of the National Theatre.

The Tories are completely culturally witless except in private life where you have often highly nuanced and educated men of an Alan Clark type, although he was unusual in all sorts of ways and a cultural gadfly at that. But there is a degree to which the Tories have never understood what the enemy is and who the enemy is. They've never understood how you engage in cultural struggle. They've never understood the importance of culture. Only the Left and the extreme Right understand the importance of cultural struggle. The liberal center has inherited the extreme Left partiality for it.

The reason that I talk about Eliot, talk about Pound, or talk about Yeats in a future talk, for example—and his attitude to-

wards Irish nationalism amongst many other things — is to keep alive these figures of power. These are figures of cultural power who should not be lost sight of. They are not just an area of hedonist decadence and celebration of everything falling to pieces. They can be an area of restoration and renewal both individually and collectively. People need the heroic in their own life, and considerable artistic achievements border on the heroic at times. Other people can feed off that and feed the nature of their identity.

Eliot wrote quite extensively about Greek tragedy, and Greek tragedy, of course, is the basis of Renaissance tragedy and the basis of Shakespeare's art and the basis of the other great Elizabethans. In the Elizabethan Age, which was highly prized by Eliot, we created the greatest form of drama seen since the Greeks. Yet how many people out here know of it? We created this. England created it. In the hierarchy of poets and playwrights who then existed, this was England's creation.

This is why the English are a proud group who are actually in some respects socially and psychologically awkward. The diffidence of the English interrelates with their love of theater. Theater is a form of play and a form of externalization where you can be yourself and not be yourself. Every town once had a theater. Theater was our form. Of course, it's grounded in a sort of middle-class, lovey culture to a degree. But there's a degree to which it was our unique form. Unless you realize that people like Eliot, through his criticism, are keeping, in an attenuated way, these forms alive, you miss the point of the social organicism which he's preaching.

Extreme conservatism in the arts is very unusual, because extreme conservatism is often associated with extreme stupidity. This cannot be the case with men like Eliot, who I would regard as a conservative. There are proto-fascistic elements to Eliot, but Eliot does not cross over a particular line. Eliot remains on the blue of the conservative side, culturally speaking.

Now, in the "Four Quartets" for which he was awarded the Nobel Prize, Eliot draws out from the Christian tradition many associations which we need just briefly to have a look at.

This is "Ash Wednesday." This is the first poem after the re-

conversion.[3] "Having to construct something upon which to rejoice" is the belief that when there is no cultural future you turn back.

There was a film recently, a decade or so ago, by a French director in Hollywood. It was quite an unusual film where people have a dinner party and discuss the state of the West as they sit round at this dinner party. One of them says, "What can you do when you can't go forwards? What can you do when there's nothing to progress towards?" Progressivism and doctrines of the liberal Left and the Left generally believe in progress. They believe that everything now is heading forwards towards greater and greater degrees of joy, liberty, equality, and progress: progressivism. What can you do if you can't progress any further?

One of the other characters, plotted at the dinner table and its discussions, says, "You can go back." When you can't proceed any further, you go back. But you never return to what existed in the past. You return to ideas that you had about it, which opens up a new prospect for the future. That's the importance of the radicalism in radical Right ideas. That you turn back towards a prospect of what existed that you half-remember, and you wish to go on from in a different way.

What's the point of reading people like Eliot now? The point, in my view, is to incarnate yourself in structures of sensibility which once existed in a more general way. A general decline in Western educational level, a general decline in sculpture of will in order to be what we are, has had a devastating effect on all of our people: top of the social structure, middle of the social structure, bottom of the social structure. The more nakedly you look at the decline which has occurred, the more terrible the prospects for the West appear.

We're living in what radical Christians of a Pentecostalist cast call the End Times. Now, I don't believe in the End Times, but we are living in the end of a particular era of Western history. We must determine what future our people have. And the first thing that has to be done is mental. Our people are mentally

[3] "Ash Wednesday" omitted due to copyright.

asleep and partly mentally diseased and complacent to the point that they're toppling over. They are so polite that they don't even really wish to survive in their present incarnation.

The point of people like Eliot in a metapolitical context, not in a purely cultural one, is that they stand out against the general rot, and there are things about him still which are unassimilable, which cannot be assimilated. What liberalism does is it just ignores those unpleasant factors. Anthony Julius wrote in *T. S. Eliot, Anti-Semitism, and Literary Form* that Eliot's anti-Semitism was equivalent to his failure as a human being. Failure as a human being. Failure to stand up to *a priori* liberal standards. Failure to adopt a politically correct canon. How can somebody have those views, given what allegedly happened in the mid-twentieth century, even if it's a retrospective coinage?

Why did he never re-publish his particular book about the organic society in 1934 to 1935, *After Strange Gods*? Obviously, he wanted to preserve a notable reputation for conservative assimilation and accessibility to the doctrines of the then establishment. But there is a degree to which what one was at a certain period, and what one remains, cannot be erased.

The point of high culture is to give ideas to our people even if they don't subscribe to it. The point is always to live outside one's own cultural comfort zone. The point is always to try to strive for that which is higher and that which is above. I partly preach artistic concerns and considerations of what I believe to be a higher type because I think they are a way to go for people who are totally blocked in relation to expression of their own identity. Lots of people today yearn for a clean and a new way in which to express their own identity. Why do you think that every arts course in every British university deconstructs its main cultural figures as a way of proceeding? They do it so the danger of the prior essentialism—even with a Modernist like Eliot—will not be taken up.

The irony is that just before Yockey committed suicide he said that his enemies understood him better than his friends, and that is the view that, in a way, one should take from high culture. Many people on the Right are not interested in high culture, let's face it. But there's a degree to which the enemy on the

other side knows full well the power that it can have and the way it can transform lives, values, psychologies, purposefulness, and identities. That's why it takes it away from people.

If it was of no importance, there wouldn't be a stink around the names of some of the people that I talk about. They would be regarded as bohemian men with folly-laden attitudes which have no importance. No one can dismiss the political allegiance of W. B. Yeats, the metapolitical tangentialism of T. S. Eliot, the open espousal of forms of pre-religionistic fascism by Wyndham Lewis, and the open advocacy of fascistic politics, never mind metapolitics, by Ezra Pound. These are not things you can have a laugh about. These are not things that can be deconstructed out of existence. Because the point of those theories is you break it all down, and then you reconstitute it again, because it's still there. And if it's still there, it's still powerful. It's still residential It can still be used by the other side. It can still be used by our side, if we have the wit to do so.

Now, Eliot had a stone erected to him in Westminster Abbey two years after his death and therefore joins the Western tradition that stretches back to Shakespeare, stretches back to Chaucer.

Poetry is heightened language. Poetry is a language adopting and attempting to be musical, hence the fact it's often set to music. Poetry is close to religious incantation, closer than prose. Poetry hasn't died, although as an art form it has been broken down and privatized to a degree that there are few major poets left today. Because although there are thousands of people who write poetry, it's disseminated in a bitty, fractured, and postmodern way. A few talents boot up in the post-war era like John Ashbery.

But T. S. Eliot is a bit of a grim giant, a bit of a morbid hierarchical, puritanical conservative fused with the high bohemian passion of a great artist, hence the prudery in his work, hence at times the prissiness in his work, hence at times the indirectness of statement in his work. But he's very much part and parcel of the sensibility, particularly of the English people born here, in Australasia, in America, or in southern Africa. Wherever people of English and British descent are born they will understand the

diction of T. S. Eliot.

T. S. Eliot is not important because he wrote a few poems that people consider to be anti-Semitic. T. S. Eliot is important because he metaphysically opens a prior way of assessing reality and proceeding. I'm not arguing that people convert back to the Christianity most of us have lost. But what I am arguing for is that one has the sympathy for that particular trajectory, and one understands why figures like Enoch Powell and T. S. Eliot adopted it. I don't think it's the answer for our people in the individual circumstances, the odd individual excepting, or the majority, but it is something that can be respected, and it is something which should be valued as such.

To close, I would like to read "The Hollow Men."[4]

"The Hollow Men"

A penny for the Old Guy

I

We are the hollow men
We are the stuffed men
Leaning together
Headpiece filled with straw. Alas!
Our dried voices, when
We whisper together
Are quiet and meaningless
As wind in dry grass
Or rats' feet over broken glass
In our dry cellar

 Shape without form, shade without colour,
Paralysed force, gesture without motion;

 Those who have crossed

[4] Most of the poem has been omitted due to copyright considerations.

With direct eyes, to death's other Kingdom
Remember us — if at all — not as lost
Violent souls, but only
As the hollow men
The stuffed men.

II

Eyes I dare not meet in dreams
In death's dream kingdom
These do not appear:
There, the eyes are
Sunlight on a broken column
There, is a tree swinging
And voices are
In the wind's singing
More distant and more solemn
Than a fading star.

 Let me be no nearer
In death's dream kingdom
Let me also wear
Such deliberate disguises
Rat's coat, crowskin, crossed staves
In a field
Behaving as the wind behaves
No nearer —

 Not that final meeting
In the twilight kingdom

III

This is the dead land
This is cactus land
Here the stone images
Are raised, here they receive
The supplication of a dead man's hand

Under the twinkle of a fading star.

 Is it like this
In death's other kingdom
Waking alone
At the hour when we are
Trembling with tenderness
Lips that would kiss
Form prayers to broken stone.

IV

The eyes are not here
There are no eyes here
In this valley of dying stars
In this hollow valley
This broken jaw of our lost kingdoms

 In this last of meeting places
We grope together
And avoid speech
Gathered on this beach of the tumid river

 Sightless, unless
The eyes reappear
As the perpetual star
Multifoliate rose
Of death's twilight kingdom
The hope only
Of empty men.

V

Here we go round the prickly pear
Prickly pear prickly pear
Here we go round the prickly pear
At five o'clock in the morning.

[The introduction of nursery rhyme, of course.]

 Between the idea
And the reality
Between the motion
And the act
Falls the Shadow
For Thine is the Kingdom

[That's a very famous stanza, which is repeated.]

 Between the conception
And the creation
Between the emotion
And the response
Falls the Shadow
Life is very long

 Between the desire
And the spasm
Between the potency
And the existence
Between the essence
And the descent
Falls the Shadow
For Thine is the Kingdom

> *For Thine is*
> *Life is*
> *For Thine is the*

This is the way the world ends
This is the way the world ends
This is the way the world ends
Not with a bang but a whimper.

"The Hollow Men," a poem for the Old Guy, from 1925. Notice how many of these phrases have entered the English lan-

guage. "This is the way the world ends." How many tens of thousands of people say, "not with a bang but a whimper" and don't know where it comes from? That's, of course, what poetry does. It frees glottal stops. It freezes inarticulacy in people. A lot of people become amateur poets in war or when they're faced with illness or when they're faced with the death of a relative. Because that is the moment when they have to confront many of the things that this society exists never to confront.

So, I ask that people have a look at T. S. Eliot as they had a look at Ezra Pound, as they had a look at Wyndham Lewis, as they have to have a look at W. B. Yeats. Joyce, who was associated with them, is in a different category morally, artistically, and politically, never mind metapolitically. Next time I shall talk about W. B. Yeats.

Thank you very much!

Counter-Currents, July 29, 2011

W. B. Yeats[*]

I've been speaking on a range of writers during the last couple of meetings of the New Right. We've done T. S. Eliot; we've done Ezra Pound; and this time we're going to do W. B. Yeats, who was born in 1865 and died just before the outbreak of the Second World War, in 1939.

Now, it's slightly ironic that we're doing Yeats given that General Wilson figured earlier in our particular build up, because of course Yeats is an Irish nationalist. Although hardly the house poet of the IRA, he was associated with the Irish national movement throughout most of his life, even though he was English by blood and Protestant by religion. He became a senator in the Irish Republic as it then was, or had just become an Irish Free State before, in the late 1930s.

Yeats won the Nobel Prize for literature in 1921. The Nobel Prize has increasingly become a politically correct designation now, in the last twenty years. But some worthy people have won the prize. Some great people have been overlooked, like Leo Tolstoy. But Kipling was given it. And W. B. Yeats was given it.

Now Yeats is an arch-conservative or a paleo-conservative writer in many ways. His career spans at least three phases. The first is concerned with transcendentalism and a traditional attitude toward European culture and civilization. The middle period is a much more personal and idiomatic poetic. And the last period brings back the mental, the theoretical, and the metaphysical themes and is really the coping stone of his career.

Yeats was strongly influenced by the belief that the Celtic peoples of the British Isles should revive and was strongly influenced by Young Ireland, which was a sort of parallel to the Young England movement that existed in Victorian times in nineteenth-century England.

Yeats was born into a family of artistic practitioners, and his brother, Jack B. Yeats, was a famous painter in Ireland in the

[*] A lecture to the 35th New Right Meeting, London, Saturday, October 15, 2011. Transcribed by F. F.

twentieth century. To understand Yeats we will have to understand something of the background of Irish politics and society during this period, the obverse of the Unionist tradition. Irish nationalism had many strands. A large number of Southern Protestants were actually always involved in it. And it looked back to Wolfe Tone and the Republicans of the 1790s. However, the Republican tradition is only one tradition within that particular milieu which Yeats could be said to favor.

Yeats had an aristocratic vision of society, and he believed that money was the curse of modern culture and that money destroyed and broke down the organic unity between man and man, and persons within a particular national community. He believed that the Cromwellian vision of the Puritan state in 1600s England was something to be resisted, and he believed that only a restoration of an aristocratic sensibility — as against a mercantile, materialist sensibility in relation to culture — would see European art and letters thrive in the twentieth century.

The Wikipedia entry for Yeats — which is quite long and quite interesting, particularly about his private life and his relationship with the fiery Irish nationalist and literati Maud Gonne — mainstreams him, really, and regards him as an establishmentarian figure. But he was always a much more radical figure than that.

The Marxist poet W. H. Auden always despised the occultism and the mysticism and the spiritualism with which Yeats was concerned. Yeats deeply believed in something which he regarded as the "race soul" of each independent and separate people. And he strongly believed in the power of the unconscious. He believed that individuality and the romantic cult of individuality, which indeed prospered very much during the nineteenth century, was overplayed artistically and that what an artist had to do was to go down into semi-, sub-, and unconscious parts of the mind in order to bring up the wellsprings, the tropes, and the archetypes of a particular people, in his case, the Irish people.

He was responsible for the creation of the Abbey Theatre with John Millington Synge and with other people. And the Abbey Theatre is the main artistic and experiential theater in Ire-

land, still going in a differentiated sense, under state patronage to this day. It is, essentially, the quasi-national theater of Ireland. He wrote a large number of plays, and Yeats was a prolific writer all of his life, in poetry, in prose, and in incidental writing.

Yeats was sought out by Ezra Pound, who has been the subject of one of my previous talks, and Pound became his secretary for a while. Pound said he was the only writer in that period that was worth emulation and was worth seeking out to that end, although they had a bit of a falling out because he insisted on editing the rather overblown, prosodic Victorian verse that Yeats was then producing.

Yeats' phases as a poet are instrumental in many ways of Irish life. Irish life responded to the famine by emigration in the 1840s and 1850s, gradually began to adopt a more nationalistic course in the 1860s and 1870s, which took the form of parliamentary Irish nationalism linked to English liberalism.

As always, the liberal or Left-wing part of a nationality favors those doctrines which are less nationalistic and, in British terms, less Unionist. This is why Gladstone's great transformation, when he believed in the 1880s that Ireland should be given home rule within the Union, was one of the most contested issues in the Victorian period of that time.

The violence that has characterized Irish politics in the twentieth century was born in the nineteenth century and was born in particular by secretive, elitist, cabal-like organizations in the United States such as the Irish Republican Brotherhood which were created out of the Fenian movement. The Fenians were created in Chicago in 1859, and members of the Fenians fought on both sides of the American Civil War, for either the North or the South. There are famous moments where Irish militants met under a green flag because they couldn't have met under a unitary American flag, divided as that sensibility then was, into the Confederate and Unionist or national unity zones.

Now, the Irish Republican Brotherhood re-transplants itself as a paramilitary, squadist, and terrorist organization—a vanguard nationalist organization in its own surmising, of course—back to Ireland during the latter part of the nineteenth century. The Irish Republican Brotherhood links with Griffith's organiza-

tion, Sinn Fein—which in Gaelic means "ourselves alone"—in 1908. Now, Griffith was Welsh and was Protestant, and he led an extraordinary number of eccentrics, willful charlatans in some respects but also opinionated idealists, often of a quite crankish sort involved in Irish Republicanism well up to and including the Rising.

The Rising—which occurred in Easter 1916 against British rule in Ireland, and which involved the capture of nearly all of the Rising's nationalist leaders and the execution (bar the odd individual such as Eamon de Valera) of almost their entire number by the British—was a period of soul-searching for Yeats. Yeats never identified with the working-class and lower middle-class aspirations that fed that wing of the nationalist movement. His belief was always that democracy was an ill-fangled and new-fangled and rather pejorative coinage which he didn't wish to see introduced to Ireland, into Britain, or anywhere else.

Yeats' most controversial political and metapolitical soundings were in the 1930s, when he associated, albeit tangentially, with the Blueshirt movement, as it was called, or Civic Guard in Southern Ireland, which is the nearest you had to a mainstream, quasi-fascistic movement in what would become the Irish Republic but was then the Irish Free State.

To understand the importance of Eoin O'Duffy's movement, at that time and the near civil war conditions that existed throughout Southern Ireland which had of course, experienced a civil war in the 1920 between the two wings of the IRA, you have to know a little bit about the Irish history of the period.

Eoin O'Duffy was the deputy commander of the IRA against us, against the British, in the Anglo-Irish War as we called it, between the crushing of the Rising and its aftermath in 1916-'17 until the Anglo-Irish Treaty in 1921. The Anglo-Irish treaty established the Free State throughout what is now Southern Ireland or Eire. The Free State was very much a hybrid and very much a compromise which nationalist ultras on the Republican side could never accept. Michael Collins, who was the undisputed leader of militant Irish Republicanism and was then leader of the IRA, was killed by his own side and by the De Valera or anti-treaty wing of the movement, because he'd signed the peace

treaty with Lloyd George.

After his death, a savage war was conducted with far greater ferocity than the war between ourselves and the IRA, between 1917 and 1921, involving Black and Tans and everything else. When they fought with each other all the gloves came off in the sense of ex-comrades violating the bed they'd both shared.

Eoin O'Duffy became the leader of the pro-Free State forces, as they were called, and the official IRA or the official wing of the Eire state that used crushing military force, particularly the use of artillery in concentrated fire to break the anti-treaty IRA. The anti-treaty IRA lost the war and won the peace, because of the political party they set up, Fianna Fáil, which means "Soldiers of the Nation." Can you imagine a British party called "Soldiers of the Nation" holding power in an undaunted and unideological way for most of the century?

Fianna Fáil's old slogan was "Not Right, Not Left, but Irish" and "No Policy but Ireland." Until, of course, De Valera's death, they did pursue a slightly third way or alternative type of politics within the European mainstream. Not only were they studiously neutral in the war between the Axis powers and the West—indeed, when Hitler died of course, when he committed suicide in the bunker, De Valera formally sent on behalf of the Irish government a notice of regret to the German embassy in Dublin and to the German Reich's Chancellor, something for which Ireland was pilloried, particularly in the United States. (Relations with the United States are crucial in Irish politics since certainly the early middle of the last century, given the enormous power of the Irish-American political lobby.)

Yeats' attitudes towards Southern Ireland were equivocal, because although a mystic, who was drawn toward occultism poetically and who had all sorts of literary, ideological axes of his own to grind, Yeats disliked Irish "Popery," if you like, despite very clerically-based Southern politics that looked to the Catholic Church for all answers, as a post-IRA Fianna Fáil tended to do. They allowed their moral authority and their social compass to be governed, in the south at any rate, by the dictates of the Roman Catholic Church. That role of the Roman Catholic Church as the ancillary rulers of the Irish Republic—without be-

ing involved in day-to-day legislation but by providing the grid within which the state operated—largely existed until about 1980 when Ireland remained a conservative and in Western liberal terms, socially backward Republic.

Yeats had supported O'Duffy's Blueshirt movement by writing three odes and three marching songs, some of which were used by the movement. The movement emerged out of the need to confront the IRA, which, in the south, was re-vivified in the 1920s by De Valera's accession to the Irish Taoiseach or premiership. In Irish politics the president is a purely nominal position, although having certain symbolic power and importance. All power is concentrated in the Taoiseach or premier. Parliamentarians are known as "Deputies of the Dáil," T.D.s.

O'Duffy decided on the non-revolutionary course. There was a moment when there was a march on Dublin, in which many people saw in the Republic or Free State as it then was as a parallel to Mussolini's "March on Rome." The movement was much closer to Mussolini's indeed than to other European societies. Their use of the blue shirt had St. Patrick-type associations, and you had to be a Christian, a professing Christian, to be a member of the Blueshirts. Massive Blueshirt rallies occurred all over the northern part of the Irish Free State. Parts of Southern Ireland, of course, are actually further north than parts of Northern Ireland.

Northern Ireland is the dispensation that the Unionists carved out for themselves out of six of the nine counties of Ulster. Ulster is nine counties, but they couldn't keep the nine because the population would then have been 50% Roman Catholic, 50% Protestant or reformed faith. And Carson and other Unionist leaders at the turn of the twentieth century felt that this was unsustainable, so they reduced Ulster to six counties in order to hold Belfast and to have a separate British state on Irish soil which has existed in a quasi-independent manner within the Union through their own version of devolved Unionist assemblies in Stormont until the beginning of "The Troubles" in the late 1960s.

Yeats believed politically in the Protestant minority in Ireland, which has always been extraordinarily culturally important as a culture-bearing strand. Most of the great Irish writ-

ers are Protestants, and they are the cultural minority of the Irish Republic as a whole. Twelve percent of the population was Protestant when the Free State was formed. It's now about one or two percent. Of course in relation to marriage with Roman Catholics, if you intermarry your children become Catholic, otherwise the marriage has no formal existence in Catholic terms, and a Catholic can't marry a Protestant, certainly in a country as socially conservative as rural Ireland without that being acceded to.

Now, I once went into a pub in Dalston, in Hackney, in inner London, and if you know anything about Dalston, within which there were large riots recently, Dalston is now part of Africa, essentially. However, this pub was an Irish pub, a traditional shebeen, where literally you had sawdust on the floor. And on the wall there were photos, some of them very old, brown sort of tourist type photos, of all the great Irish writers and intellectuals. Now, you can bet your bottom dollar that the topics of conversation in that shebeen were not about Irish writers and intellectuals. But the reason they were on that wall is pride. Self-pride. Rejection of the Irish joke at the colloquial level. But also, the insistence that these individuals are vanguard minds for the nation. It's why we have pubs called Shakespeare, after all.

And all of these great writers—Synge and Sean O'Casey and Samuel Beckett and Oscar Wilde and George Farquhar and Yeats and James Joyce and so on—most of them were Protestants from the ascendency class. The reason that they provided a lot of the intellectuals is because they were the elite class that ruled under British patrimony. You needed an elite, upper class that was drawn from the Irish population but was largely put into the country by the first Elizabeth the better part of 400 to 500 years before.

The Irish-Irish had fled and provided quite a few of the generals in Napoleon's armies and in other French armies and were yet part of another part of the endless waves of Irish emigration, which, given the multiple Irish economic collapses of recent years, has re-begun. We all remember stories of the so-called "Celtic Tiger" where large numbers of people of Irish extraction came back, now the reverse process is occurring, and they're fil-

tering out again.

The Civic Guard movement emerged from the pro-Free State or pro-regime IRA, which was tacitly backed by both the British and the Northern Unionists. There have always been surreptitious links between the more moderate, less anti-Orange tradition that Fine Gael now represents in Southern politics and Unionism and British national identity.

It's always the case that people seek symmetries in cross-border disputes given the large number of people who live in Britain of Irish ancestry, two million of whom claim to be Irish four-square and even have documents of the Republic's derivation. This means that there is an intense interest between the nation-states. Enoch Powell once delivered a speech in which he said that the two million should be forced to decide whether they're British or not. But there's a degree to which the close interrelationship between British and Irish identities and the complicated nature of the relationship whereby tens of thousands of Irishmen volunteer to fight in Britain's wars, particularity the First and Second World War, both through love of fighting and through a residual relationship with Britain.

The core Southern Irish attitude towards Britain is very complicated and is nuanced and is probably a love-hate relationship, to be frank. There's often a very strong social identification between English and Irish people. But there's an ideological hostility amongst the Southern Irish to the British state, as such. There are also considerable tensions between Northern and Southern Ireland, and you have a strange relationship between the two northern communities, that are daggers drawn with each other, and yet are often politically aligned against Southern interests within the same society, fractious as it is, into two nation-states and with two separate identities.

Half of the population in Northern Ireland — which the Catholic minority always call "the north of Ireland," they will never call it Northern Ireland — of course, looks to the south, or to a northern version of the south, to represent them in their own politics. So the complicated and multifaceted nature of these intra-Celtic relationships, never mind the relationship between Scotland and Northern Ireland, and Scotland and Irelanders *per*

se, are all part of this particular broth.

Now O'Duffy's movement had a choice, after most of the IRA prisoners in relation to the civil war in 1920-'21 and '22, were released by De Valera. De Valera opened the prisons and let out most of the squads and most of the men who fought on the anti-treaty side and been locked up by the party of the Free State and its allies in the 1920s. This led to a radicalization of Irish politics as these militants came out again, and the IRA began to organize all over Ireland. The IRA had Sinn Fein as its political vehicle, not Fianna Fáil. Fianna Fáil tried to keep the IRA and Sinn Fein at arm's length, but they were heavily influenced by them and by their militancy, and the division in Irish politics in the late-1920s and early-1930s was between the party of the Free State on the one hand—which became Fine Gael—and its quasi-paramilitary wing, the Civic Guard or Blueshirt Movement of National Unity led by Eoin O'Duffy the former deputy IRA commander in the war against us and the former commander of the pro-Free State IRA against De Valera's IRA, which engaged in a lot of killing, particularity extra-judiciary killing, killing of prisoners and so on. Once they caught their old comrades, there was no mercy shown on either side, thereby proving the point that civil wars are always the cruelest, because the people involved are so close together, when they split, there's no mercy on either side.

Now, O'Duffy called off the Dublin march, and there were large marches in other provincial cities such as Cork and so on. And probably that decision saved the quasi-Republic from actual violence and a second civil war within a matter of years of the first. Had he not called off that march, it is debatable what would have occurred, because a large number of the police, of whom O'Duffy was the ex-commander, would not have fired on the Blueshirts, and might have led to a situation where De Valera's government was toppled by *force majeure* and a corporatist Ireland, of a sort, which O'Duffy's movement advocated, would have come into being.

To this day, members of Fine Gael in Southern Ireland are called "Blueshirts" and even call themselves Blueshirts. Members of Sinn Fein loathe Fine Gael, and Fine Gael loathes Sinn

Fein in a sort of intra-community rivalry which is often difficult to understand from the outside. That's because the polarity of the type of politics that was represented was national. But don't forget that nearly all of these people, in one form or another, came out of the IRA, all of them! Even Collins, who was ex-commander of the IRA, don't forget.

Irish politics in the twentieth century came about because of violent vanguardism, not the democratic, ameliorative, and bourgeois type of politics. The politics of the Irish Republic might be said to resemble that now, certainly given their economic difficulties, but that certainly was not the case earlier in the twentieth century.

Karl Marx said in an essay in the *New York Times* in the 1870s that a lot of Britain's revolutionary energy was displaced into Ireland. And in terms of certain revolutionary energies that took national and communitarian forms, that's partly true. Certainly, Britain has had a quiescent political history despite marginal movements of radicalism in fulfilment. But the mainstream has remained solid, high-crusted, bourgeois, and unbroken for most of the twentieth century. And even today most people can only think of the dichotomy Labour-Tory, with the Liberals in the middle coming in between the two. Whereas in Ireland, revolutionary politics—even in relation to the present Northern settlement—has largely been the order of the day, and tiny little vanguard movements were able to graft themselves on in a semiconscious way to much larger social and cultural forces.

This is why Yeats' cultural or metapolitical discourse is so significant. Because Yeats always believed that artists and intellectuals were the key components of a community in how it talked to itself. And yet of course in themselves they are isolated individuals. How do they overcome the sea of isolation that differentiates themselves from other members of their national population? By plugging into the national myths and to the aboriginal cultural inheritance of the society and the people from which they come. They then become a custodian of the racial and emblematic nature of that society and are representative of its culture-bearing stratum in a very real and visceral way.

It's by having ideas like this that links Yeats to European na-

tionalist writers and artists going back to the Romantic period across western and indeed, central, northern, and southern Europe—and Eastern Europe as well. So Yeats is seen by liberal critical opinion as an ultra-conservative and slightly and tangentially fascistic cultural figure who is part of this movement of thinkers and writers and idealists who dreamed of a different type of Europe and a different type of national societies. He chose Ireland, basically, as the basis of his dreams.

He was involved in a lot of occult and mystical lodges, the Theosophical Society and above all the society of the Golden Dawn in Britain during the late nineteenth century. And these explored, basically, the subconscious archetypes and mythical facts of a people which can be dredged up and made fit for purpose by their great artists and intellectuals.

Yeats believed that you had to communicate to people in a way they could understand. And in the twentieth century that will take two forms. It can take the forms of commercial art and the market which drives things down to the lowest common denominator, clears at a point of commercial reference, and is all around us. The "culture industry," as Marxists call it, is the culture you will see when you go back into Victoria later this evening after these talks. Yet the culture that many of these European idealists wanted to establish in Europe between 1920 and 1950 was of a quite different sort, it was a more reactionary, ancestral, racinated, and rooted type of culturalization that looked back to the past but also looked forward to the future.

Yeats believed that all of the Egyptian rituals of the Golden Dawn should be replaced in an Irish sense by Irish mythical figures, warriors, and various circles and cycles of legendry. Just as he believed language and culture were cyclical, he believed that historical processes were cyclical, long before Spengler's ideas became fashionable at the end of the First World War. Spengler, of course wrote *Decline of the West* which appeared in German in 1918 and seemed to strike a resonance across the cultured part of the European population, a book of extraordinary depth and complexity and Byzantine dexterity and size, which is about this thick and sold 100,000 copies in its first edition because people really did believe that a decline had come.

Just as Yeats didn't believe in humanism or progress as an amelioration of the peoples, but in identity and the causation of morphological change. He believed in aristocracy and the absence of democracy. He also believed in eugenics. One thing that you won't see in the Wikipedia profile of Yeats was his membership in Britain of the Eugenic Society from about 1910 onwards.

Eugenics was partly a Left-wing movement at that time of what would now be called sociobiology. It's very interesting to note that many of these ideas born from the natural sciences and from the biological sciences had an enormous heyday in the early part of the twentieth century, the twenties, thirties, and forties, then dipped down, almost to semi-visibility within the establishment, within academic and literary life, and have only been revived in the last thirty years with the mapping of the human genome and with the mainstream processing of genetic knowledge in the late or the new biology. Even to this day, biology and social ideas, sociological and political ideas based upon biological norms have to be incredibly careful of being tainted, as is perceived, by the political associations of things like eugenics and the links to the radical right, that eugenicist policies evinced in the late-1930s and thereafter.

The irony is that every society had its eugenics movements, and eugenics influenced social policy in relation to children's homes, in relation to asylums, and in relation to much else in all sorts of societies where far-Right movements were tiny or insignificant, such as in Sweden, or in the United States, where eugenics had strong resonance. Basically, the idea was concerned with "breeding up." The population was increasingly becoming degenerate and botched, and you needed something that would creatively infuse the better elements of it with growth, with dynamism, with greater intelligence, health status, and resilience in relation to disease. Dysgenics is the negative side of eugenics, which is its most controversial part. But eugenics, on the whole, can be interpreted—and was largely for the first thirty years of the twentieth century—as a "building up," as a "building to task."

So Yeats had a range of these ancestral ideas of a romantic, spiritist, and metaphysical sort. But he wasn't beyond getting his hands dirty by joining something like the eugenics movement.

Yeats' poetry, as I said, can be divided into three separate areas which largely correspond with his life. The first was strongly influenced by the Celtic Dawn revivalists of the nineteenth century and Irish Ossian-type myths. The second phase is a more personal diction, when he attempts to interpret these myths in a manner which is more recognizable from the perspective of men and women of his era. And the third stage, towards the end of his life, the late 1920s and 1930s, is an attempt to merge those strands—the theosophical and metaphysical with the more personal and the immediate.

As with all great poets, many of his words have come to enter into the language, and of course he's one of the greatest English-language poets of the twentieth century. Collections like *The Green Helmet* were world famous when they were produced and led to his Nobel Prize. He saw the Nobel Prize as a gratification of Irish liberation as he perceived it. He believed that Irish man and woman, that Irishness was being celebrated by giving him the prize at that time, and there's no doubt that literature is an outrider to the souls of peoples, and there is a degree to which prizes are given politically for great weight.

When Solzhenitsyn was given the Nobel Prize in the mid-1970s, no one doubts that that was being played out within the symmetry of the Cold War between American and Soviet blocs. Similarly, when African and Eurasian and Latin American authors are given the prize today, no one doubts that these are, in part, statements of political preference and the desire to appease new blocs which are emerging and new countries which are having a minor state on the global stage, the new Brazil, the new South Africa, the new Chile, and so forth.

Yeats changed his attitude towards the Republican movement as part of Irish nationalism with the Easter Rising in 1916. Patrick Pearse, who was one of the leaders of the Rising, was a quite major poet in Gaelic. He was shot like all the others. Indeed, those who were wounded were put on stools so they could get a good firing range at them. De Valera—who was a mathematics lecturer in prior life—was one of the few not executed and would later emerge, of course, as the leader of the political forces of the anti-treaty IRA which became Fianna Fáil and

that became the government of Ireland. Until relatively recently, 46% of people in the Irish Republic used to vote for Fianna Fáil, this large Irish-Irish, unideological party that basically stood for the national community and the residual strength of the residual Irish Roman Catholic Church.

Nevertheless, an enormous amount of corruption and boss and gang type politics—which has always been part of Irish life, and always been part of Irish communities in North America and Australia—was also part of the Fianna Fáil axis. This came to its apogee with the leader and Taoiseach Charlie Haughey, the richest man in Ireland who paid no tax and was a remarkable and sort of shamanistic individual, the "bosses' boss," the "boss of all the bosses," the slightly ludicrous and caricatural formulation of this "boss" politics that stretched to the cities of Australia and stretched to the cities of North America. If you remember Mayor Daley in Chicago was very much part of this "boss culture," always on the Right-wing of the center-Left party, which is where Irish immigrants of all generations have always found their patriotism in new societies to ally.

The truth is that many people in Britain of core Irish descent find it difficult to totally assimilate to the national tradition, although some do. But they're not Left-wing people at all, so what they do is they agglomerate to the edge of the labor movement, this sort of anti-communist, hard social democratic wing of the Right-wing, the Eric Chapel wing within the unions and elsewhere, of the labor movement, particularly in Australia where certain elements of third way type politics, on the margins of the Right of the center-Left have often been quite paradoxical, quite corporatist, and quite far-Right or ultra-Right in their leanings due to the inevitable social conclusions that can be drawn from certain Catholic ideas.

As an aside, Mayor Daley is very amusing, because when the anti-Vietnam War protesters had their great protests in Chicago at the Democratic convention in 1968, Daley beat up a journalist on national television with a stream of the most extreme expletives, all of which were played over the media with no sound but with voice going. And he beat this journalist up, hitting him in the face, hitting him in the stomach, hitting him again! Daley

was the boss, you see, and he'd been insulted, and this is how politics was often dealt with, in these back-room type shenanigans that Irish political cronyism and "boss politics" introduced even into the Right-wing of the Labour Party in Britain and well beyond.

Now, someone like Yeats had a much more elevated view of Irishness than that sort of stew in the cities of the diaspora across the Western world. But there's a degree to which a passionate Celtic identification with idealism, with a transcendental set of idealisms, and with a transcendence even of those perceived limits is a part of his poetical diction and part of the Celtic imagination.

It's no surprise to me that in the present circumstances, Welsh, various forms of Irish and Scottish nationalism within the UK and British-wide context are much more prized than English nationalism, because they're white minority forms, and because they can be allowed a certain space because they're also relatively unthreatening in relation to the demographic as a whole and because they also make an insistence.

One of the most successful movements is the Welsh language movement which began from a tiny little base and in relation to a language which by the 1960s in the principality was truly dying and has now been revived, and every document in Wales from the smallest to the highest is bilingual. So it shows what can be done, culturally through cultural struggle if a militant minority has a mind to do it.

I remember a Radio 4 program about five years ago in which they dealt with respected poets from the different parts of the British Isles. The poet from Northern Ireland was an Ulster-Scots linguistic grammarian who was writing in a variety of local diction; he was a sort of oralist, if you like. The poet from Scotland was a Gaelic poet from the northern highlands and islands, who was speaking a minority Celtic language. The Welsh poet was an Anglo-Welsh poet who wrote both in Welsh and English, of an Iris Thomas type of extraction. The English poet who was chosen was a black lesbian from Brixton in central south London.

Why was that done? It was done because, in a way, these

Celtic formulations could be given their head and could be treated with a certain amount of respect, almost part of a museum of culture if you like, in a way. Whereas if you ask the question "Who is English?"—and poetry does answer the question about what a people is and who it is. Because when people have agony in their lives, if they have disease, or if they bereavement, or if they have war, or if they have social strife, the response of a large number of people—maybe not millions, but hundreds of thousands of people—is to write verse. People who face the prospect of dying in a battle the next day will often write verse. And the reason that they do that is because it is a musical intensification of language and feeling.

Now, if a people is borne to write verse in order to testify to the immediacy of an experience, they are also liable to state their identity through that heightened language and through that heightened experience. And when you begin to ask, "Who is something?" "Who are the English people?" "What are the English people?" "Who is English in this room?" "Who is English in Victoria now?" you are beginning to approach the topic of who is not.

And that negative dialectic plays very badly because, of course, everyone can presume to be British under present jurisprudential standards, where you are British just because you have a passport to say that you are. But English is more problematical because it involves licenses of blood and idiom and identity, and it's the same with Irishness, it's the same with Welsh, and is the same with Scottishness. It's the same with even more minority identities such as the Cornish one or the Manx one or the residual identity in the Channel Islands. Or the differentiation between highland Scottish identity and that of mid-belt Scotland, for example. Or the difference between the Welsh-speaking Welsh identity and the English-speaking Welsh identity, the difference between the Welsh-Welsh, as they are called, and the rest.

When you get into these complicated, mosaic-like peelings away of nationality and identity you'll realize that the British Isles have a thriving multiculturalism of their own, long before mass Third World immigration. You don't need mass Third

World immigration to have multiculturalism, because we speak a large number of languages just on our own, and diversity of the white population is one of the intriguing aspects of facets of *ur*-textuality and of *ur*-nationalism as I would perceive it. And yet it has always been widely ignored, except by liberals who often express a surrogate national feeling through reclaiming white national minority figures. That's why Celtic culture is so officially prized in the England and post-Britain of today. Because it can be permitted and because such people are militant minorities.

It's also true that the Celtic people of these islands have been militant about their identity, and there is a species of militancy that exists that is part of that identity. Even parties as tame as the Scottish National Party and as tame as Plaid Cymru do have, at their base, a far-Right accretion.

To return to Ireland and the topic of Yeats, when Eoin O'Duffy refused to march through Dublin and confront the IRA and the De Valera state in a manner which could have led to internal and civil strife, with Britain in the background and without a republic ever being formed in Ireland, he turned away from the prospect of civil war. He also turned toward democratic politics because the part which opposed Fianna Fáil, which is called Fine Gael, was a merger between parties which then exited and the Blueshirt movement. So, if you like, he took his movement off the streets—he was an ex-police commander, after all—and merged them in with other political parties. This is why Ireland never experienced a second civil war in the twentieth century.

Now, Yeats' political contribution was tangential and didn't really occur until he entered the Irish senate in the 1930s. Like the House of Lords, the Irish senate has never been elected. It's appointed and is appointed by the government. This led to quite a lot of upper-class Protestants being appointed to the senate by the patronage of the Republican elite, or the softened Republican elite, because, by that time, the Fianna Fáil elite were well in power and had their feet under the collective desk, the militancy and fire of the IRA was a generation or so back, and they were mainstream bourgeois politicians looking after their own inter-

ests, indistinguishable from most other figures, particularly in the low countries and elsewhere.

Now, one of Yeats' most famous poems concerns "Easter, 1916." I'll just read a bit of it. I always think that you have to adopt an Anglo-Irish accent to get the best out of it, but we will see!

> I have met them at close of day
> Coming with vivid faces
> From counter or desk among grey
> Eighteenth-century houses.
> I have passed with a nod of the head
> Or polite meaningless words,
> Or have lingered awhile and said
> Polite meaningless words,

He's talking about the Ireland that existed before the Rising and before the galvanization of what he would consider, romantically and poetically, to be a blood sacrifice. You see, to a poet a defeat is more important than a victory. If the rebellion hadn't gone into terrorist/guerilla warfare afterwards it would be a meaningless gesture by a small cadre who were gunned down and have gone into history. But as he says at the end of the poem:

> And what if excess of love
> Bewildered them till they died?
> I write it out in a verse—
> MacDonagh and MacBride
> And Connolly and Pearse
> Now and in time to be,
> Wherever green is worn,
> Are changed, changed utterly:
> A terrible beauty is born.

The phrase "a terrible beauty is born" has entered into the language of the twentieth century, rather like the fact that he also considered history to run in cycles, and he considered that the

Christian age was coming to an end in his cycle of life. It would be a 2,000-year culture. This has a certain prescience because as the organized expression of Christianity as a civic faith, certainly the Irish Anglicanism that he was brought up in, the Church of Ireland, has largely died out in the country whose existence he supported. Partly as a result of the policies of some of its governments.

"The Second Coming":

> Turning and turning in the widening gyre
> The falcon cannot hear the falconer;
> Things fall apart

Another phrase that has entered into the mainstream of the language.

> Things fall apart; the centre cannot hold;
> Mere anarchy is loosed upon the world,
> The blood-dimmed tide is loosed, and everywhere
> The ceremony of innocence is drowned;
> The best lack all conviction, while the worst
> Are full of passionate intensity.

That phrase has entered into the English language during the course of the twentieth century. "The best lack all conviction, while the worst are full of passionate intensity."

> Surely some revelation is at hand;
> Surely the Second Coming is at hand.
> The Second Coming! Hardly are those words out
> When a vast image out of Spiritus Mundi
> Troubles my sight: somewhere in sands of the desert
> A shape with lion body and the head of a man,
> A gaze blank and pitiless as the sun,
> Is moving its slow thighs, while all about it
> Reel shadows of the indignant desert birds.
> The darkness drops again; but now I know
> That twenty centuries of stony sleep

Were vexed to nightmare by a rocking cradle,
And what rough beast, its hour come round at last,
Slouches towards Bethlehem to be born?

The last two lines have largely entered into the English language in the twentieth century. "And what rough beast, its hour come round at last, slouches towards Bethlehem to be born?" So even in the early middle of the twentieth century Yeats believed that great social, national, cultural, racial, and other forces were being unleashed—unleashed all over Europe and beyond. And the point of great artists was to elaborate on the nature of that unleashing.

He sees individuals like himself as the sort of lode stars of the people, that they are the communicants, that they are the voices. It's very much like in old Nordic culture where the poets were singers and reciters of song, whereby you had the entire collective experience of the tribe internalized by a songsmith, essential. Somebody with a lute, somebody with a harp, somebody with what we would consider to be a primitive guitar would play *Beowulf*, who would give out a threnody like an epic poem at a gathering where others would be silent or would drink or occasionally would join in.

They were communicating the racial essence of the people in the room *back* to the people in the room in a way which was conversant with something which they could understand, and also that each performance would be integral and yet different, because the next night, due to the improvised nature of the performance, at least in part, the diction would be slightly altered. This is why there aren't necessarily many textual models from that period of history. Although *Beowulf* has come down to us, we believe, by a Northumberland monk and been preserved. But the tradition had an oracular element to it. In Nordic culture it's called the *skald*. It's this idea of illumination and intoxication that seizes you and which is a form of language.

Speakers who are good or great speakers, who don't use notes, who speak in a mediumistic way, often talk about "hearing the voice," and this is part, in some ways, of that tradition, whereby certain things which are internal to you are communi-

cated to others, and in the bond of that communication there is an alliance that speaks to the rational part of the mind, but also speaks to the irrational part of the mind.

Men can be moved by feeling and by emotion rather than reason. The great power of the Right is that it can move people emotionally, which is why it's everywhere repressed because the danger of such movement, the danger of such emotional transformation, the danger of such an invasion of self and purpose is there for all people to see.

In this society now, as you'll see as you go back into Victoria, our attitudes toward things are almost everywhere absent. But the very fact that they are everywhere absent, is a clue to the possibility of their potency. Because there are only two tendencies in modern British and other European and Western life that can't be integrated. They are foundational religiosity of one sort or another and the radical politics of identity. They are the only two things that can't be adapted and assimilated into the marketplace, into the 24-Hour Video, Tesco, Shopping Bay culture. They are the only two things that cannot be integrated.

Would they if they could? There probably would be an attempt to do so, if it could be done by hybridizing the more moderate people, by saying "so-and-so is moderate," "so-and-so is an extremist," even within an allegedly extremist area, by inculcating dialogue with the moderates—or populists—in order to differentiate them from the more hardline. Maybe something like that would be attempted if there was the belief that such a tendency could be assimilated. But the whole point is that now with mass immigration, with the transformation of European cities out of all recognition from what they were even thirty years ago, such assimilation is impossible.

People will either look to what exists now as a portent of the future they wish to rebel against, or there will be a general decline, an entropy. Decline into the obverse of civilization, into an anti-civilizational or de-culturalized sub-structure of a sort that people like Yeats would never have realized.

In fifty years' time, if immigration into Southern Ireland continues at its present rate, the Irish will be a small minority in their own land. When you bear in mind all of the violence and

the vigor and the sort of anti-British blasphemy and apostasy that the Republican movements engaged in for over two centuries to wrest control over a relatively small country and to put a vanguard in, in order to lead it, against the more preponderant power within the British Isles, all of that will be for nothing. What was it all for? What as all that blood and energy and rancor and specious rhetoric and sort of blarney for, if you find that even within your capital city in twenty years' time you are in a minority? What was it all for?

Similarly, if we focus on the greater extent and to our own society, in Britain now, what is this 2,000 years? What is the empire and everything that went with it? What were the two world wars of the twentieth century all for? We have just become a "community" within our own island which has become a subsection of the overall, communitarian absences of privileges which generally exist. What is the purpose of this country and its history if all we've become is just one group among the others? The white British, just one segment of the taxonomy of peoples that's delivered every ten years with the census. Just one part of the population, as indeed White Americans are becoming.

Obama's election is just a signification of the fact that White Americans are in a minority in Texas now, a minority in New York a long time ago, and a minority in California very soon. The truth of the matter is unless we go back to that Irish pub and we look at the wall and we look at the great iconic figures that are on those walls, on those murals of identity if you like. There's a mural in Reading which is a "Black Power" mural. It's on the side of a particular club, which is now defunct actually.

People need their icons, and people need their murals, and people need their myths, and they need people to articulate those myths in ways which leads to a heightened sense of self, a heightened sense of being, and a heightened sense of sensibility.

Music and poetry are interlinked because, of course, a song is really poetry set to music, and poetry enables people to cut through prosody, to cut though the detail, and to invest language with emotion. And it remains a very powerful tool. And it's also of incredible importance to my way of looking at things that many of the greatest artists of the first half of the twentieth

century, but not the second half, had political opinions very close to some of the speakers earlier on in this meeting today.

There is a reason for that, and the reason is that they wanted their cultures, and they wanted their nationalities, and they wanted the civilization that all European cultures are a part of — they wanted that civilization to revive. Irish and British people have fought with quite considerable violence against each other at certain times in the last 150 years, and yet both are part of the same civilization. We are all part of a racially-based civilization which we have given the world.

White people are now 10% of mankind, basically. If we are to prevent ourselves from becoming smaller and smaller and less and less important we must revive these cultural figures, we must cleave them to us, and we must make sure that the iconography of their photographs and what they represented remains before us as we go forwards into the future.

On a tube train in central London, to read Yeats is a very, very minor form of rebellion.

Thanks very much!

Counter-Currents, August 28, 2014

ZEUS HANGS HERA AT THE WORLD'S EDGE:
ARNO BREKER & THE PURSUIT OF PERFECTION

Arno Breker (1900–1991) was the leading proponent of the Neo-Classical school in the twentieth century, but he was not alone by any stretch of the imagination. If we gaze upon a great retinue of his figurines, which can be seen assembled in the *Studio at Jackesbruch* (1941), then we can observe images such as *Torso with Raised Arms* (1929), the *Judgment of Paris* (1977), *Saint Matthew* (1927), and *La Force* (1939).

The real point to make is that these are dynamic pieces which accord with over three thousand years of Western effort. They are not old-fashioned, Reactionary, bombastic, "facsimiles of previous glories," mere copies or the pseudo-Classicism of authoritarian governments in the twentieth century (as is usually declared to be the case).

Joseph Stalin approached Breker after the Second European Civil War (1939–1945) in order to explore the possibility for commissions but insisted that they involved castings which were fully clothed. At first sight, this was an odd piece of Soviet prudery—but, in fact, politicians as diverse as John Ashcroft (Bush's top legal officer) and Tony Blair refused to be photographed anywhere near Classical statuary for fear that any proximity to nudity (without Naturism) might lead to their tabloid downfall.

All of Breker's pieces have precedents in the ancient world, but this has to be understood in an active rather than a passive or re-directed way. If we think of the Hellenism which Alexander's all-conquering armies inspired deep into Asia Minor (and beyond), then pieces like the *Laocoön* at the Vatican or the full-nude portrait of *Demetrius the First* of Syria, whose modelling recalls Lysippus' handling, are definite precursors. (This latter piece is in the National Museum in Rome.)

Yet Breker's work is quite varied, in that it contains archaic, semi-brutalist, unshorn, martial relief, and post-Cycladic material. There is also the resolution of an inner tension leading to a Stoic calm, or a heroic and semi-religious rest, that recalls the Mannerist art of the sixteenth century. Certain commentators, desperate for some sort of affiliation to Modernism in order to "save" Breker, speak loosely of Expressionist sub-plots. This is quite clearly going too far—but it does draw attention to one thing . . . namely, that many of these sculptures indicate an achievement of power, a rest or beatitude after turmoil. They are indicative of Hemingway's definition of athletic beauty—that is to say, *grace under pressure* or a form of same.

This is quite clearly missed by the well-known interview between Breker and Andre Müller in 1979 in which a Rottweiler of the German press (of his era) attempts to spear Breker with post-war guilt. Indeed, at one dramatic moment in the dialogue between them, Müller almost breaks down and accuses Breker of producing necrophile masterpieces or anti-art (*sic*). What he means by this is that Breker is artistically glorifying war, slaughter, and death. As a Roman Catholic teacher of acting once remarked to me, concerning the poetry of Gottfried Benn, it begins with poetry and ends in slaughter.

Yet the answer to this ethical 'plaint is *that it was ever so*. Artistic works have always celebrated the soldierly virtues, the martial side of the state and its prowess, and all of the triumphalist sculpture on the Allied side (American, Soviet, Resistance-oriented in France, etc. . . .) does just that. As Wyndham Lewis once remarked in *The Art of Being Ruled*, the price of civility in a cultivated dictatorship (he was thinking of Mussolini's Italy) might well be the provision of an occasional gladiator in pastel . . . so that one could be free from communist turmoil, on the one hand, and able to continue one's work in serenity, on the other. Doesn't Hermann Broch's great postmodern work, *The Death of Virgil*, which dips in and out of Virgil's consciousness as he dies, rather like music, not speculate on his subservience to the Caesars and his pained confusion about whether the *Aeneid* should be destroyed? It survived intact.

Nonetheless, the interview provides a fascinating crucible for the clash of twentieth-century ideas in more ways than one. At one point Müller's diction resembles a piece of dialogue from a play by Samuel Beckett (say *Endgame* or *Fin de Partie*); maybe the stream-of-consciousness of the two tramps in *Waiting for Godot*. For, whether it's Vladimir or Estragon, they might well sound like Müller in this following exchange.

Müller indicates that his view of Man is broken, crepuscular, defeated, incomplete, and misapplied—he congenitally distrusts all idealism, in other words. Mankind is dung—according to Müller—and coprophagy the only viable option.

Breker, however, is of a fundamentally optimistic bent. He avers that the future is still before us, his Idealism in relation to Man remains unbroken, and that a stratospheric take-off into the future remains a possibility (albeit a distant one at the present juncture).

Another interesting exchange between Müller and Breker in this interview concerns the *Shoah*. (It is important to realize that this highly-charged chat is not an exercise in reminiscence. It concerns the morality of revolutionary events in Europe and their aftermath.) By any stretch, Breker declares himself to be a believer and that the criminal death, through *a priori* malice, of anyone, particularly due to their ethnicity, is wrong.

At first sight this appears to be an unremarkable statement. A bland summation would infer that the Neo-Classicist was a believer in Christian ethics, etc. . . . Yet, viewed again through a different premise, something much more revolutionary emerges. Breker declares himself to be a "believer" (that is to say, an "exterminationist" to use the vocabulary of Alexander Baron); yet even to affirm this is to admit the possibility of negation or revision (itself a criminal offense in the new Germany). For the most part contemporary opinion-mongers don't declare that they believe in global warming, the moon shot, or the link between HIV and AIDS—they merely affirm that no "sane" person doubts it.

Similarly, even Müller raises the differentiation in Breker's work over time. This is particularly so after the twin crises of 1945 and 1918 and the fact that these were the twin Golgothas

in the European sensibility—both of them taking place, almost as threnodies, after the end of European Civil Wars, Germany and its allies taking the role of the Confederacy on both occasions, as it were.

Immediately after the War—and amid the *kaos* of defeat and "Peace"—Breker produced *Saint Sebastien* in 1948, *Saint George* (as a partial relief) in 1952, and the more reconstituted *Saint Christopher* in 1957. (One takes on board—for all sculptors—the fact that the Church is a valuable source of commissions in stone during troubled times.) All of this led to a celebration of rebirth and the German economic miracle of recovery in his unrealized *Resurrection* (1969) which was a sketch or maquette to the post-war Chancellor Adenauer.

Saint Sebastien is interesting in its semi-relief quality which is the nearest that Breker ever comes to a defeated hero or—quite possibly—the mortality which lurks in victory's strife. Interestingly enough, a large number of aesthetic crucifixions were produced around the middle of the twentieth century. One thinks (in particular) of Buffet's post-Christian and existential *Pieta*, Minton's painting in the fifties about the Roman soldiery, post-Golgotha, playing dice for Christ's robes,[1] or Bacon's screaming triptych in 1947; never mind Graham Sutherland's reconstitution of Coventry Cathedral (completely gutted by German bombing); and an interesting example of an East German crucifixion.

This is a fascinating addendum to Breker's career—the continuation of Neo-Classicism, albeit filtered through socialist realism, in East Germany from 1946–1987. An interesting range of statuary was produced in a lower key—a significant amount of it not just keyed to Party or bureaucratic purposes. In the main, it strikes one as a slightly crabbed, cramped, more restricted, mildly cruder, and more "proletarianized" version of Breker and Kolbe. But some decisive and significant work (completely devalued by contemporary critics) was done by Gustav Seitz, Walter Arnold, Heinrich Apel, Bernd Gobel, Werner Stotzer, Siegfried Schreiber, and Fritz Cremer.

[1] John Minton, *The Gamblers*, 1954.

Cremer's crucifixion in the late forties has a kinship (to my mind) with some of Elisabeth Frink's pieces—it remains a Neo-Classic form whilst edging close to elements of Modernist sculpture in its chthonian power and deliberate primitivism. A part of the post-maquette or stages of building up the Form remains in the final physiology, just like Frink's *Christian Martyrs* for public display. Perhaps this was the nearest a three-dimensional artist could get to the realization of religious sacrifice (tragedy) in a communist state.

Anyway, and to bring this essay to a close, one of the greatest mistakes made today is the belief that the Modern and the Classic are counterposed, alienated from one another, counter-propositional, and antagonistic. The Art of the last century and a half is an enormous subject (it's true), yet Arno Breker is one of the great Modern artists.

One can—as the anti-humanist art collector Bill Hopkins once remarked—be steeped both in the Classic and the Modern. Living Neo-Classicism is a genuine contemporary tradition (post Malliol and Rodin) because photography can never replace three-dimensionality in form or focus.

Above all, perhaps it's important to make clear that Breker's work represents extreme heroic idealism . . . it is the fantastication of Man as he begins to transcend the Human state. In some respects, his work is a way-station towards the Superman or Ultra-humanite. This remains one of the many reasons why it sticks in the gullet of so many liberal critics!

One will not necessarily reassure them by stating that Breker's monumental sculptures during his phase of Nazi Art were modeled (amongst other things) on the Athena Parthenos. The original was over forty feet high, came constructed in ivory and gold, and was made during the years 447–439 approximately. (The years relate to Before the Common Era, of course.) The Goddess is fully armored—having been born whole as a warrior-woman from Zeus' head. There may be Justice but no pity. A winged figure of Victory alights on her right-hand, while the left grasps a shield around which a serpent (knowledge) writhes aplenty. A re-working can be seen in John Barron's *Greek Sculpture* (1965).

But perhaps the best thing to say is that the heroic sculptor of Man's form, Steven Mallory, in Ayn Rand's Romance *The Fountainhead* is clearly based on Thorak, Breker's great rival. Yet the "gold in the furnace" producer of a *Young Woman with Cloth* (1977) remains to be discovered by those tens of thousands of Western art students who have never heard of him . . . or are discouraged from finding out.

Counter-Currents, December 17, 2010

STEWART HOME:
COMMUNISM, NIHILISM, NEOISM, & DECADENCE*

I'd like to talk about Stewart Home: communism, nihilism, neoism, and decadence. I've given three talks on the extreme Left. One is called "Marxism and the Frankfurt School and the New Left."[1] Another was called "The Totalitarian Politics of *Nineteen Eighty-Four*." And another one was about the concept of brainwashing and the use by the North Koreans and the Chinese of behaviorist techniques, particularly on prisoners in the Korean War—a totally forgotten struggle now—and a novel by an Italian-American called Pollini that was based on those events.[2]

Stewart Home is an incredibly obscure figure who is on the margins of the cultural *avant-garde*, so I'm going to come to him towards the latter stages of the talk when I've dealt with some of the building blocks to begin with.

Most conservatives, with a small "c," look around Western European countries like Britain today and wonder why they're living in a mildly, but evidently Left-wing society. They wonder why they're supposed to have won but have actually lost. As they look around them, everything's changed from what it was forty to fifty years ago—every normative social value and experience—and they wonder why that has occurred.

There are many reasons for why it has occurred, but one is the complete containment and taking over of the cultural space by what we'll call cultural Marxism or Marxian ideas or soft-Left ideas or post-communist ideas and their march through the institutions after the 1960s. But it didn't just happen then. It had been prepared much earlier in the twentieth century.

* Presented to the 25th New Right meeting, London, Saturday, February 13, 2010. Transcribed by V. S.

[1] Published as "Marxism and the Frankfurt School," in *Western Civilization Bites Back*.

[2] Bowden reviews Francis Pollini's *Night* (Paris: The Olympia Press, 1960) in *Pulp Fascism*.

Marxism is a doctrine—before Lenin added the conspiratorial element of a vanguard party that seizes power with its paramilitary wing in a declining state—a doctrine that originates from the middle of the nineteenth century and has a refutation of idealistic and utopian socialisms, some religious, some secular that preceded it. Marx believed that he had a science of history, that the thing was prior and determined, that history could be read like a runic pattern or the pattern of a Persian carpet, and he was the master of the dialectic that would determine humanity's future. We now know that the nightmarish regimes that were created across the planet in the twentieth century on the basis of some or all of his ideas failed, and most of them have been destroyed. But their legacy is still here.

Clare Short's got a bit of the witness at the moment in the liberal press because of her appearance at the Chilcot Inquiry. She said something very interesting when the Soviet Union collapsed. She said, "Communism is over, but Marxism is not." That's a very prescient remark, because what's happened in the Western world is that the idea that everything is economically predetermined in Marxian theory, that everything has a social dynamic which is structured and physical at the basis of economic life and it is materialistic, has been changed.

It was changed at the beginning of the twentieth century by an Italian communist theorist in prison called Antonio Gramsci. He had the idea that the superstructure and the base—that which was beneath and economic and material, that which was above and philosophical and cultural—can be disjoined. They can be separated and teased apart. That's actually a heresy in classical Marxism. But it enabled an enormous vista of struggle to be opened up right across academic, artistic, intellectual, and media-related life right across the West.

Part of the Left disengaged from the politics of vanguardism and engaged in what is now largely called cultural struggle. One of the great weaknesses of all forms of conservatism—whether Gaullism in France or Republicanism in the United States or Christian Democracy in Germany and Italy and elsewhere—is their refusal to fight cultural struggle, their refusal to believe that their enemies were in deadly earnest.

In the 1960s, persons who were regarded as "reactionary," particularly in the academy, used to laugh at a lot of what was occurring. It was almost a joke. I'm sure most people are aware of that satire called *Porterhouse Blue* by Tom Sharpe, which is based upon Peterhouse College, Cambridge, of all these reactionary and ultra dons, people like Maurice Cowling, people like Roger Scruton who were associated with that college. They are metaphysical or deep blue conservatives, illiberal conservatives, people who were right on the edge of the conservative range of opinion before the far-Right begins, as far as you can go within the mainstream, basically.

Those individuals—and I knew Cowling once (he's dead now)—didn't give in. But in a way they didn't understand that in order to fight back against the tidal wave of Leftist ideas throughout the twenties, thirties, forties, fifties, and thereafter you had to go further out ideologically, even if you weren't prepared to make organizational commitments, even if it turned to fellow-traveling. You had to use far-Right ideas, even if you didn't call them that, to fight against the Left in its militancy. Basically, conservative academics from Michael Oakeshott onwards refused to do so, absolutely refused to do so, and in doing so they basically put the noose around their own neck in relation to the forces that were coming.

Because their enemies were in deadly earnest. They wanted to transform the mindset of Western societies, and the way that they configured to do that wasn't through vanguard parties—although they supported them—wasn't through doctrines of social revolution—although they may have residually supported that. It was by changing the grammar that people used to think with at the advanced level.

Strangely for militant egalitarians, they used an extreme form of cultural elitism. You take the universities; you take the dons and the academics in the universities; you take the people who mark the PhDs that provide the methodology of attainment through which you get a don at the university. You then replicate that through all male and female students at the first, second, and third levels of tertiary education, never mind the people coming up from the secondary level.

As egalitarian education has been spread, we're going to have a society where 30 to 50% go to university; there's the University of Slough, which used to be the Poly in the Thames valley. You can do degrees in hair-dressing. You can do degrees in golf studies. You can do degrees in anything! You know, you send this away to a PO box number in Edinburgh, and in a couple of weeks it's packaged, and you get a PhD in nuclear physics, then straight back in the post! This is the way it's going!

There are a few upper-class people now who refuse to go to university. Princess Diana refused to go, partly because she wasn't too bright, but also because it doesn't have any social cachet anymore, because if everyone goes it's got no kudos. This is the idea! If everything is degraded, do you want to eat the bread that's been in every other mouth? This is the thing about egalitarian ideas.

The plan of Leftist subversion, which is a wave of academics in all sorts of areas, not necessarily networked, not necessarily doing it in relation to each other, but doing it in relation to the logic of their studies. They do it in discourse after discourse.

They do it in economic theory, which before John Maynard Keynes was classical liberal methodology, Alfred Marshall being the last of that particular school, revived by F. A. Hayek and Milton Friedman in the middle of the twentieth century as a dissident current that would then come back. Keynes comes first, and Marxist economists like Professor Joan Robinson at Cambridge come later.

Then you go to anthropology. The first great textbook of anthropology is Arthur de Gobineau's book, *The Essay on the Inequality of the Human Races*. This begins anthropology as a subject. This is a "racist" text. Anthropology is the science, or semi-science, that always has to deny its first text, because its first text is now so offensive in relation to all of the discourses that have come after. From the early part of the twentieth century, you get the growing up of various discourses which are called social or socialized anthropology: the idea that race has nothing to do with anthropology, when race is the periodic table of anthropology and is the taxonomy of the human within that particular academic discipline. You reach a situation where, by the 1970s, if

a don at, say, the University of Sussex, an ultra-Left institution on the south coast, said that there were cardinal racial differences in intelligence between people, there would have been an absolute riot on that campus, an absolute riot which would have had to have been controlled by the police and the authorities.

One thing the Left realized throughout the twentieth century is that people who are very mental and people who are very abstracted in terms of their intellect can be physically intimidated very easily. The mind and the body are so split in Western life that all you have to do is have a small mob wave their fists at a couple of dons, and they're *prostrated*, and they can't do anything, and they're in fear of their lives, and they will write in a different way afterwards. Trotsky said in a pamphlet called *The Necessity of Red Terror*, which was published in 1917, that you shoot a thousand to intimidate a million. But all you need to do at many universities is lob a brick through on Fresher's Day, and people are frightened to discuss and to write about and to theorize about whole sets of ideas.

Everyone knows that there is a spectrum since the French Revolution of far-Left, moderate-Left, center, moderate-Right, radical-Right views. Since about 1968, the radical-Right chunk—which is to the Right of Oakeshott, Scruton, and Cowling—has been broken off and cannot be talked about other than as critique. You can talk about how you detest these ideas. You can talk about how evil and wrong they are. You can talk about how mistaken they are. But they can't be adumbrated in and of themselves.

This is complicated because there are certain academies, such as the French one, where that's not always true, and this is because in France there was a very powerful intellectual fascist tradition—essentially, that's what it was—which goes right through to today and even to the New Right. There's a degree to which in the Sorbonne in the seventies you could see a poster saying, "Drieu La Rochelle: lecture this afternoon." He committed suicide, of course, after the war because he was a collaborationist intellectual with Otto Abetz and other people in the German cultural ministry in Paris in occupied France at that time.

So, it's not uniform. These things are process-led and dynamic. It doesn't just happen in economics and anthropology. It

happens in psychology. It happens in sexology. It happens in English literature. It happens in the creation of new discourses such as cultural studies, which is the dissemination of ideas about mass culture. And it happens in critical theory.

Critical theory is a viewpoint that's grown up across the arts and across the humanities and even into areas of law like criminology, which can also be considered to be one of these "ologies," one of these subjects, and other areas of history of art, aesthetics, in philosophy courses, philosophy itself, and so on.

The Anglo-American world, of course, had an empirical view of philosophy largely since Hobbes, but certainly since Russell in the twentieth century, and a hostility to European philosophy which meant that there was less Marxist influence here. But the trouble with Bertrand Russell's type of philosophizing is that it doesn't believe that any of the big questions can be answered, and therefore philosophy itself becomes slightly pointless, and a *cul-de-sac* where you discuss the language you use to arrive at a concept that you might arrive at to which there are multiple interpretations and of which you are forever unsure. In and of itself, that's the preparation—this radical, tepid uncertainty—which leads from conservatism to liberalism and from liberalism to something that's a bit more certain and lies to the Left of it.

Everything in Western societies has moved to the Left throughout the twentieth century. I am not a Christian, but you could argue that after Vatican II many Catholics became Protestants; many Protestants became liberals; many secularist liberals who are ex-Protestant moved further to the Left and adopted views that they would have regarded as semi-extreme in the past as long as they were not connected to physical force, militant working-class politics, vanguardism, and the absolute politics of communism.

You have many Left-wing liberals now who have views which are to the Left of hardcore communists in the twenties and thirties, and they don't realize that, and they're *horrified* by the atrocities of Stalin and Mao and Pol Pot and all the others. But what they don't realize is that they have imbibed a doctrine of totalitarian niceness and squeaky-clean correctness about these concepts, which existed in the way that their minds were

attuned to before they became conversant with it.

This march through the institutions has also been a march through the media, because when you have an intellectual clerisy it tends to control the conceptual ideas in the society, and the way that society talks to itself in modernity is through the media, and also propaganda and ideas about how you talk to the media. Most polytechnics, or post-polytechnics now—because polytechnics were once vocational institutions, of course, dominated by people who tended to support the Labour Party—have now been upgraded to new universities or universities have been downgraded to new universities which are polytechnics, because if all have a degree, what does it mean?

In America, you can go to a university, and, outside the Ivy League, you don't necessarily have to have the qualifications to get in. So, you have a remedial course. There's a considerable number of people from certain types of racial minorities in those remedial courses—taught to do English, taught to do math, and then they do sports science or sports psychology. They won't be doing physics. They won't be doing mathematics. They won't be doing metaphysics. They won't be doing Shakespeare.

There are certain colleges now that have votes about whether Shakespeare should be on the English course. But that's a mistake, you see, because democracy is always a mistake! When hardline Marxists allow the students to vote, the students, even though they're liberal, often come up with more conservative results than what the professors want! That's the logic of vanguardism: you don't allow them to decide. You *say* Shakespeare is a reactionary Elizabethan bigot with undue essentialist notions that you shouldn't permit!

The notion of essentialism has come in in the last thirty to forty years in relation to great fads in intellectual life. It has to be understood that for the last hundred years or so all mainstream, hardcore, Western intellectual developments have been atheistic. They've taken atheism as read, not as something to be debated. The first great ideology after the war was existentialism, which contained many elements including a dissentient far-Right strand as well.

Existentialism was replaced by a new creed, fad, wave of his-

tory, whatever you want to call it, called structuralism, which relates to ideas at the beginning of the twentieth century called formalism. Then people got bored with structuralism. Structuralism was around at the time of the student revolts in the late 1960s. Not totally a Left-wing idea, but in a way bent towards the Left by certain ideas. If the revolutionary Left on campus couldn't take an idea as read they would turn it around. Hegel was not a Left-wing thinker, but Left-wing Hegelianism emerged. Marx was part of a group of Left Hegelians with Engels. They used to meet in a beer cellar prior to the German revolution in 1848 to discuss Left theory. Similarly, Left-structuralism begins to emerge, particularly with Claude Lévi-Strauss in anthropology and with Ferdinand de Saussure in linguistics.[3] These ideas relate to certain currents in Modernist art in particular in the late nineteenth and early twentieth century. If we approach this subject area we get a bit closer to Home, who nominally is the hook that I'm hanging this particular talk on.

You can't do English at a contemporary British university — certainly outside Oxbridge, where there's just a received canon — and not come across critical theory. Critical theory is based upon a notion called deconstruction, and most people who are intellectually minded have heard the word deconstruction somewhere floating around, floating in the back pages of *The Observer* color supplement, that sort of thing. They've heard the word.

Deconstruction is another word for post-structuralism, which is the ideology or the new fad that replaced structuralism in the sixties and seventies. It's most closely associated with a thinker called Jacques Derrida, who wrote a number of books basically saying that history doesn't exist, that biology doesn't exist, that the writer of a text does not exist. There is only the text. There is only the grammar of the text. A painting can be a text. A poster can be a text. A film can be a text. Only the text. Nothing but the text.

It's the view that essentialism leads to the gates of Auschwitz, which is repeated again and again as a mantra within these par-

[3] Ferdinand de Saussure was the founder of structuralism, not one of its later developers as Bowden seems to imply here.

ticular courses. They believe that any prior identity—say the statement "men and women are different," the John and Joan book, you know, a child says, "Men and women are different"— *wrong* on every count! Prior essentialist agenda, revolutionary, sub-genocidal reactionary ideologies in relation to the specification of male and female. Don't you *know* men and women are interchangeable? Don't you *know* that they are the same? If somebody says, "But don't they have different brains?" "*Lies* put about by eugenicists linked to reactionary and essentialist ideas!" Again re-routed to the ovens. "Listen to your theory!"

Of course, in these areas, to think differently from the nature of this theory is to be impossible, because you will not finish the course. You will not even get a 2.1, which is the sort of median level for your average student, in that course if you don't go along with this.

Some of this thinking relates to Western ideas that go very far back, because in medieval scholasticism there's a doctrine of hermeneutics whereby you analyze the text of the text of the text. You look inside it to see the hint of the divine that is there. And some of these ideas actually do come out of that particular trajectory. So, in some ways it's a very ancient thing that's been repositioned and is being reused for hostile purposes. Only the core theorists in this area, Deleuze, Guattari, Derrida, and others, would actually know that is the case.

When the Enlightenment and modern scientific rationalism began, and they argued that the schoolmen were concerned about the number of angels that danced on the top of a pin and philosophy was about natural process and law of nature as the Greeks believed 2,000 years before, 1,500 years before their postulations of course, there was a degree to which they'd thought they had got rid of that type of thinking. But interestingly, that type of thinking, which in some ways is very "reactionary," has come back through these New Left ideas.

The one thinker who is partly outside all of this and has a special status as a monster within the twentieth century is Martin Heidegger. Now, Martin Heidegger was an extreme essentialist and a religious thinker who was highly influenced by these ideas of extreme hermeneutics and the peeling away of the

onion of the text. Heidegger has one book that is 500 pages saying, "What is thinking?" or "What is the nature of thinking?" Heidegger wrote eighty books, all eighty! Most of which have never been released.[4]

Although Heidegger is one of the most radical thinkers of the twentieth century, Heidegger's political affiliation, if only for a year between 1933 and 1934, has meant that in a sense he has become an unperson. After the war, when he was allowed to write and continued to write, he used to write in the Black Forest. He had a wooden cabin in the Black Forest, and he used to commune in this particular woodland fastness, this shed almost, with nature and by himself in pure theory.

A lot of these ideas are based upon pure theory. They are based upon the idea that the bourgeois—the enemy in Marxian terms—goes to life with common sense. *The Marxist goes to life with his theory!* Only if you see the veil of theory before reality, the pink prism through which reality is refracted, only then can you be in history; only then are you truly alive, because you're interpreting the dialectic of future knowledge.

Now, the irony is that these communistic systems that statally imposed these ideas on people have all collapsed. People who lived in Poland during Gomułka and other regime leaders had to do Marxist-Leninism four times a week, just like the Catholic schools that these schools replaced, where we did religion four times a week. They did Marxist-Leninist theory four times a week.

There was a far-Left party in Britain called the Revolutionary Communist Party, which was a split from the Socialist Workers' Party, a so-called Rightist deviation within Marxist-Leninism. In 1986, they set exams for their cadres. You had to do exams on *Grundrisse* (*Groundwork*) and *Kapital* volume I, volume II, volume III to pass exams on this sort of material just like in Poland.

People imposed this on themselves internally within the West, and yet historically these ideas have lost. These ideas have come crashing down as statal and political and architectural

[4] Heidegger's *Collected Edition* (*Gesamtausgabe*) runs to nearly 100 volumes, most of which were published posthumously.

structures. Yet in the minds of elite Western academics, the softer non-vanguard version of these ideas is alive and well and kicking and are in control.

It's largely true that most artistic departments—used as a term for the humanities and the social sciences—across the board are in the hands of the West's most ferocious ideological opponents *inside* the West, mentally. Not necessarily in terms of how people live their lives and so on, but in terms of what they accept.

The worst ideas in the world are some of the ideas in this room from the perspective of these sorts of people! And they know what they are against, although most of them are in a sense more coherently in favor of what they're for. Most Left-wingers and liberals, like Tony Blair, begin with the first thing Blair ever did, which was to go on an anti-National Front march. The first moment was negative. He knew what he was against almost before what he knew what he was for. But many of these people actually know what they're for as well, and what they're for is a world without any prior signification.

Deconstruction is the idea that you have a text before you, and this text has a system of rhetoric which is related to the personality of an individual author, but the author doesn't exist. It's just a text. It's just a signification. What you do is split the power of the rhetoric, the oratory, the nature of the language used, the control of the phrases used, the essentialist markers that delimit the promiscuity of linguistic and moral choice, and you deconstruct them. You open up the field of signification so that language can flow freely in its joy and in its meaningless splendor. This is called *jouissance*, the joy of deconstructing the text so that it reveals its anti-essentialist possibilities when the crypto-fascistic moments of identity in it have been removed, and this is what they do.

They will take an author like Céline—who is a French National Socialist essentially, if words have any meaning—and they will say, "This anti-Semitic statement shows the insecurity of a lower middle-class background. He obviously wets his bed. He was beaten by his father." They will deconstruct every particular notification. Actually, this is a philo-Semitic text, which

loves foreigners, which loves homosexuals, and is egalitarian! The whole point of deconstruction is that you reverse the meaning of the text.

But these ideas have their dangers, because there are certain things that liberals believe are sacred, and there are certain things that they believe shouldn't be deconstructed and are beyond deconstruction. One of the primary deconstructive figures, who wasn't necessarily a Leftist, was a man called Paul de Man, who was head of English and Philosophy, head of the Yale school of deconstruction at this Ivy League college. Ivy League college, Yale, has a school of deconstruction![5] Yes, it does! Acting against the West in order to affirm the negation of its identity. This is the sort of thing it said.

Now, Paul de Man was head of philosophy there, but Paul de Man had a secret past far worse than beating his wife or something like that. Paul de Man was a collaborator in occupied Belgium and was a minor member of the Rexist movement of Léon Degrelle. It was all very serious. And he also wrote some articles for a magazine like *Scorpion* shall we say, but it was in occupied Belgium at the time, so it was a *bit* more serious.

When it was discovered that he had this past, the whole of the movement of deconstruction gathered at the University of Alabama in the Deep South of the United States to discuss this unfortunate recrudescence of essentialism in the life and time of their chief American guru. Derrida came up with a remarkable wheeze. He said that because there were articles on the one side of the page of these collaborationist journals that were more extreme than what de Man had written, de Man was actually protesting against the extremism of the rival and mirror-reflected text with his own understated fascism, therefore revealing that he was in internal critical protest at the nature of this foul language and this sort of thing. Foul language in another way.

[5] The Yale School of Deconstruction signifies an intellectual movement, not an academic department or college. De Man joined the faculty in French and Comparative Literature at Yale. At the time of his death in 1983, he was Sterling Professor of the Humanities and chairman of the Department of Comparative Literature at Yale.

Interestingly, deconstructionism and post-structuralism have never survived this particular revelation, and it's not fallen off a cliff, but it's much less fashionable now than it was. It's also begun to be attacked by certain hard Leftists who are more materialistic, more pro-science, and so on, and who don't agree with this type of what they consider to be empty and rather vacuous theorizing. So, there's been a certain revisionism.

Not all of these ideas have it their own way. There often outliers who are dissentient. They're often critics within the system as well as without who are progressive. You can only criticize progress if you are yourself a progressive. This is part of the deal. So, there are progressive critiques of this sort of thing. Lévi-Strauss loathed elements of modern culture, loathed Modernist art, and so on. There's a degree to which certain impermissible reactions or "fleets to the essence," as it is sometimes called, are permitted by very radical theorists.

There's also certain of the revisionists like Serge Thion, for example, who played with post-structuralist ideas, which makes them very dangerous. As soon as I heard about post-structuralism in the 1980s, I knew that certain revisionist types would make use of some of these methodological tricks, because it's inevitable. You can apply deconstruction to deconstruction. You can get Céline's text, you can get the deconstructive answer to the text, and then you can deconstruct the deconstructive answer to the text, and you end with Céline again!

So, you think, "What's the point of doing all that?" And the point of doing all that was to question the affirmations of Western society. That's what the point of all that is. The people who flood into the humanist disciplines in sociology, in fine art and elsewhere, if you say, "Well, you know, Caravaggio is a homosexual," people will say, "Oh, dangerous assumptions there. A bit too essentialist. Are you reading the author or the artist who wrote the text too much into his own work?" And so on. It creates a fog of uncertainty. It creates an irony of the absence of affirmation, the absence of pride, certainly the absence of the justification of hierarchy, which it's all about.

Ken Livingstone is a populist libertarian Left-wing politician. When he was asked about political correctness and banning

Black children in south London from saying nursery rhymes like "Ba-Ba-Black Sheep" and so on, he said, "That's *Evening Standard* garbage." He said, "Political correctness is an attempt to change people's minds and language. It is concentrated on two egalitarian premises: absolute moral equality in questions of race and gender." He's a real Leftist.

That's what it's really about! It's not about any of these epiphenomena. It's about making inegalitarian and elitist assumptions morally and linguistically impermissible. And if they're impermissible for a university professor, they'll be impermissible for a struggling fourth level post-degree student, and they'll be impermissible for a middle-class bloke who sort of half-believes what's in the *Daily Mail*, and they'll be impermissible right the way down the society. And they will, in a garbled way, come out of every news channel you can speak of.

Many liberals now say, "We're fighting for Western values in Iraq. But what are Western values? Do we have a right to fight for them? In any case, should we affirm ourselves? We're attacking the essentialism of their own. We should deconstruct at home first before we go abroad imposing our signifiers upon these worthy foreigners." And so on. You see, it begins small. It begins with a debate about language, then it becomes much more powerful. In the intellectual ideologies that operate outside the sciences now, these ideas are *de rigueur*. To be actually against them is to morally shock, far more than transgressive postmodern art in relation to the Turner Prize and that sort of thing.

Things like the Turner Prize bring me to Stewart Home. Now, the Turner Prize is attacked by Home, but from the Left. You can only criticize Left from Left. He's to the Left of the Turner Prize. The sort of art that is exhibited in the Turner Prize, which is a sort of stitch-up by various dealers particularly in the 1990s in relation to a particular school of postmodern artists that came out of Goldsmith's College of Art in the late eighties, early nineties. Damien Hirst and Tracey Emin and Gavin Turk were the most prominent of the three. They were picked up with a lot of big money, and people wanted to make their own money as a result of it. However, it's based on an ideology called Anti-Objectivist Art which comes from the 1960s and was largely part

of the hippie movement.

John Lennon was involved extensively in Anti-Objectivist Art. Do you remember getting into a bag for peace? This is where a naked John Lennon, covered with hair, would get into a bag. A bag! Yoko Ono, who was a member of a group called Fluxus, would draw the zip on the bag, and Lennon would stay there for a day, because the idea was that if we were all naked and in bags and covered with hair, we wouldn't fight, and there would be no more war! There would be a realm of peace on this earth for us all to enjoy!

Another Fluxus fad that Yoko was very keen on was the revelation of the buttocks. They would sit there naked before NBC and CBS and ABC and the BBC and all the big channels of that era revealing their naked buttocks. Because of course you won't fight if you've revealed yourself in that way, and the point was to avoid struggle by not fighting.

These ideas had little currency and didn't last too long, but Anti-Objectivist Art begins there, and from it, Stewart Home begins his particular intellectual career at this time.

Home is an anarchist, essentially, or a libertarian communist or an anarcho-communist. He's written many books, but his one real claim to fame is a book called *The Assault on Culture*—the assault on culture!—*From Lettrisme to Class War*.[6] And he deals with an assembly of extreme Left *avant-garde* groups that come out of the major Modernist tendencies as they end.

Modernism is a very complicated area that goes back to the middle of the nineteenth century. It's a reaction, in part, against photography. It's a desire to go inside the mind and fantasize. It was despised for much of the late nineteenth century, early part of the twentieth century, then became the major aesthetic discourse of liberal humanism. There's a complication there, because both fascism and communism flirted with Modernism. Most of them then turned against it, although the Portuguese, Spanish, and Italian far-Right regimes made use of moderate Modernist tendencies.

[6] Stewart Home, *The Assault on Culture: Utopian Currents from Lettrisme to Class War* (London: Aporia Press & Unpopular Books, 1988).

Modernism has always had a devilish side from the perspective of Left-humanism, because a lot of the early Modernists were fascists, were anti-humanists, and were radical Rightists like Ezra Pound, like Wyndham Lewis, like Marinetti, like Gaudier-Brzeska, like Céline, and so on. That's because there was an anti-democratic element to it, because of course Modernism was a bohemian attack upon the sensibility of the majority. It loathes what ordinary people think about art, so it will destroy what they want and impose what intellectuals want. It's a sort of vanguard hostility to the boring majority. Bomb the suburbs! That's the sort of view of Modernism.

But that can tend to the Right as well as the Left in strange moments, because national cultures were still alive to the degree that there could be national Modernisms. Expressionism was a largely Germanic form; Futurism was an Italian form; Surrealism was a French form. Surrealism was the only major Modernist movement that linked formally with communism, through the radically state socialist ideas of its founder, André Breton. Basically, Surrealism died with him, but as it died all sorts of shards came out of it, one of which was called Situationism.

Situationism was a minor ideological current that's achieved quite a bit of currency, particularly on the far Left, because a lot of the students in 1968 mouthed Situationist slogans. The media was convulsed to find that, on one hand, there were these hippies throwing bricks at members of the CRS—the very tough central riot police in Paris and the other big cities—but they would paint these slogans on walls saying, "Seize the imagination" or "Release the factories" or "I want to play with myself" or something like that. Strong-hearted philosophical stuff like this, they would spray-paint on the walls.

Most of these were Situationist slogans taken from a book called *Society of the Spectacle* written by Guy Debord in the late 1960s.[7] Debord later committed suicide in dubious circumstances. There was another intellectual associated with this tendency called Raoul Vaneigem who wrote *The Book of Pleasures* and *The*

[7] Guy Debord, *Society of the Spectacle* (London: Rebel Press, 1994).

Revolution of Everyday Life.[8]

These books had a lot of impact in revolutionary artistic scenes. It's very interesting to notice this combination of far-Left art, anti-social practice, misanthropy, and extreme amounts of money, and their ability to attract each other in disassociated ways. Anti-Objectivist Art began as hostility to the art market. It began by producing artworks that no one would want to buy! That's the whole point. You were rebelling against the market! They used to have marches on Sotheby's saying, "Death to Sotheby's! Death to Sotheby's!" Now they're all *sold* in Sotheby's for enormous amounts of money!

The most classic example of this was an Italian conceptual artist in the 1970s called Piero Manzoni, and Manzoni used to sell blocks of his own ordure. He used to sell blocks of his own ordure in gold-tinted, beautifully framed sort of 18th-century gold-leafed tins. An Italian-American heiresses used to buy this for $7,000 a tin to say at their kinky and trendy parties that, "I bought one."

Because artists always loathe the dealers. They always loathe the middlemen, a third of whom have always been of a certain ethnicity. Always. A third of art dealers are Jews, and a third of art dealers are homosexuals, and not always an overlapping category. But artists loathed the middlemen, and there's a desire to revenge yourself on the middlemen by producing work that can't be sold, that's impossibilist, if you like.

But the market can sell anything. You can sell debt as an asset from which you can make more money. So, why not sell cars that are bolted together? There's a famous case of one artist who was neo-conceptual and was an Action Artist who tried to sell his dead body after he'd committed suicide. There's also a man called Rudolf Schwarzkogler, who's Austrian, and he wound himself in mummification, and either did commit suicide or feigned to commit suicide. I hope not to ruin anyone's appetite by some of this, but it's all true. It's all true, I assure you of this!

[8] Raoul Vaneigem, *The Book of Pleasures*, trans. John Fullerton (Seattle: Left Bank Books,) and *The Revolution of Everyday Life*, trans. Donald Nicholson-Smith (London: Rebel Press, 1983).

There were several other ones who left bits of their bodies, including arms and legs, in various galleries and so on, and this was photographed in the 1970s. This was Action Art, wasn't it? I mean, let's face it! There's something that's going on here! Home's book *The Assault on Culture* has Schwarzkogler's pre-corpse mummified body on its front, so you know what you're getting.

Now, the movements with which Home deals are Situationism, which is a Left-wing critique, in other words a critique from the Left, within the Left; there's Lettrism, which is another idea which relates to certain formalist and linguistic ideas; and there's the Movement for the Imagist Bauhaus, which is a splinter from Breton's Surrealism. They're also slightly dangerous movements, because Home has an equivocal element, not in what he wants but in what will happen.

One of the dangers about the cult of the new and the cult of the future is that there can be different futures that Left-wing people don't like. There was a group in the 1970s called Mail Art, and this woman would do these traditional biographical pictures, very traditional academic art, the sort of thing William Orpen would have done at the turn of the twentieth century and just in and around the Great War, and she would send them to people. She would send them to the Prime Minister. She would send them to the Pope. She would send them to the Chief Rabbi. And they were all pictures of Adolf Hitler. They opened them and were appalled. It was quite a scandal, and she said, "But I'm not a Nazi. I'm just being transgressive. I'm doing what is non-bourgeois. Hitler may have done evil things, but I'm not evil. I'm just painting a picture. It's just a representation."

So, you see, if you adopt the cult of the new . . . And Home had this idea called Neoism where he wants to create culture anew, which is largely based on Marinetti's ideas that you can bomb everything and begin again, because we are the masters of the ruins. It's the rhetoric of people who've never been to a real war, you see, and those who were just about to, because a lot of this stuff came out in 1912 and was just the quivering in the antennae of the Armageddon that was about to erupt. Although, to be frank, many of the Marinettists, the Futurists, actually did

fight in the war, because they believed in war. They glorified war. "We glorify men! We glorify war!" This is why they linked with Mussolini later, or some of them did.

Now, Home's work is based upon the idea that you can go beyond the Left and push even that which is Left-wing further Left. He's in this odd position, because the Left never thinks it has won. Even when it's triumphant, even when many dons agree with some of their assumptions, they think, "It's not gone far enough. The revolution has been betrayed! You need to go further! More radicalism, more self-criticism, more anti-essentialism! It's not enough! Turds in a box: not enough! Deconstructing classic opera: not enough!"

Turandot and other operas now, even in the West End, often have a urinal on the stage. Urinal? What's that about? That's Duchamp's idea of the ready-made, you see. This plate is art! Who are you to say it's not? I look at this work. I mediate it. I objectivize it as my view of life. The stained dregs of life in this coffee cup. Life ending in doom. Didn't Beckett say they were born over a grave, there's a cry, and then it's all over? You see, art! I want 2,000 for this now, and you'll give it to me! And that's how that sort of thing starts.

I heard a bloke once at the English National Opera, and a critic said, slightly bemused, "Why do you put a toilet on the stage?" And he said, "We're acting against the piece. We put the thing on, but we try to destroy it as we put it on. It's deconstruction."

And you know why these ideas have got a hold? Because they're bored. Because they're bored with Western culture. Since the Second World War, state funding of the arts has replaced bourgeois capitalist money. It's replaced aristocratic patronage. And you can only do Shakespeare so many times. There's a great tiredness to these state institutions, and this tiredness often breeds a kind of nihilism. "Why, let's tear it all down, this fuddy-duddy stuff that we endlessly have to replicate with the taxpayers' money!" These ideas course through even revived and classical theater.

Racing Shakespeare is the favorite one. At the beginning of the twentieth century, Othello was always played by a white

man blacked up: Olivier very famously in the fifties and thereafter. Middle of the century, always played by a black actor, because you had to bring to the foreground the nature of race and the nature of oppression and the nature of Shakespeare's unfortunate alienating and objectifying tendencies: odious. Now, usually, Othello is played by a white actor, because not to black up is to draw attention to the hideous racism of the piece so that guilt should be infused in the audience for the crime of Western civilization. Nine million dead. Farrakhan said in the United States, "Never mind the six, what about the nine!? The nine million who died in the Atlantic slave trade! What about us?"

There was a famous Richard Eyre version of *The Merchant of Venice* in the 1990s where the female lead apologizes for the *Shoah* on stage. She's kneeling before the audience. Don't remember that in the text, actually! Don't remember that in the original play! This is ironic considering that some of these ideas have come out of this idea of extreme textual specificity. "But you can always change the text when you want! It's only a text!" And this sort of thing.

There's is a sort of comedic element to these ideas, but I assure you that it would be instructive for everyone here to go to the Institute of Contemporary Arts. The ICA's in Pall Mall, near the Queen. Right in the center of all the establishment buildings, and it's all very nice in there with mellow lighting and all this. You go in, and there's a bookshop in there, and that is very interesting, because that bookshop is like a cathedral bookshop to this type of culture. Home's books are all prominently displayed in that particular bookshop. All of these deconstructive, anti-identity, post-racial, non-class, non-gender specific, gender-neutral-language particularisms are all there. Volume after volume after volume.

Actually, Home did a book once that had sandpaper on the cover so it would cut up all the books next to it, you see? Revenge! Revenge on the books! And you'd also damage yourself when you touch it, you see? So, he's attacking the reader! William S. Burroughs was once asked, "What do you want to do with the reader?" And he said, "Kill him. I want somebody to open the page and be so appalled that they virtually drop into

it, you know?"

There was a famous moment with *Nineteen Eighty-Four*, the BBC one with Peter Cushing in the 1950s. There was a Mrs. Treddis of North Wales[9] who allegedly did drop dead during the rat scene, Room 101. She was watching this on a state-subsidized channel on the BBC—art programs on the BBC—and when O'Brien gets the rats out in the Chinese torture scene—"Do it to Julia!"—she just caved over, poor old Mrs. Treddis. The MP was straight on the thing. He was in the Commons saying, "It's disgraceful that the state broadcaster is killing its own constituents with art!" You couldn't make it up, could you really? There is a degree to which the desire to attack the audience is very much part of this art.

There's actually a form of art called Auto-Destructive Art by Gustav Metzger where the art actually blows up, or a tube of acid will turn over one of those sort of mechano-wheels—you know, one of those sort of amateur things—and the tin tips up and pours acid down the front. So, the art attacks you, you attack the art, the art attacks itself. And then you buy what's left, even though it's been completely destroyed.

These ideas actually entered into popular culture because a lot of rock bands and so on were made up of students who go to art colleges. The Who used to destroy their instruments on stage. Pete Townshend, when he wasn't looking at dubious sites on the internet, was wrecking his guitar. And these guitars are expensive things. Keep it plugged in. And he'd smash it on the ground, and sparks would be going up. I think it's totally counter to health and safety, personally. And he'd smash it, and it would blow up! It would blow across the room, and all the crowd would be chanting. This was based on auto-destructive art. But, of course, they were working-class lads, and there were dangerous moments of essentialism in The Who because they always had the Union Flag behind them when they'd perform. Ah, the danger of those estates. More deconstruction, that's what's required.

[9] Apparently, the woman was actually named Beryl Merfin of Herne Bay, Kent.

Home criticized the Situationists because it was always a Hegelian theory and therefore allowed certain religious notions in from the outside. There was a communist called Jean Barrot who wrote a critique of Situationism. He was later a supporter of Pol Pot, but he's not heard of too much these days. Certainly would have been heard of if he had been Cambodian.

Now, Home got into trouble a couple of years ago, and Larry O'Hara, who's a sort of libertarian anti-Rightwing critic who's prepared to be at least reasonably factual up to a point, wrote an article called "Stewart Home's Fascist Friends." Because if you advocate for new areas of culture, total newness, you will attract in people who don't necessarily believe in equitable variables. And he attracted certain people, certainly Richard Lawson, who's well known from the National Party and *Scorpion* and *Perspectives* and had his website called *Fluxeuropa* and was a Left European nationalist, I think it's fair to say. He also struck up a bit of a relationship with Bill Hopkins, an old friend of mine, and there's a film, six minutes of Stewart Home interviewing Bill Hopkins. It's on YouTube.

Now, he's been heavily vilified for this, because by an ideological detour into the concept of the new, he forgot progressive verities. He's recovered. But it's bad news to reach out to radicals before you know who they are. You can get into deep trouble doing that, and he has. Because people say, "Didn't he have some friends who were . . ." That's what's remembered in this tap it in and Google your name sort of an age.

Home believes that everyone can create a culture just as there were certain classical music concerts in the 1970s where the orchestra would make it up as they went along. Xenakis was another one. You wouldn't have a piece. You would deconstruct the music. Indeed, they would tear the music up before the performance and stamp on it! Stamp on it in a rage at the bourgeois class! Then they would sort of make some music. Home believes that everybody can do that. He calls it the universal proletarianization of culture: *the universal proletarianization of culture*.

And he idolizes these slightly Rightist elements. He idolizes these skinhead novels in the 1970s. Does anyone remember these novels by Richard Allen called *Skinhead* and *Suedehead* and *She's*

My Bitch and all these sorts of novels that used to be read under the table in schools, seized in reformatory schools because, you know, no reading in this Borstal. They were written by this old drunk on the south coast called Richard Allen, and Home loves all this.

He's written several books. *Red London* is one. He's also written books that are just swear words, the C-word is the title, oh yes. And the S-word and the F-word. These are all in Smith's. They're all in Waterstones. He's done it because he thinks, "Why not? And also I'll push distribution to such a degree that are they going to go on Radio 4 and say 'Well, we have books with all sorts of swear words in them, but we won't allow them on the cover. The Royal Chamberlain lives in memory. We will not allow it on the cover.'" And Home is saying, "Why not? Why not? Are you some bourgeois snob, mate? I'm pushing this in front of you."

He's also a very extreme homosexual. You would have to have this. So, his works are these sort of cartographic fantasy of proletarianized homosexual blokes rampaging around London. This is on sale at any Waterstones, books called C— and S— and F—. I've looked at the covers, and I've read the theories. But the theory's important in a way, because at the end of *The Assault on Culture* he endorses Class War.

Now, Class War is a group that emerged in the early 1980s and is led by an anarchist called Ian Bone. And they do believe in Bakunin's idea of total war on the state. When Bakunin was asked "What is anarchy?" he said, "Total revolution against God." And that is what anarchism believes: total revolt against all ideas of transcendence, total revolt against all ideas of hierarchy. "Pull it down! Destroy it!"

There's a famous story about Bakunin in E. H. Carr's—a Sovietphilic writer—biography. Bakunin's riding along, because he's an aristocrat of course. He wanted to destroy everything, even the aristocrats first. And he sees some brigands robbing a house, and they're smashing it to pieces with axes and so on. He says, "Stop!" in Russian, gets out, and joins the brigands, and he starts destroying and running out with the paintings and butting them and leaping up and down on them and hurling bricks

through the windows and all this. When somebody said, "Mikhail Mikhalovich, why are you doing this?" He said, "Because it's there." Because it's *there*.

And Home's view is that destruction is a creative passion. First you destroy, then you create on the destruction. Even if you create and destroy, because you level the field for new forms: Neoism! The cartography of inversion! And if you don't like it, you can get a bit of *this*! It's this sort of stuff. The interesting thing is that these ideas are not revered. They're eccentric ideas even within the milieu of the cultural Left. But they're there.

Scorpion's not sold in the ICA bookshop. Alain de Benoist is not sold in the ICA bookshop. Books about Heidegger are sold in the ICA bookshop: *Heidegger, Monster of Nazism: A Philosophy of Inhumanity Exposed! Heidegger and the Jewish Question.* Unanswered questions: who was his mistress? We demand the facts! Heidegger! 400 pages of his Party membership between 1933 and 1934. *Husserl: Did He Ban Him from the Library? The Truth! Heidegger: Deconstructed.* Pluto Press in three editions. *That's* in the ICA library! But the authors of that which constitutes European identity are for the most part conspicuously absent from the ICA library.

Class War has, of course, died many years ago, and Bone is largely retired from active politics. He appeared on Jonathan Ross once—who I call Jonathan Dross—and he appeared wearing a wig, screaming and ranting. Bone's just treated as a freak show, you know. Just something to laugh at, really.

However, from our point of view, not altogether laughable because a group called Antifa emerged from Class War. Antifa would very much like to beat us all to death. I mean, they really would. But they're very small and of little significance. The interesting thing is that he was drawn to Class War because they're situational, because it's not going to succeed, is it? But you create a happening space, you create Action Art in society. Do you remember the march on the rich? "Bash the rich!" Remember the marches in Henley? "Bash the rich! Bash the rich!" You know, this sort of thing. Bored policemen, drongos and hippies and white Rastafarians, people with purple mohicans and this sort of thing walking along surrounded by the Special

Patrol Group, screaming execration at the bourgeois class and that sort of thing. It was all good fun. Then they'd go back on the train up to Twyford or wherever it was. Bone was there. The hard men were there.

There was a famous moment of anarchism in Chicago where all these very old bourgeois people are eating in an extremely rich restaurant, and the anarchists unfurl a banner in front of them saying, "Behold your future executioners!" And they love this sort of sport as play as action as theory. Anarchism, unlike communism—because of course anarchism is to the Left of communism—has a theory called direct action: direct action on the anger of the class, which of course is terrorism really. They don't call it that, but that's essentially what it is. These sorts of stunts, even that Class War stunt, "make the middle class afraid," tossing and turning in their beds and only wondering if those Mohican yobs are coming for them.

Those demos are very interesting. I once went on one of those demos and watched, and the hardcore anarchs, the hardcore activists, stand at the back and they throw forward the hippies and the drongos and the others. And they're the ones who are beaten by the Special Patrol Group or whatever the riot squad is called now. They're on the ground, and they're covered in blood, and the policemen step on them and kick them. This was the eighties. I mean, I saw it with my own eyes. It wasn't a travesty of British behavior. I saw it. But the hardcore activists with leather jackets are at the back, and when one goes down there's another there, you know, because the masses are just fuel—fuel for anarchy.

The point of these doctrines is that you open a space in the society where you can create new forms, because when you open a space anything can happen. If you assassinate a politician, anything can happen. That's why they used to assassinate them all the time in the nineteenth century.

These sorts of ideas of rage and deconstruction and alienation—particularly impinging on all forms of identity—have probably reached their high-water mark. But the very fact that they can be canvassed, the very fact that they are in the ICA, they're in the NO, they're in the theoretical book branch of the National Theatre—all state-subsidized. There's tens and tens of

millions of pounds that are spent on these institutions every year through the art boards and so on. The fact that these ideas are in the Western academy is a testament to the fact that communistic doctrines of radical destruction and deconstruction have taken over the mindset in the society. People who speak against them are, well, they're nowhere to be seen basically, because they're terrified. They're partly waiting for the next fad, really, in the hope that some of this stuff will wash away.

But the interesting thing is that they always know what they're against. Home is certainly aware of the New Right. He used to edit a magazine called *Smile*—smile!—which was a nihilist, communist magazine. That's what it said on the front. You can go to Smith's, you know, "Would you like to buy a nihilist, communist magazine? *Smile*." It would have an article about Lenin and an article about the Bonnot Gang, and then you would have diseased genitals, because it would shock the bourgeois audience and scratch the hatred of the masses. And in that transgression you open up a moral space for more radicalism of the mind and of the spirit. It is psychologically subversive, and they know what they're doing! They know what they're doing. The shocked person goes, "Disgusting trash!" and throws it away. They've actually had an effect, the effect of rejection before the next strike.

My view has always been that that sort of militancy has to be stood up to. And you have to fight back. And you have to fight back as hard and as ruthlessly as they do. That's why they are aware of us and fear us.

Stewart Home also has an interesting view of race, which is an original formulation. I've never heard it even from the Trotskyists, and he's not a Trotskyist. He believes that race doesn't exist, but the masses believe it does. Now, that's an interesting formulation, because if you think about it, you either have it as a foregrounded form of iterization, its being, *Dasein*, being in being as Heidegger would call it. It's that which is there. It's biological. It's there. It's foundational. It's prior. It's elemental. It's essential.

Or you don't believe that. Maoists and extreme communists believe that all humans are a white sheet of paper. Any sexuali-

ty, any ethnic specification, any culturalization, any level of intellect could be pre-programmed into you. As Mao's people would say, you can torture a man into progressive ideas to the degree that they're coming out of his ears.

Do you remember what O'Brien says to Winston Smith in *Nineteen Eighty-Four*? "First, we make you love Big Brother, then we kill you. Don't you remember, Winston," he says, "you're just a cell in the body of the Party? Do you die if you cut your fingernail?" Do you remember that, and the great actors like Sir Richard Burton who played that part?

Now, Home's idea is interesting in a way, because they believe in false consciousness. He's basically saying race is the false consciousness of the masses, but if nothing is prior, then reality is in the consciousness of the masses. Therefore, if the masses think that race exists, it *does* exist, even in far-Left terms, because only that which is thought moment by moment in the struggle exists! So, in a strange sort of way, he's ended up with a Right-wing deviation within Marxist cultural logic. He's actually got back to a position he says he refutes.

But it's an interesting one, because if you notice, the dip in biological thinking in the middle of the twentieth century, as a reaction to the Second World War, is the highpoint for these types of New Left ideas. Now biology has been re-emerging in the last thirty years. And it's very interesting, for example, that the Anti-Defamation League in the United States opposed the creation of the Human Genome Project. And many gay libertarian groups opposed the Human Genome Project. They are radically opposed to the idea of the biological investigation of the building blocks of life, because it will lead to the possibility of acceptance by the masses of a prior essentialism.

There was an interesting incident last year when the Genome Project's scientific review board wrote to the German Academy of Sciences and said that "In our opinion, life is 80% natural law and prior biological purpose." Not 60%, not 70%, but 80%. Man is socialized by 20%, and I view the socialization as environment, and environment is ecology, and ecology is a species of biology. So, in a way, it's all biological.

And the German Academy wrote back, "We cannot accept

this thinking. We cannot accept this thinking, because we understand that your postulate is from good intentions, but it draws us perilously close to rejecting the methodology of the basic law upon which contemporary German governance, state, society, and academic learning is based." So, the German government says that a particular scientific outcome is wrong, and as a citizen of the contemporary united German republic, founded under occupation by Adenauer in 1948, you have to refute it. We don't care what science says! We repudiate science! This is a revolutionary development really, whereby the Left, the organ of progress, is rejecting science. There's a concept on the New Left of scientism. Scientism. Science is ugly, male, reactionary, authoritarian, phallocratic. All this sort of stuff. There's a strong streak of feminism in all of these discourses.

The Left has sort of given up on that. Many Leftists are now debating about how they deal with biology. Peter Singer, who wrote the book *Animal Liberation*, which founded that whole movement: "Liberate the animals, you filthy speciesists," "Put down that ham sandwich," that sort of thing. Singer, of course from a certain ethnicity, from Australia where he was in the Australian senate. He was a civil libertarian and radical green. He's a utilitarian. He's a very interesting thinker. Because he's introducing a new hard liberalism.

Singer says maybe biological ordinance is true; maybe disability is inherited; maybe gender is inherited; maybe sexuality is due to brain function; maybe the Right is correct. But what you must do is pass every law and every methodology that lies behind the law, jurisprudence, to make sure that there is either equality of opportunity or equality of outcome, or those who proselytize for inequality of outcome are not allowed to affect it by the nature of their discourse. So, what he's saying is even if biology is unequal, you make the society so impervious to that logic, even though you've got a hierarchy, that it's not aware of that.

That's the most important and intelligent form of far Leftism. They can only sustain anti-science. They built their entire creed on science. They can't repudiate it. That's just a stunt for a couple of decades. They're going to have to accept the Human Genome Project. They're going to have to accept the biological and

prior ordination of man.

Every time I go into an NHS clinic there's a leaflet for transplants, and in the middle of that leaflet you're asked about your race. It says, "Are you White Caucasian? Are you Asian? Are you Negroid or Diaspora African?" All these little boxes. And that's because human internal tissues will not transplant or graft as well in relation to one race as another. Prior racial difference within the taxonomies of the human even at the physical level.

If a scientist at Oxford or Cambridge or the London School of Economics had said that openly in the 1960s or 1970s, there would have been rioting! There would be rioting in the canteen. There'd be rioting in the lecture hall. The Special Control Group would have been on the campus. You would have been hounded out of that place of learning. It's now in an NHS leaflet. Quietly, no fuss. It's just intruded there as a fact. "Who can reject it? We're helping people! We're helping people!"

And talking about helping people, there are ultra-liberal groups in the United States who are campaigning against certain forms of medicine that affect individual ethnicities. There are certain diseases that blacks and Africans suffer from, particularly sickle cell anemia, which is almost congruent to them, and certain drugs that have genetic potential and originate from some of the theory and experimentation of the Human Genome Project react primarily on their group. There are ultra-liberal groups who are campaigning to not allow the Food and Drug Agency to license these.

Why? Why? Because it undermines the idea that man is a white sheet of paper that you can do with what you want and there is no prior identity. They would rather blacks suffer than that these drugs were produced, because they admit the prior biological differentiation of the human. And when you begin there, when you begin with such a monstrous prior essentialism, the doors to you-know-what are swinging open. So, you must close down the thing before you even begin to agree with what you disagree with.

Thank you very much!

Counter-Currents, August 18, 2014

STEWART HOME &
CULTURAL COMMUNISM

In a recent article entitled "Violence and 'Soft Commerce'"[1] Dominique Venner spoke about leftist radicals being absorbed by the system which they affect to detest. He was referring in particular to the collected manuscripts of Guy Debord, the left-wing revolutionary and Situationist, whose pabulum was recently saved for the national library by Chirac's minister of culture.

The same could quite easily be said of Stewart Home who has inveighed for years against the cultural establishment and the Turner Prize, but now finds himself ensconced as the writer-in-residence at the Tate Gallery.

Note: for those not privy to this magic circle, the Turner Prize is the "leading" art bequest for postmodern work in the visual arts in Britain. It is the brain-child of Nicholas Serota at the Tate and only gives awards to anti-objectivist art from the last twenty years. If you're wondering how you can have artworks without objects then read on . . .

Home's career began with a communist and nihilist magazine called *Smile*, which he later sold on, and that was distributed via Left-wing bookshops. Twenty years ago, when the post-sixties Left had some kick, every large town in Britain featured a progressive bookshop of some kind. *Smile* set the scenes on his early productions, in that it combined materialism, gross anti-transcendence, libertarian-communism, and scatology (or virulent descriptions of sexual acts) in the same brew. It was, if you will, a hybrid of John Rechy, the Bonnot Gang's legacy, elements of William Burroughs' aesthetic, and a kind of bohemian slapstick.

A militant homosexual, Home refuses to accept that sexuality is grounded in biology, but, instead, believes in *détournement* and

[1] Dominique Venner, "Violence and 'Soft Commerce,'" trans. Greg Johnson, *Counter-Currents*, November 20, 23, & 29, 2010.

processes of social and cultural determinism. Home's cultural pornography is not just dirty-mindedness, however. It is Situational, in that he believes in anti-bourgeois transgression, shock as a tactic in and of itself, as well as attraction through repulsion or inversion — much like Baselitz's upside-down paintings, of course.

It's a species of cultural terrorism (if you will) which I doubt that too many trustees of the Tate Gallery have taken on board over the coffee and croissants. In many respects, Home's work isn't very important save for the fact that it has led him into the bosom of the artistic establishment via the *avant-garde*, and that he has attempted to theoretically justify it.

Home, having wiped the *Smile* off his face, published a series of perverse novels which combine pornography, the skinhead aesthetic, Left anarchism, and militant gay liberationism. One could call it a species of conceptual onanism mixed with communism and loosely based on the skinhead novels from the 1970s of Richard Allen. These were a publishing phenomenon in and around the rise of the National Front in Britain during the seventies. Allen was a drunken soak who churned out hundreds of pulps down in Brighton, but the skinhead series became so notorious that several Labour MPs urged them to be banned.

Home attempts to invert them in more ways than one, yet these fandangos, laced with Situationist theory though they are, are really an effeminate he-man hunting for a lost masculinity. They denote a sexualization of Guy Debord's Situationist maps from the surrealist underground a quarter of a century before.

Nonetheless, Home's obsession with force, violence, and working-class masculinity lends a cross-over aesthetic to his *oeuvre*. This has got him into trouble in more ways than one. For, by virtue of their exaltation of strength, Home comes perilously close to Left-Right productions like Jack London's stories of wolves and dogs, never mind his third positionist novel *The Iron Heel*. Likewise, a hard-edged, bitter, and violent sub-current in Lewis Grassic Gibbon's *Spartacus* (say) links it over time, and semiotically, to national-Bolshevik lesions, even Joseph Goebbels' Strasserite novella, *Michael*.

Home attempted to justify these outpourings with his one

theoretical work to date, namely the *Assault on Culture: Utopian Currents from Lettrisme to Class War*, which was published by a tiny outfit called Unpopular Books in the mid-eighties. It deals with a range of *avant-garde* art movements that had hardly been systematically documented until his time. (This is Home's real claim to fame—as a taxonomist of cultural decay.) It is also important to point out that these movements were relatively "fringe" even in terms of Modernist art.

In order of sequence, he deals with Situationism, Lettrism, the Movement for an Imagist Bauhaus, Fluxus, Auto-Destructive Art, Mail Art, and a couple more. He commences with Situationism due to the fact that it emerged from French Surrealism as it died. (Remember: Surrealism had been formally aligned with communism, and the French Communist party under Maurice Thorez in particular, from the thirties onwards by André Breton.)

Home himself is highly critical of Situationism and senses quasi-transcendent, semi-religious, and idealist urges in it. If they exist in Guy Debord's or Vaneigem's texts at all, they are present due to their debt to Left Hegelianism in the past. Home also makes use of Jean Barrot's *What Is Situationism?*[2] This is a hardline, neo-communist critique which typifies the Marxian notion that every father devours his young like Zeus' parent, Kronos, feeding on his offspring in Goya's painting.

Stewart Home needs to clear the Situationists out of the way so that his own cultural warfare can flourish. He does so by supporting personal creation and auto-infantilism in *Kultur*, yet, interestingly, he doesn't support *Art Brut* or Outsider Art which stems from the art of the insane. Nominally speaking, this was another tributary of Surrealism via Jean Dubuffet.

No, Home advocates the creativity of a universalized proletariat—i.e., no culture whatsoever. Nonetheless, the fringe art movements which he champions all have various things in common... such as shock value, anti-bourgeois defamation, the currency of excess and reverse entropy *à la* Bataille, as well as

[2] Jean Barrot, *What is Situationism? Critique of the Situationist International* (Fort Bragg: Flatland, 1991).

the intrusion of perversions. (This is meant to impact with the unconscious or implicit mind, as well as acting in a "terrorizing" way.)

It is important to understand this psychopathology. In *The Necessity of Red Terror* Leon Trotsky declared that the vanguard would subdue a million by killing ten thousand in their name. The terror advocated here was physical, material, martial, Left paramilitary, and so forth . . . yet Home and the Situationists were concerned with cultural "terror," distortion, progressive misalignment, and (de)vastation. It links—albeit implicitly—to Samuel Beckett's concept of viduity.

In short, you work upon the tremulous and post-religious despair of the stultified majority. You do this by utilizing the nihilistic imprimatur of many contemporary intellectuals and their artworks—including quite considerable creators like Beckett and J. G. Ballard. Why do you do all of this? So that individuals, wallowing in despair and self-contempt, will look to you in order to lead them out of this impasse. In one respect, and without its practitioners realizing it, it's a Left-wing variant on Spengler's *The Decline of the West*.

How far it technically ramifies with the earlier Communist forms of cultural warfare, pre-Frankfurt School, which advocated making Western civilization stink in the nostrils of those who have to live in it is unclear . . . it's perceptibly the same sort of struggle enacted at different times. One can see this quite clearly in Raoul Vaneigem's advocacy of child molestation in the Situationist text *The Book of Pleasures*. Why does he do this? It's primarily to spit in the face of civics and conventional society, to express his hatred and contempt for everything which exists, particularly biologically, prior to his attempt to change it.

Conventional conservatives (Tories in Britain, Republicans in America) never understand that their enemies are in deadly earnest. They mean every word of it—one of the many reasons why, in Revilo P. Oliver's words, *conservatism is never enough*. It never conserves anything anyway.

But to return to Home's example, his ideas contain dangers for his own side. The advocacy of a new start for culture where the slate is wiped clean (Neoism in his jargon) can lead to a phe-

nomenon like Mail Art where a female sent unannounced traditional paintings of Adolf Hitler to various dignitaries. This was not necessarily the "transgression" which Guy Debord had in mind via his doctrine of *détournement*. Also, Home's sheer aestheticism can devour itself or just veer off into a demented stunt—a sort of leftist *Rocky Horror Show*, Archaos (negative circus), Vermin from the Sewers (out of Catalonia), or an industrial band like Throbbing Gristle. At this level, it amounts to little more than a freak show from the nineteenth century brought up to date.

Likewise, the aestheticism can come home to roost. On the front of Jean Barrot's *What Is Situationism*? one sees piles of human skulls—just like the killing fields in Pol Pot's Cambodia. But hold on a moment: weren't his peasant cadres, mostly teenagers high on drugs and indoctrination, implementing the fanatical hatred of the family advocated by Maoist-feminists like Kristeva? She explained later on that it was merely *salon* effrontery—literary extremism, in other words. She hadn't really meant it . . . a bit late now.

Furthermore, what about the cover of one of Stewart Home's editions of *The Assault on Culture*? It depicts a mummified man, swathed in bandages like Boris Karloff in a film from the early thirties, and intent on auto-mutilation. It could have been a metaphorical extension of Metzger's Auto-Destructive Art—the root, incidentally, of rock stars like Pete Townsend from The Who wrecking their electric guitars on stage. But, in this case, it relates to Action Art and a particular Austrian performer called Schwarzkogler who used to make suicidal gestures of despair, alienation, and bi-polarity in gallery spaces. Some artists in the seventies (of this sort) were alleged to have committed suicide or lopped off their limbs as a mute protest against contemporary conditions. Right on . . .

Perhaps Home could engage in the ultimate *détournement*, akin to Schwarzkogler's, by going on strike and not producing any more art works at all? In fact, he once advocated such a course in the early 1990s, but nobody noticed, and the tide of self-expression continued. But there is one answer: to turn Anti-Art into art through Objectification; just take a blue noose from

Jewsons or Travis Perkins (the leading suppliers of building materials in Britain), put it round your neck like in Punch and Judy, and, as you're doing it, take a photograph of yourself on your mobile phone. Perhaps the images could be later blown up and exhibited by the committee, chaired by Serota, who awards the annual Turner Prize? I christen it Corpse Art, a new and veritable happening: the rescue of all of those who suffer under the tyranny of representation. Perhaps what remains could be turned into a Plastinate or an exercise in mortal taxidermy by Professor Gunter von Hagens? I'm joking, of course—but, as a character in a Godard movie ought to have said, laughter is a gun in the hands of the class enemy.

Counter-Currents, December 10, 2010

AGAINST THE TURNER PRIZE*

This film shall be entitled *Against the Turner Prize*.

We have here the most famous image associated with this prize, which has been largely run out of the Tate Gallery over the last quarter of a century or thereabouts under the reign of Nicholas Serota. This is Damien Hirst's shark. It's called *The Physical Impossibility of Death in the Mind of Someone Living*, and it dates from 1991, about fifteen years ago now. Now, in a sense, it has a certain power because of the sheer physical magnificence of the shark. Sharks are perfect. They move. They eat. They kill. They make baby sharks. There's not an inch wasted. The force of creation that gave rise to them is divine, if you want to use that with or without inverted commas.

But, of course, the shark was there before Damien Hirst. So he's just made use of this image, and he's put it in formaldehyde in an enormous tank, about one-and-a-half times its length in dimensions. This sold a couple of years ago to a very, very rich American—with obviously much more money than sense—for twelve million dollars or, as the media pointed out here, six million pounds. It is always remarkable how that figure keeps coming up again and again and again in the most unlikely contexts imaginable.

Now, formaldehyde will not keep this shark, because in actual fact it should have been put in pure ethanol, and if Hirst were a taxidermist he'd know this. And this is a form of taxidermy rather than sculpture. It's sort of taxidermy masquerading as sculpture, if you like. To keep the shark, you should have injected ethanol into the shark and have steeped the shark's body in pure alcohol. Eventually, over a twenty-, thirty-, forty-year span—and this case will be shipped back to the US and probably has been already—the shark will reduce in size. It will get slightly smaller and then smaller again. It also will

* A transcript of a video documentary by Jonathan Bowden that can be seen on the Jonathan Bowden Archive Odysee and Bitchute channels. Transcribed by V. S.

eventually flip over, reverse itself, and float down—reduced in size—to the bottom of the tank. So, there's an auto-destructive or deconstructive element built into this art. And the reason for this art's existence, amongst many other factors, is that it is anti-artistic, as people who had it boosted for them by the *Sun* newspaper of yesteryear partly understand.

Why is it that a significant proportion of our people only know of the artistic culture of these islands through the Turner Prize, which is the postmodernist, minor exhibition which has been boosted out of all logicality and reason by certain middlemen, press, and art dealing/gallery interests?

Now that we've looked at this shark, we'll go to a few other of these works and explore some of the ideas that lie behind them.

This is an image of the murderess and sadist Myra Hindley by Marcus Harvey from 1995.[1] It's acrylic. It's on canvas, of course. It's the same effect as paint, but you use water, for the most part. It's made up—or it's painted to look as though it's made up—from small handprints of children. Of course, she was a murderess, with Ian Brady, of children. She has the look that she had in the courtroom, and it's taken from a press photograph of the era. It's rather heavy, a sort of pre-Raphaelite virgin sort of look, sort of bottle blonde, sort of lugubrious sixties semi-iconic image of its time.

Now, Harvey's used this to be "offensive," to be anti-bourgeois, to be truculent, to make a pathetic little statement of rebellion, which many of these people are very keen on. He's done it to be "outrageous." Many of these images, which are taken from Tate Modern, late Tate Britain, Serota-influenced Turner Prize art of yesteryear—because some of this stuff goes back the better part of a decade-and-a-half now—is part of a movement that is against art as traditionally understood. It's sometimes called Anti-Art. It's essentially forms of Conceptual Art which are an attack upon what people like, an attack upon bourgeois and middling notions in art, an attack on that which is considered *passéiste* or outside of that radical cutting edge of

[1] Marcus Harvey, *Myra*.

modernity, although I would argue that a lot of this stuff is not particularly *avant-garde* because it's been done before. The idea that by painting a murderer you actually do something offensive, because the murderer is an outsider in relation to bourgeois order, relates to libertarian and liberal Left views of crime where the criminal is considered to be a rebel against the social order.

Here's Myra Hindley, championed by Lord Longford for many a year, although whether he'd have approved of this particular image or not is debatable. When I met Lord Longford a long time ago, he said to me, "I love Myra Hindley." "I love Myra Hindley," he said, and I said to him by way of reply, "Do you really? Couldn't you find something better? A better object for the nature of your affections?" I said, "What should have happened to Myra is she should have been hanged in 1962, and that would have been an end of it."

But here we have this image by Harvey of an offensive sort, and when it was exhibited in the Sensation exhibition at Burlington House in Piccadilly where the Royal Academy is, they had to hire various gorillas to guard it from people who were throwing or attempting to throw eggs at it, which was all rather amusing. They also had an exclusion zone, like a hockey pitch, whereby they painted a white square in front of the image, so that people who stood beyond the boundary of this square couldn't, if they threw an egg, given the parabola of the egg, get to the picture. So, that was rather exciting.

This is *The Holy Virgin Mary*, a Catholic and iconic image, of course, from 1996. Again, another Turner Prize winner/exhibit. This is by the African—I believe Kenyan—artist Chris Ofili. This is a black, bloated, alleged Mary, mother of God, with a sort of sex doll-like mouth, covered in elephant dung. The elephant dung is real, and he obtained it from the elephant enclosure at London Zoo in Camden where ordure was deposited. He allegedly crept up when warders weren't looking and shoveled in several black bin liners full of this ordure and later attached it to these canvases.

One of these works was bought for something like twenty- to thirty-thousand pounds, something like that, certainly less than fifty-thousand, by Chris Smith, MP. Chris Smith was the first

Labour Arts Minister after Blair's landslide in 1997. It wasn't widely known outside certain metropolitan circles, but Smith, who's been an "out" homosexual for a very long time now, has been "living with AIDS" for the better part of twenty years. So, given that retroviral drugs take up at least twenty-thousand pounds a year of one's money in order to expedite the possibility that one doesn't develop AIDS and green lupus, an infection growing out of one's skull, and this sort of thing, the combined price of Ofili and the retrovirals is obviously quite significant in the Smith mélange.

This is an image of Tracey Emin's bed—*My Bed*—from 1998. She's never won the Turner, although she's come close and is one of its most "controversial" figures. An Anglo-Turkish girl born here, she basically with this piece is attempting what is called in this Anti-Art tradition the Ready-Made. One of the points about this type of art—and she's attempting to use certain quasi-feminist clichés during its adumbration—is the fact that it's not new. Hardly any of this stuff is really that original, because the Ready-Made begins with Marcel Duchamp in 1920–1921, where he goes into a gallery with a urinal, one of these small ones, and says, "Prove to me it's not art!" And it was later included as a "Ready-Made" in gallery spaces.

She is essentially, in a rather sort of chick-lit way, revisiting this territory and reportedly says that it is reasonably original. She is also, it's important to point out, part of a generation of so-called Brit Pack artists who emerged in the 1990s. Gavin Turk, herself, and Damien Hirst of shark fame/infamy, were actually a particular generation of students who came out of Goldsmith College of Art superintended by one particular art lecturer in South London. So, they're very much this rather "in" crowd, who, for a while in the nineties, became a going concern both aesthetically and commercially.

There was also a very minor interface with the Blair regime. In the early years of the Blair government, there was this doctrine, half-articulated, of Cool Britannia, which consists of a large number of allegedly cool and happening metropolitan persons who were gathered around Blair and Co. to make them look funky and sort of down and real and "with it." Nearly all of

these types, of course, have been alienated and estranged by the course of New Labour and, in particular, the Iraq War.

Here's an image of a mask of blood just called *Self*, again from 1991, similar era with all of these works, by Marc Quinn, a conceptual sculptor from Liverpool. Now, Quinn is slightly more interesting than many of the other Brit Pack artists, so-called, although he wouldn't really care for me pointing it out particularly on behalf of a cultural video produced on behalf of the British National Party. Quinn is actually a slightly traditional artist in the sense that he's looking back. Although the head of blood, refrigerated so it keeps its shape, appears to many people as sort of garish or ghoulish or in poor taste, the death mask goes back to the ancient Greeks and is part of Western culture.

When Beethoven died, an extraordinary mask was taken from him in death showing the power of the man—a power that few of these artists could come anywhere near replicating. But also Keats when he died, an Italian took his death mask. It's a very old tradition in our culture, because he'd taken a mask of himself while living. And in a way, Quinn is hinting at going back, but only in a deconstructive way, only in a way that's fashionable with his liberal friends, only in such a way as he can get his work on at the present time, and his work certainly gets on.

A crucified ethnically disprivileged Christ figure is one of his previous efforts, and if you walk around Trafalgar Square, which a lot of people do, at the present time you will see an enormous sculpture at one end of the square looking out upon the National Gallery as it were, and this is thirteen tons in weight. It's of a pregnant thalidomide victim called Alison Lapper.[2]

But even this, you know, relates to certain classical orders in sculpture: it's linear, it's representational. A lot of sculpture in the ancient world, of course, has limbs missing because they haven't survived. Some ancient, pre-Hellenistic, and pre-classical forms of tribal and aboriginal art in the Western context show enormously pregnant women, because, like the Venus of Willendorf, they are actually figures of primitive fertility and usual-

[2] Marc Quinn, *Alison Lapper Pregnant*.

ly relate to religious fertility rites of one sort or another. So, in a sense, Quinn is playing games. A lot of these people are. He's bringing certain things back from the past in a way which is acceptable to Ken Livingstone's London.

Ultimately, this society cannot decide what to do with the empty plinth in Trafalgar Square, because you can't have a hero. You can't have a military figure in this postmodernity on that plinth. Why? Because it's considered to be conceptually fascistic, that's why. And that's why they have pregnant thalidomide victims instead.

This is *Great Deeds Against the Dead* from 1994 by the Chapman brothers, who have a concept called Chapman World. Those who don't like grotesque abattoirial nudity should look away, and don't put it on pause either. This is based on Goya from the Peninsular War, because the French committed a large number of rather savage and atrocious deeds in the Peninsular War when we fought with the Spaniards against them. The Chapmans are making a point about futility, folly, the morphology of the human. It partly does draw upon the classical tradition actually in a sort of abbattoirial way. It means to shock, but it's actually more redolent of savagery and heroic cruelty than much of the rest of this art, and it actually, unlike a lot of their stuff, has more to do with the genuine Western tradition. It's offensive, but then again there's going to be plenty of severed bodies in Iraq.

This is an image of two American tourists from the late eighties: life-sized, obese Americans with cameras in tow, looking on, shopping in hand, slightly arrogantly wondering what all these foreigners are doing when they themselves are, of course, abroad.[3] There is a certain truth to this one, and it is not disagreeable. This phenomenon is known as the ugly American abroad even inside American mass culture. The American embassy has distributed literature to hundreds of thousands of American tourists all over the world trying to get them to say "please" and "thank you," trying to get them to behave a little better abroad. This rather redundant and middling piece never-

[3] Duane Hanson, *Tourists*.

theless has captured something of that.

Lastly, this is a radical feminist image of a sort by Jenny Saville.[4] She specializes in unattractive female nudes in various abattoirial postures. She thinks that a glamorous sort of page-three image of a woman is in actual fact a desecration, and she's into the depiction of militant female ugliness as an anti-heterosexual, anti-bourgeois, anti-phallocratic, and anti-family statement. So, what do we have to say about this? Well, these bodies essentially are like bits of meat in an abattoir really, which is a surrealist tradition that goes back to the beasts in the thirties and the forties who used to paint in abattoirs to get the right savagery, to get the right sort of effect. But in the end, Saville is just producing images of ugly women that look like trussed up abattoirial specimens. So, it's the sort of pictorial equivalent of Andrea Dworkin's ideology, writ in paint, in ugliness, in obesity, in its unattractiveness to men, as a mute and futile statement of the absence of motherhood.

Now we've had a look at quite a few Turner Prize images, Tate Modern, late Tate Britain images.

What is this art about, and where does it come from? Also why has it been pushed particularly by a mass market tabloid newspaper like the *Sun* of all things?

To deal with the things in correct order, these works come out of conceptual art. Conceptual Art is an art movement that pretty much began in the 1960s, but there are antecedents further back in Modernism. Modernism is a very old idea and goes back to the middle of the nineteenth century with the Impressionists. This type of Anti-Art comes from the sixties but relates to a movement which was in protest against Western civilization at the end of the Great War.

This movement was named after a sort of child's gurgle and was called Dada. Da . . . da . . . da. . . Dadaism! Yes. And this movement, which flowered for a brief, brief period as Weimar Germany in particular was coming in just after Germany's defeat in the Great War, late second decade of the twentieth century–early 1920s, had attempted to produce a pastiche of childish,

[4] Jenny Saville, *Fulcrum*.

infantilistic art as a protest against the adult society which had led to the carnage in Flanders.

Now, factoring forwards about forty years, the hippie and Left and counter-cultural movement of the 1960s, best known for its inflections in fashion and music, also had an artistic side. They rebelled against the artwork as object, and they wanted to create objectless art. They wanted to create anti-middle-class art, anti-bourgeois Conceptual Art, which would be totally resistant to the blandishments of the market. You notice the hypocrisy here, because this image that we have before us now (Hirst's shark) has just been sold for many millions of pounds and dollars depending.

Over time, that which was ugly, fierce, deconstructive, melted down, against the grain, against society, against traditional taste, even within Modernism, has become acceptable, and it has become in turn a vehicle of exchange which can be exchanged for vast amounts of money. And the Saatchis in particular have been buying this work from this post-Goldsmith's sect for many a long year.

They have a warehouse in Leyton in inner East London that burnt down rather recently, and a cynical Catholic friend of mine rang me up after this warehouse had burnt down with a lot of this stuff in it and said, "You know, there is a God." What he was trying to say by that it was a sort of righteous vengeance for all this. But, in actual fact, at the material level of existence, it was some faulty electrical fitting which caused the thing to burn down.

One of the exhibits that burnt down was an enormous array of sort of quasi-pedophile dolls which were arranged by the ubiquitous Chapman brothers as part of their Chapman World. When I attended the Sensation exhibition at the Royal Academy in Burlington House, Piccadilly a couple of years ago—this was the one with the crowd outside and the demonstrations against the Myra Hindley image and so on—I noticed that there was a sign before you entered an inner section of the exhibition; this related to the Chapman World's efforts, because you had to prove in a sense, at least conceptually, that you were over eighteen years of age before you'd go on and see these alleged-

ly shocking images and that sort of thing.

But, in actual fact, it's all unoriginal stuff, because this was done by Bellmer in the 1920s and thirties. He was a surrealist, who in a mute protest against a certain German régime that then existed, produced a large number of naked female dolls in various poses. It relates to Balthus' paintings as well. So, there's a degree to which none of this stuff is original. The shark is a return to the ready-made of Duchamp and later of Warhol, so is Emin's efforts her unmade bed, her Anti-Art, her scissors that won't cut, the sort of camping tent that consists of the names of her aborted fetuses and all the men she's slept with, and so on and so forth.

It's actually recidivistic material. It's a dog returning to its own vomit, if you pardon the phrase. All of these sorts of things have been done before and partly done to death. There was a pop band, I believe, called Pop Will Eat Itself. And there is a degree to which this is postmodern art devouring itself, returning to various sources early in the century, deconstructing itself, acting against its own tradition, rather like many of these contemporary operas where, you know, they had *Don Giovanni*, but then they put a toilet on stage because they're "acting against the piece," it's called.

But they're doing so because they're bored, because they haven't got anything to say by virtue of the fact that they're sort of liberal and decadent. And it's less the Modernism of style and finish than the valuelessness that lies behind it which has to be our source of critique.

You may now feel that we've done the Turner Prize to death, but not quite because in our talk about the negation of the aesthetics of the Turner Prize and related Brit Pack artistry we are now going to turn the clock back to go forwards. The important point about the Rightist attitude towards modernity and modern art is not to be "reactionary." One should not reject the modern. One should change the vortex and the system of values and energy that lie behind what's ended up with turds in boxes, which is actually an artwork in the 1970s by a so-called conceptual artist named Manzoni. An Italian-American heiress bought his own ordure in a gilded box for seven thousand dollars US, so that in

Rome she could, actually rather *dolce vita*-like, say to her decadent and sophisticated friends that this is what she had done.

But we wish to move away from that towards radical but traditional art. And there can be nothing more radical and nothing more traditional in our conspectus of new against old and rival forms of modern artistry, albeit historically displaced, than church gargoyles.

These images—which sometimes are called corbels in Yorkshire and which influenced very strongly the young Henry Moore in their three-dimensional form—are post-medieval images and medieval images in turn. They are to ward off evil spirits mythologically. They are powerful. They are on the interface of ugliness and beauty, which is part and parcel of the Modernist aesthetic *per se*.

In this particular image, which is in the Royal seat at Windsor at St. George's Chapel on the exterior, we see an anthropomorphic figure partly lion-like, semi-animal/human, wrestling with a fetus, wrestling with a child that's partly under its arm. Is it guarding it? Is it throttling it? Are they both crying out? Are they in pain? Or are they in joy?

Now, this is a very powerful image made by an artist working in traditional church art and the craftsmanship and genuine artistry of the post-medieval interior and exterior. It's a superb piece of art. We will never know the man's name, but this piece of work is far more important than Hirst and Turk and Emin and some of Quinn's and many of the others.

There are thousands of these images in our churches up and down the land. It is an image of power! It's a threnody. It's visceral. It's ten times more powerful than anything these Turner Prize people can produce, and why is that? It's because it's based on *belief*, and it's based on a semiotic of meaning, and there are values that lie behind it that reach into the depths and come out from them.

This is another image from tradition which is more radical than that of alleged modernity. It's a mermaid holding a fish on the exterior of Exeter Cathedral. Again, one sees a strong image of powerful femininity rooted in medieval craftsmanship. Many of the men who produced these sorts of images wouldn't have

considered themselves to be artists, but they're actually very great artists. And it puts Jenny Saville and her ilk into the shade. The reason is that it relates to canons of preconceived aesthetic beauty, female beauty perceived heterosexually through the male eye. And don't forget, this is on the exterior of a church, so one has erotic mythological imagery of a heterosexual character as part of the tradition in stone of conceived Christianity.

The difference between it and the Turner art which we've had across this screen in the early part of our talk is that these images are rooted in belief. They exist in the mind of the artist prior to their execution. If they don't draw them prior to the sculpting of them, they're drawn mentally in their own mind. They proceed to the object. They're pro-object. They are object-friendly, and they believe in objectification. It is not, as Metzger would say, "art against the object" or Auto-Destructive Art as his little movement, essentially confined to himself in the seventies, testified to.

So, we have here the inverse of the Turner methodology in its praxis, in its prior beliefs, and the form that it comes out with. And, in the end, it ends with an object, which although it may not be to everyone's taste, relates to the instinctive understanding of beauty as conceived by the majority of people.

This is a rather dragon-like or reptilian gargoyle head from a church in Yorkshire. It's a sort of form of white aboriginal art, virtually, by a craftsman who is totally unknown. It's from Hedon. It's described as the termination of a stringcourse, but it will be outside of a provincial, probably rural, church facing downwards, looking ferociously at somebody who is looking up. It relates to a sort of antithetical principle really, sort of evil to ward off evil in a way. But it's a figure of quasi-satanic majesty put on the outside of a Christian church by a northern craftsman and artist of genius, because that's what these corbel sculptures were. Make no bones about it. These men exemplified the Gothic tradition, and they exemplify Flemish art transplanted to the north of England in stone and in three dimensions on the outside of our churches.

When Modernists of a Turner Prize sort, but not of the sort which could be characterized by a Lewis or even a William Rob-

erts, talk about power as beauty they should look at images like this.

Here's a monkey whipping its young on the York Chapter House. It's a superb image, a sort of truly silent version of King Kong and in stone several centuries beforehand. It's a sort of deeply anthropologically knowledgeable image. The form of the beast is correctly captured. It's sort of an imp of the perverse image. Don't forget, the monkey in this configuration is completely pre-existing any evolutionary theories that might look at higher primates and simians in a different way than this sculptor looked upon them. But it's another of these grotesques and images of European fantasy on the outside of our churches in traditional cities like York. Looking on, beating its young, an image of the primordial, of the powerful, of the most savage, of that from which we have come.

We now move from the outside of a church or cathedral to the inside. This is in Ripon Cathedral, and it's an elephant with a sort of traveling house on top of it, a sort of canopied structure on the back of the beast that humans and other goods could be carried in. It's probably influenced by Clive's forays into India. There's a sort of post-imperial feel to this piece. It's on the edge of a row of seats or pews inside the body of Ripon Cathedral. The interesting thing to me about this image is the imagination that's gone into it. It's the delineation. It's a piece of white aboriginal art in a way. It's fierce. It's visceral. It's militantly three-dimensional. The thing is alive. It's protean.

When Henry Moore from Yorkshire was very young he went to see Wyndham Lewis in the 1930s, and he said to him, "What's sculpture about?" And Lewis said, "Have no fear. Relate to the past. Be aware of past precedents, but create for yourself in the time when you're alive. Believe that all is plastic under your vision, and you can change the world anew. Think only of power and beauty in form." This elementary and elemental sculpture of the elephant in wood inside Ripon Cathedral has it.

This is a more abstract piece in many ways. It's slightly florid. It could be conceived as more feminine, weaker than the others, but it's still a powerful piece. It's a caterpillar in its sort of vegetation laid out in a slightly mosaic way, in a slightly patterned

way. It's not meant, in my opinion, to be too clear. It's slightly serene and also slightly surreal. It's also strongly related to the purity of natural form bearing in mind it's on stone, and it's outside Exeter Cathedral on one of its walls. It's a caterpillar in foliage. It's probably quite a bit better, three dimensionally speaking, than a Turner Prize exhibit such as *My Dead Dad*.

This is an image again on the outside of a church which could come completely from the British Museum but is ancestral to our art here. It's a crocodile head from Kilpeck in Herefordshire. It's almost abstract in a way in its power, in its delineation. There's a hint of what in classical art would be called the worm ouroboros. It is the snake that devours its own tail and is a serpent within a circle of fire and represents a primeval European racial and cultural symbol. There's great power in this imagery as the head comes out of the stone in one way, reflexively, to devour. In the culture which it originates from, the crocodile is a serpent, is a dragon, is a snake, represents the snake in the Garden of Eden, represents knowledge, fulfillment, desire, eros, and the choice that humans have to make in this life.

Here's another image which is ancient and yet modern bearing in mind that a lot of these monsters depict the "horrid," but they do so from the perspective of the twelfth-century imagination. So, we're looking at work which, give or take the odd hundred years, is a millennium old. It's a thousand years old, yet it springs out fully formed. This is a monster from York Museum. You see a man with a club fending off various demons of the dark nearly always configured in reptilian terms. The reptilian part of the brain, if you believe in evolutionary brain theory, is devouring the individual in the twelfth-century imagination. The mouths come out. The body of the sinner, as it were, is devoured and carnivorously ripped asunder, although the delineation in this piece of three-dimensional relief refers to the soul and to the spirit of man corporealized, seen as a body, on the outside of a church, now inside of a Yorkshire museum.

Yes, here's a sort of horror video of its time, in a way. It's a vaulting boss from Alston in Gloucestershire. You've got four interconnected heads here around a sort of Celtic cross, an interconnecting nodal point from which their sort of skull heads ra-

diate. You can see the mouths. You can see the teeth. You can see the eyes. They're gruesome, they're grim, they're devouring, they're diabolical and yet divine. It's quite a small space by the looks of it, and it's carved in a sort of kaleidoscope of malevolent stone. It's like an image from Tolkien's *The Lord of the Rings*, but it's a thousand years back, and it shows the fecundity of the English medieval imagination.

These are forms of traditional primitive art. This one, which represents an early angel, represents a sort of powerful chthonic early image of an angel based upon Romanesque precepts. There seems to be an eagle or a bird of some sort above it. The eagle cosmologically often represents the superior part of the spirit soaring above. You've got the angel with a sword. It seems to be fighting with a creature. You have the wings coming out of the back of the angel. It's very much in stone relief, the sort of art that existed in the catacombs from whence Christianity emerged to take the Roman Empire and then the Western world. It's from Kilpeck. And it's yet another of these examples of primitive art which in its power of statement far exceeds postmodern primitivism and post-industrial primitivism, which doesn't believe in anything.

Yes, this is an image inside Coventry Cathedral as it was. It's now destroyed, of course, because of the bombing of Coventry during the war which decimated the cathedral and forced post-war planners to rebuild it. Now, in this image, to concentrate on this first, we see a sort of rather avuncular angel with its massive wings like an eagle bursting from its frame on either side, possibly playing a harp here, given the plane of the instrument to the body. Wide-eyed. The eyes have no eyeballs. Alive, vigorous, very powerfully present and three dimensional. Poised. A certain repose, but almost a certain jocular aggression.

Now, there's an interesting story here because when Coventry Cathedral and environs were destroyed, it was rebuilt along essentially contemporary lines, lots of concrete used in the new cathedral. Graham Sutherland, a figurative and anthropomorphic artist who melded shapes in nature together to produce reliefs in the fifties and was a rival to Bacon for artistic preeminence within Modernism at that time, produced the stained

glass for the new cathedral. And a woman who was apparently some slightly crazed Christian believer came up from the south coast with a hammer to the Midlands to attack this object, the crucifixion, a staple of Western art throughout two millennia, because she didn't like the look of it, because she considered it to be a desecration.

But the idea of Sutherland being a bit of a desecration is in contemporary terms a bit of nonsense, because Sutherland relates to primitive art traditions that go back to these medieval carvers and stonemasons and workers in the three-dimensional. Because his images of the Christ are images that pre-date early Renaissance art. They're Romanesque; they're Byzantine; they're Gothically primitive. They are white aboriginal pieces of non-classical refinement.

Here's another ancestral and traditional English image. It is from Worcester Cathedral. It's entitled *The Tournament*. It's a relief, of course, because it's not three dimensional in the round, so you look at it one way on. It's a joust. If you've ever seen the 1950s Hollywood film, quite a good film, *Ivanhoe* of Walter Scott's epic, you'll know what I mean. We have the two warriors fighting it out within the context of Christian dominion. Possibly there's two ladies, maybe, on either side, or they're warriors who are fighting on behalf of women who tie their ribbons to the lances. Even if the lance goes through one of them and pins them to the heart, they'll have a sort of grand dame's ribbon on the tip.

So, we have here glory, the heroic, the masculine, the violent, the English, or at least the post-Norman in the context of a religion of peace. Because it is important to understand that the medieval period and thereafter was not a dispensation of Christian humanism. It was a traditional Western and organic society whose belief system, semiotically, was Judeo-Christian. But this type of warriorship pre-dates Christianity and is there at the very beginnings of our culture and, of course, in the better traditions of even the contemporary armed forces still exists.

This is a powerful, a primeval, and a triumphant image. The eagle is cardinal to Western civilization. In Nietzsche's *Thus Spake Zarathustra*, the archetypal Aryan Persian mystic, Zarathustra, the originator of Zoroastrianism, has two pets. One is an

eagle, and one is a serpent. This goes back to ancient Greece where the gods, in particular Zeus, the primary god after the overthrow of the titans before him, has pets like an eagle, which symbolizes courage and partially masculinity, and a snake, which symbolizes partially femininity and knowledge, because in this life all you need, deep down, is courage and knowledge.

Now, this is in St. Wiggenhall's Church. It's part of a brass lectern. A divine would have stood next to this, alongside it and given a Christian oration. One sees in all of this art the narrative of Christianity unfolding through replication of primeval Indo-European imagery in an English and British context. But you have to understand that this type of Christianity is very much integrated completely into the doctrine of the Western civilization. And obtruding out of it in a heroic image like this, no matter how Christian the context, is the paganism that went before.

Here we have an interesting and rather paradoxical image from St. Alban's. It comes from the 1500s. Are they heroic sort of rearing sheep? Paradox upon paradox. Or are they sort of Romanesque and rather half-formed lions, which don't particularly look lion-like? Or who knows? But they're interesting rearing creatures on either side of a heraldic motif for a late abbot. The eagle again appears triumphantly, claws out, wings distended. It again shows this sort of heroic and martial element even for a dead cleric in three-dimensional stain work of early modern, and approaching the Reformation, Christianity.

Here we have a traditional heraldic device in stone. Margaret Patton's London. The lion and the unicorn, traditional images of the royal house and of England. Heroic. Mythological, of course, in the case of the unicorn. Rearing, symbolizing the union. Florid. There's a sort of baroque and even rococo feel to the thing. It's deliberately stylized, deliberately ornate. Fierce and it's exaggerated in the splendor it is displaying. It's almost like a patriotic peacock display in stone. It's a relief, but it has certain of the energy and solidity of a three-dimensional work that you can actually walk around, because it fills its own space and extends from it.

Now, with all of this traditional material that we've been looking at as a response to the Turner Prize formulations of

earlier in this talk, we are attempting not just a reversal. We're not just being reactionary in liberal terms, going back. We're going back to go forwards, because when you look at this art you realize it has far more energy, far more life, far more vigor. It's more alive, even if it speaks to us across half a millennium or a thousand years and more. Why is this? It's because, as I have already intimated, it's pre-formulated, it comes out of an organic culture. The artist expresses racial essence through cultural form. It has a dynamism and a vigor and an arrow which shoots into the future.

One doesn't have to be a Christian at all to appreciate it, because Christianity was the narrative and the semiotic of our culture. When our warriors went abroad, when they killed foreigners, when they did what was necessary for this country, they had a cross on their shields and on their jerkins. But they were pagans who had a cross. And this is what this Christianity really means and is.

This tradition has now died. And one sees in the deconstructive art of modernity and late modernity, as exemplified by the Turner Prize, a sort of anti-Western tradition, a sort of narrative impulse which is against the bloodline of our own history and identity. Doesn't portend to all of these works. There is some quality to some of them in a nuanced way. Some of them are hinting to elements beyond themselves, which I personally see in the work of Quinn, amongst others.

But they would have to go back to go forward. And they have committed the cardinal mistake that much of Modernism is research and development for Classical art, as was. Everything has to be renewed, just as Rodin, the great French sculptor, renewed Neo-Classical art at the end of the nineteenth century by injecting into it Impressionist movement.

This art can go on, can be reinvigorated, but it involves the British people, the English people, and their intellectuals and artists, in particular, recovering their spirit and recovering their dynamism as a people to go forwards into the future.

Art is the creation in objective form of the spiritual nature of a people. A people is essentially a racial grouping, even though the English are not a race, nor are the British. We are a part of the

Indo-European or white race, which is a polarity within the overall anthropological designation of the pale. We are a race, and then a culture, and we culturalize ourselves through nationality and through a feeling of belonging. The more English you are, the more British you are. And the more British you are, the more European you are, which has nothing to do with the precepts or bureaucratic structures of the so-called European Union. And the more European you are within a hierarchy of values, aesthetically and biologically, the more Indo-European you are.

With this art that we have looked at as a *volte-face* to the Turner Prize superimposed upon us by the semi-artistic dictatorship of Serota and his ilk, we see a prior world. We see a world which pre-existed much of what has occurred since the Second World War. It can exist again. It shall exist again. It exists within the genetic makeup of the British people. All we have to do is to reach into the present with the many talented artists who exist at this time. It's quite a mistake to think that they don't exist at this time. Some would have it otherwise, but the contrary is the truth. We need to wrench from the artistic presentation of the present the folly that exists within most of the exhibits that come forward under the banner of the Turner Prize. Let us return to tradition to go forwards with modernity in a different direction.

Counter-Currents, March 15, 2016

INDEX

Numbers in bold refer to a whole chapter or section devoted to a particular topic.

1968 (Paris riots), 14, 132, 143

A
Abbey Theatre, 100
ABC, 142
Abercrombie, Lady, 27
Abetz, Otto, 132
Abstract Expressionism, 13, 17
Action Art, 144, 161
Adenauer, Konrad Hermann Joseph, 125, 155
Aeneid, 123
aesthetics, 133
affirmation (of Western values), **140–41**
African-Americans, 55–56
afterlife, 34
AIDS, 124, 166
Alberta, 51
Alexander (the Great), 122
alienation, 152, 161
Allen, Richard, 149–50, 158
Alston (Gloucestershire), 175
American Civil War, 33, 101
Americanism, 60, 67
anarchism & anarchists, 79, 142, **150–52**, 158; conceptual, 29
angels, 175–76
Anglicanism, Eliot's conversion to, 70, 72, 73, 76, 80, 81, 85; Irish Anglicanism, 117; and Yeats, 117
Anglo-Americans, 67, 85, 133
Anglo-Catholics, 8, 72, 77, 88

Anglo-Irish Treaty, 102
Anglo-Irish War, 102
anthropology, 84, **131–32**, 173, 179
anti-Americanism, 59
Anti-Art, 161, 164, 166, 169, 171
anti-bourgeois art, 18, 158, 159, 164, 168, 169
anti-communism, 26, 112
anti-democracy, 11, 50, 142
Antifa, 151
anti-humanism, 3, 26, 126, 142
anti-objectivism (Liberal), 4
Anti-Objectivist Art, 142, 144, 157
anti-Semitism, 92
Apel, Heinrich, 125
Archaos (*Cirque Archaos*), 161
archeo-futurism, **91–93**
aristocracy, rule by, in Pound, 57; in Yeats, 110
Arnold, Walter, 125
Art Brut, 5, 159
Artaud, Antoine Marie Joseph Paul, 43
Arts Council, 89
Ashbery, John, 93
Ashcroft, John, 122
The Assault on Culture: Utopian Currents from Lettrisme to Class War, 142, 145, **158–59**, 161
atheism, 81, 134
Athena Parthenos, 126

Atlantic slave trade, 147
Auden, W. H., 100
Australasia, 93
Austrian school, 52
Auto-Destructive Art, 148, 159, 161

B
Bacon, Francis, 2, 3, 5, 14, 125, 176
Bakunin, Mikhail Alexandrovich, 79, 150-51
Ballard, J. G., 83, 160
Balthus (Balthasar Klossowski de Rola), 2, 171
Barnes, Djuna, 63
Baron, Alexander, 124
Barron, John, 126
Barrot, Jean, 149, 159, 161
Baselitz, Georg, 15, 158
"Bash the Rich" marches, 151
Basquiat, Jean-Michel, 15
Bataille, Georges, 159
Battleship Potemkin, 3
BBC, 53, 71, 142, **147-48**
Beat Generation, 59
The Beatles, 43
beauty, 9, 12, 13, 17, 116, 123, **172-74**
Beckett, Samuel, 10, 16, 76, 105, 124, 146, 160,
becoming, ecstasy of, 3
Bedlam Hospital, 26
Beethoven, Ludwig van, 167
Being (in Heidegger), 153
Belfast, 104
Bellmer, Hans, 171
Belloc, Hilaire, 70
Benn, Gottfried, 79, 123
Benoist, Alain de, 14, 151
Beowulf, 118
biology, 110, 135, 147, 154, 155, 157
Black & Tans, 103
Black Metal, 32, 36
blackface, 146-47
Blackshirts, 37; *see also* BUF
Blair, Sir Anthony Charles Lynton (Tony), KG, 122, 138, 165, 166
Blake, Williams, 52, 56
Bloomsbury (artistic circle), 20, **37-39**, 81-82
Blueshirts, 102, 104, 107
Boer Wars, 33
bohemia (millionaire or revolutionary), 37-39, 42
Bollingen Prize, 54
Bolsheviks, 9, 38, 158
Bolton, Kerry, 64-65
Bond, Edward, 89
Bone, Ian, 150, 151, 152
Bonham's, 15
Bonnot Gang, 153, 157
The Book of Pleasures, 143, 160
Bosch, Hieronymus, 1, 2, 3
bourgeoisie, 38-39
brainwashing, 128
Breker, Arno, 2, **122-27**; works: *Studio at Jackesbruch*, 122; *Torso with Raised Arms*, 122; *The Judgment of Paris*, 122; *Resurrection*, 125; *Saint Matthew*, 122; *Saint Sebastien*, 125; *Saint George*, 125; *Saint Christopher*, 125; *La Force*, 122
Brenton, Howard, 89
Breton, André Robert, 14, 143, 145, 159
Brit Pack, 166, 167, 171
Britain, 8, 14, 22, 26, 36, 39, 56, 89, 102, 106, 108-15, 120, 127, 137, 157-61, 164, 169

Britart, 18
British Gas, 86
British Modernism, 6, 31
British Museum, 174
British National Party, 149, 167
Broch, Hermann, 123
Brown, Lawrence R., 60
Brueghel, Pieter (the Younger), 1
Buchanan, Patrick J., 61
BUF (British Union of Fascists), 19; *see also* Blackshirts
Buffet, Bernard, 2, 125
Burgess, Anthony, 22, 83
Burlington House, 165, 170
Burroughs, William S., 147, 157
Burton, Sir Richard, 154

C
caesarism, 83
Calder, John, 25
California, 120
Cambodia, 148, 161
Cambridge University, 78
Camden Town, 165
capitalism, 8, 17, 39, 52, 62
Capote, Truman, 4
Caravaggio, Michelangelo Merisi da, 2
Carr, E. H., 79, 150
Carson, Edward Henry, 104
Carter's, 15
CBS, 142
Céline, Louis-Ferdinand (Louis Ferdinand Auguste Destouches), 10, 36, 138, 140, 143
Celtic cross, 175
Celtic Dawn revival, 111
Celtic people & culture, **111–15**

Central Intelligence Agency (CIA), 13
Chapman Brothers (Iakovos "Jake" & Konstantinos "Dinos"), 18, 168, 170
Chapman World, 170
Chatto & Windus, 27
Chaucer, Geoffrey, 93
Chesterton, G. H., 70
Chicago School, 52
Chilcot Inquiry, 129
Child Art, 39
child molestation, 160
China, 60
Chinese torture, 128, 148
Chirac, Jacques René, 157
Christian Martyrs (Frink), 126
Christianity, 22, 68, 71, 74, 77, 78, 83, 88, 94, 117; and images, 172, **176–79**; post-Christianity, 18
Christie's, 15, 17
Church of Ireland, 117
Churchill, Charles, 8
Cimabue, 1
cinema, 2, 5
Civic Guard, 102, 106
Clark, Alan, 89
Class War (anarchist group), 142, 150–52, 159
class war, 38
Classicism, 26, 68, 77, 82; pseudo-, 122; *see also* Neo-Classicism
Clive of India (Robert Clive), 174
A Clockwork Orange, 83
Collier, John Payne, 35
Collins, Michael, 102, 108
comics, 4, 5
communism, 9, 32; *see also* Home, Stewart

communitarianism, 108, 120
conceptual art, 144, **169–171**; see also onanism
Confederate States of America, 101
Confucius, 55
conservatism, 72, 82, 83, 90, 129, 133, 160; see also revolutionary conservative
Constructivists, 9
conversion or re-conversion, 69, 70, 73–74, 76, 88, 90
Cool Britannia, 10, 166
corbels, 171, 173
Coren, Alan, 21
Corpse Art, 162
Counter-Currents, 72
courage, 31, 88, 177
Coventry Cathedral, 125, 176
Cowling, Maurice, 130, 132
Cremer, Fritz, 125–26
criminology, 133
Critical Theory, 11, 133, 135
Crome Yellow, 27
Cromwellism, 100
cross (symbol), 175, 179
Crowley, Aleister, 43
CRS (Compagnies Républicaines de Sécurité), 14
cruelty, 43, 168
Cruikshank, George, 35
Cubism, 14
cults, of the amateur, 40; of anti-intellectuality, 61; of the child, 30, 38; of the future or the new, 145; of the homosexual, 30, 38; of individuality, 100; of the Negro, 30, 38; of the outsider, 30; of the primitive, 21, 39; of simplicity, 48
cultural communism, **157–62**

cultural determinism, 157; decay, 159; proletarianization, 39, 50, 125, 149, 150, 159; terrorism, 158
cultural struggle, 89, 113, 129; see also metapolitics
cultural studies, 133
culture bearers, 57, 58, 66, 108
Cunard, Nancy, 28
Cushing, Peter, 148
cyborgs, 14
cycles, in Yeats' view of history & legend, 109, 116

D

Dada & Dadaists, 16, 169
Daily Mail, 141
Dale, Richard J., 112
Dalí, Salvador, 2
Dante, 24, 34
Das Kapital: Kritik der politischen Ökonomie, 137
Dasein, 153
Dauvé, Gilles; see Jean Barrot
de Gobineau, Joseph Arthur de, 131
de Man, Paul, 139
de Valera, Eamon, 8, 102, 103, 107, 111, 115
Dead Souls, 35
The Death of Virgil, 123
death penalty, 82
Debord, Guy, 143, 157–60
decadence, 89, 128
Decline of the West, 83, 109, 160
deconstructionism, 10–11, 29, 135, **138–41**, **147–49**, 151–52, 164, 167, 170–71
degenerate art, 1–2
Dehumanisation of Art, 3–4, 11
dehumanization, 81
Deleuze, Gilles, 136

Demetrius the First (sculpture), 122
democracy, 13, 35, 102, 110, 129, 134
Der Stürmer, 35
Derrida, Jacques, 135–36, 139
despair, 69, 73, 74, **76–77**, 160–61
destruction, as a creative passion, 150–51
détournement, 157, 160–61
Devil; *see* Sammael
Diana, Princess of Wales, 131
diction, American, 60, 62
direct action, 152
dirigisme, 9
Dismorr, Jessie, 22
Divine Comedy, 34; *see also Inferno*
Don Giovanni, 171
Donne, John, 69, 84
Doolittle, Hilda, 48, 53
Dostoevsky, Fyodor Mikhailovich, 30, 41, 70
Douglas, Major Clifford Hugh, 49, **51–52**, 57; *see also* Social Credit
Drieu La Rochelle, Pierre Eugène, 132
drugs & addicts, 15, 82, 156, 161, 166
Dryden, John, 37
Dubuffet, Jean, 159
Duchamp, Henri-Robert-Marcel, 16, 146, 166, 171
Duke, David, 61
Dworkin, Andrea, 169

E
eagle, **175–78**
East Germany, 125
economics, 32, 51, 59, 84, 133

The Economist, 51
egalitarianism, 9, **130–31**, 138, 141
Egoist Press, 30, 64
Eiffel Tower (London restaurant), 53
Eliot, T. S., 7–8, 19, 26, 36, 49, 63, **68–70**, **71–98**, 99; works: *After Strange Gods: A Primer of Modern Heresy*, 68, 72, 92; "Ariel," 78; *The Ariel Poems*, 77; "Ash Wednesday," 69, 70, 77, **90–91**; *Collected Poems 1909–1962*, 74; "The Hollow Men," 68, 70, 73, 78, 83, **94–97**; "The Love Song of J. Alfred Prufrock," 69, **74–75**, 78; *Murder in the Cathedral*, 70, **88–89**; *Prufrock and Other Observations*, 73; *The Rock*, 70, 78; *Sweeney Agonistes*, 70; "The Waste Land," 49, 68, 69, 73, **75–76**, 78, 83
elites & elitism, 3, 6, 9, 13, 77, 130, 141
Elizabeth I, 105
Elizabethan Age, 90, 134
emigration, Irish, 101, 105
Emin, Tracey, 16, 141, 171, 172
empire, American, 61; British, 39, 120; Roman, 161
end times, 91
Endgame, 124
Engels, Friedrich, 135
English language, 37, 58, 63, 68, 80, 97, 111, 117, 118
English literature (academic subject), 31, 46, 133–34
English National Opera, 146
English people or race, 81, 90, 93, 114, 177, 179

enlightenment, liberal, 57
Enlightenment, 136
Ernst, Max, 2
Essay on the Inequality of the Human Races, 131
essentialism, 80, 92, 134, 136, 138–41, 146, 148, 154, 156
Eugenic Society, 110
eugenics, 110, 136
European Americans, 58
European Civil Wars, 122, 125; *see also* First or Second World War
euthanasia, 82
Evening Standard, 141
Evola, Giulio Cesare Andrea, (Julius), 21, 36
Exeter Cathedral, 172, 175
existentialism, 76, 134–35
Expressionism, 14, 123, 143
Eyre, Richard, 147
Ezra Pound: The Solitary Volcano, 59n3

F
Faber & Faber, 56, 72, 74
Facades: Osbert, Edith & Sacheverell Sitwell, 38
Facial Justice, 32
fame, 12, 142, 159, 166
Far Right, 110, 112, 115, 130, 134, 142
Farquhar, George, 105
Farrakhan, Louis, 147
fascism & fascists, 3, 4, 11, 29, 34, 59, 93, 132, 139, 142, 149
Fawlty Towers, 29n36
feminism, 38–39, 72–73, 155, 161, 166
Fenians, 101
Fianna Fáil, 103, 107, 111–12, 114

Fin de Partie, 124
Fine Gael, 106–107, 115
First World War, 19, 21, 26, 33, 45, 53, 69, 87, 109; *see also* European Civil Wars; Great War
Flemish art, 173
Fluxeuropa, 149
Fluxus, 142, 159
Foot, Paul, 69
forgery (art), 17, 26
Formalists, in art, 4, 9; in linguistics, 135, 144
The Fountainhead, 41, 127
Four Quartets, 90
Fowles, John, 83
Fox (network), 35
Frankfurt School, 57, 128, 160
freedom, 13, 23
French Academy (Académie Française), 132
French Communist Party, 159
French people, 168
Friedman, Milton, 131
Frink, Elizabeth, 126
Front National (France), 88
Frost, Robert, 48, 54
Futurism, 9, 22, 145–466

G
Gablik, Suzi, 14
Gance, Abel, 2
Gang of Four, 7
Garden of Eden, 175
gargoyles, **171–74**
Gaudier-Brzeska, Henri, 53, 143
Gaullism, 129
gay liberationism, 154, 158
Georgian poetry, 78
Germany, National Socialist (Nazi), 2, 12

Gibbon, Lewis Grassic, 158
Giotto di Bondone, 1
Gladstone, William Ewart, FRS, FSS, 101
The Glass Bees, 32
global warming, 124
glory, 30, 58, 177
Gobel, Bernd, 125
Godard, Jean-Luc, 162
Goebbels, Dr. Paul Joseph, 27, 54, 158
Gogol, Nikolai Vasilyevich, 35
Goldsmith College of Art, 166
Gomułka, Władysław, 137
Gonne, Maud, 100
Gorky, Maxim, 4
Gothic art, 173, 177
Goya, 159, 168
Graffiti Art, 15
Gramsci, Antonio, 129
Grayson & Grayson, 30
Great Deeds Against the Dead, 168
Great Depression, 8, 19
Great War, 16, 19–20, 22, 28, 32, 41–42, 46–47, 50, 73, 87, 145, 169
GRECE, 88
Greece, 58, 177
Greek Sculpture (Barron), 126
Greenberg, Clement, 17
Griffith, Arthur, 101–102
Griffiths, Trevor, 89
Grigson, Geoffrey, 29
Grundrisse der Kritik der Politischen Ökonomie (*Groundwork*), 137
Grünewald, Matthias, 1
Guattari, Pierre-Félix, 136
Guggenheim, Museum, 7
Guild Church of St. Margaret Pattens, 178

Gustav Seitz, Gustav, 125

H
Haigh-Wood, Vivienne, 68, 69
Hare, Sir David, 89
Hartley, L. P., 32
Harvey, Marcus, 164–65
Has Modernism Failed?, 14
Haughey, Charles, 112
Hayek, F. A., 131
Heaven, 35
Hegelianism, 148; *see also* Left Hegelianism
Heidegger, 7, **136–37**, 151, 153
Hell, 25, 34, 45, 49
Hellenism, 2, 22, 122, 167
Hellenistic norms, 2, 22
Hellfire Club, 8
Hemingway, Ernest, 23, 48, 54, 59, 63–64, 123
Hera, 122
heraldic device or motif, 178
hermeneutics, 136–37
Hermetic Order of the Golden Dawn, 109
heroism, 90, 125–27, 168, 177, 178
hierarchy, 2, 6, 10, 15, 19, 77, 80, 90, 93, 140, 150, 155, 179
high culture, 7, 88, 94
Hindley, Myra, **164–65**, 170, 179
hippies, 141–42, 170
Hirst, Damien, 16, 141, 163, 166, 170, 172
history of art, 133
Hitchcock, Sir Alfred Joseph, KBE, 2
Hitler, Adolf, 27, 29, 34, 42, 103, 145, 160
HIV, 124
Hobbes, Thomas, 133

Hockney, David, 4
Holocaust; see Shoah
Home, Stewart, **128–56, 157–62**
Homer, 65
homophobia, 3, 80
homosexuality, 20, 38, 82, 157
homosexuals, 139, 144
honor, 9
Hoover, J. Edgar, 54, 56
Hopkins, Bill, 23, 39, 66, 126, 149
Hughes, Ted, 72–73
Hulme, T. E., 3, 28
Huxley, Aldous, 27
hyper-reality, 14, 60

I
ICA (Institute of Contemporary Arts) 151, 152
idealism, heroic, 124, 126; Platonic, 86; Romantic, 78–79; transcendental, 113, 159
identitarian politics, 80, 119
identity, 72, 84, 85, 86, 92, 110, 114, 136, 138, 147, 152, 156; British, 106; Celtic, 115, 120; European, 151; sexual, 15; Scottish, 114; Welsh, 114; Western, 23, 59, 76, 139, 179
illiberalism, 43, 44, 130
imagination, 1, 2, 5, 45, 122, 174–75
Imagism, 10, 47, 53, 144, 159
immigration, mass, 81, 119; Third World, 26, 114–15; to Ireland, 119
Imperial War Museum, 26
India, 60, 174
inegalitarianism, 3, 81, 141
infantilization, 30, 35, 159, 169
Inferno, 24; see also *Divine Comedy*

internet, 32, 73, 148
IRA (Irish Republican Army), 99, **102–108**, 111, 115
Iraq War, 141, 166, 168
Irish Civil War, 102, 107, 115
Irish Free State, 8, 99, 102–107
Irish Republic, 8, 99, 103, 105, 108, 112
Irish Republican Brotherhood, 101
Irish-American political lobby, 101, 103, 112
The Iron Heel, 158
irony, 17, 32, 35, 54, 92, 110, 137, 140
isolationism, 58, 61
Italy, 7, 12, 47, 54, 58, 123, 129
Ivanhoe (film), 177
Ivy League, 134

J
Jameson, Fredric, 11
Jazz Age, 50
Jews, 35, 144
John, August, 9
John, Gwen, 9
jouissance, 138
Joyce, James, 10, 30, 32, 36, 37, 50, 64, 98, 105
Julius, Anthony, 68, 71, 92
Jünger, Ernst, 32, 42

K
Karloff, Boris, 161
Kasper, John, 59, 63
Kavan, Anna, 63
Keats, John, 167
Keynes & Keynesianism, **51–52**, 57–58, 82, 131
Kilpeck (Herefordshire), 175, 176
King Kong, 173

Kipling, Joseph Rudyard, 39, 99
Klimt, Gustav, 3
Kolbe, Georg, 125
Korean War, 128
Kristeva, Julia (Yuliya Stoyanova Krasteva), 161
Kronos, 159

L
Leavis, Frank Raymond (F. R.), CH, 78
Labisse, Félix, 2
Labour Party, 19, 62, 89, 108, 113, 134, 158, 165; *see also* New Labour
Lady Chatterley's Lover, 21
laissez-faire economists, 52
Lang, Fritz, 2
Laocoön & His Sons, 122
Lapper, Alison, 16, 167
Larkin, Philip, 49
Lawrence, D. H., 21-22
Lawson, Richard, 149
left anarchism, 158
Left, 12, 19, 58, 79-80, 89, 91, 129, 130-33, 135, 141, 143, 145, 152, 155
Left Hegelianism, 135, 159; *see also* Hegelianism
Lempicka, Tamara de (Tamara Rosalia Gurwik-Górska), 27
Lenin (Vladimir Ilyich Ulyanov), 12, 129, 153
Lennon, John, 142
Lettrism, 14, 142, 145, 159
Levi-Strauss, Claude, 135, 140
Lewis, C. S., 70, 77
Lewis, Percy Wyndham, **6-31, 32-36, 37-40, 41-44**, 49, 50, 53, 56, 62, 64, 70, 77, 80, 82, 83, 85, 93, 98, 123, 143, 173-74; works: *The Apes of God*, 7, 20, 30, **37-40**, 42; *The Art of Being Ruled*, 8, 20, 32, 39, 123; *Blast*, 22, 53; *Canadian Gun-pit*, 26 *The Childermass*, 7, 24-25, **32-36**; "The Code of a Herdsman," 6, 8, 43; *Count Your Dead: They are Alive!*, 20; *The Demon of Progress in the Arts*, 10, 24; *The Doom of Youth*, 20; *Hitler*, 27, 29, 34; *The Human Age* trilogy, 24-25, 30, 33; see also *The Childermass, Monstre Gai, Malign Fiesta*; *The Jews: Are They Human?*, 21; *Journey into Barbary*, 30; *Left Wings Over Europe*, 20; *Malign Fiesta*, 24-25, 34; *Men Without Art*, 23; *Monstre Gai*, 24-25; *Paleface: The Philosophy of the "Melting-Pot"*, 21; *The Revenge for Love*, 26, 30; *Rotting Hill*, 26-27; *Tarr*, 18, 19, 30, **41-44**, 50, 64; *The Vulgar Streak*, 26; *The Wild Body*, 20
liberal critics, 43, 109, 126
liberal humanism, 4, 10, **12-13**, 142
liberal Left, 91, 165
liberalism, 8, 57, 81, 92, 101, 133, 155
libertarian-communism, 142, 157
Library of Congress, 54
Limbo; *see* Purgatory
lion, 172, 178
Little House on the Prairie, 60
Liverpool, 31, 167
Livingstone, Ken, 141, 168
Lloyd George, David, 103

London Zoo, 165
London, Jack, 158
Lord of the Rings, 175
Lowell, Amy, 48, 53, 63
Lowell, Norman, 5
lumpen, 9; see also masses
Lysippus, 122

M
Machiavelli, Niccolò di Bernardo dei, 20
magazines, 47, 58
Mail Art, 145, 159, 160
Malliol, Aristide Joseph Bonaventure, 126
Mannerism, 123
Manzoni, Piero, 144, 171–72
Mao Zedong & Maoists, 133, 154, 161
March on Dublin, 107
March on Rome (Mussolini's), 104
March on Rome (painting), 4
march through the institutions, 134; through the media, 134
Marcuse, Herbert, 57
Marinetti, Filippo Tommaso Emilio 22, 143, 145; Marinettists, 145
marriage bond, 82
Marshall, Alfred, 131
Marvell, Andrew, 69, 84
Marx, Karl, 71, 108, 129, 135
Marxism, 9, 39, 57, 79, 89, 100, **128–29**, 131, 133, 134, 137, 154, 159
Marxist-Leninism, 137,
Massacre of the Innocents (Poussin), 3
masses, 3–4, 6, 10, 15–17, 50, 57, **152–54**; see also *lumpen*

materialism, 32, 65–66, 157
mathematics (academic subject), 111, 134
Maurras, Charles, 8
McLuhan, Marshall, 36
media, 23, 32, 35–36, 87, 134
Men without Women, 23
The Merchant of Venice, 147
Merfin, Beryl, 148n9
Metaphysical Poets, 69, 84
metaphysics, 69, 70, 74, 84, 88, 134
metapolitics, 29, 43, 86, 92, 93, 98, 102, 108; see also cultural struggle
Metzger, Gustav, 148, 173, 161
Meyers, Jeffrey, 29
Michael (novella), 158
Middleton, Thomas, 69
Miller, Arthur, 54
Miller, Henry, 64
Milliband, Edward Samuel, 62
Milton, John, 24
Minton, John, 125
misanthropy, 3, 11, 143
modern art, **3–5**, 11, 39, 126, 171
Modernism, 3, 4, 6, **10–19**, 39, 41, 47, 58, 69, 71, 123, 142–43, **169–71**, 176; early, 10, 13, 39, 69, 143, 178; radical, 11, 13, 15, 29, 31; ultra-Rightwing, 3
Modernist aesthetic, 13, 172
modernity, 10, 11, 13–15, 19, 28, 30, 76, 134, 164, 171, 172, 179–80
Moore, Henry, 172, 174
Mosley, Sir Oswald, 7, 19, 86
Movement for an Imagist Bauhaus, 145, 159
MSN (network), 35

MTV, 35
Müller, Andre, 123
Mullins, Eustace, 59
multiculturalism, 82, 114–15
Murdoch, Iris, 43
Mussolini, Benito, 7, 47, 50, 53, 55, 60, 104, 123, 145
Muybridge, Edward, 1, 5
"My Bed," 166
My Dead Dad, 175
myths, national, 108

N

Naked Angels: Lives & Literature of the Beat Generation, 59n4
Napoleon Bonaparte, 105
Nash, Thomas, 8
National Front (UK), 138, 158
National Gallery, 167
National Roman Museum, 122
National Socialism, 4, 12, 138
National Theatre, 89, 152
National-Bolshevism, 158
nationalism, 39, 89; Irish, 101, **111–15**; Welsh, **113–14**
Nazi art, 4, 17, 126
NBC, 142
The Necessity of Red Terror, 132, 160
Neo-Classicism, 3, 12, 17, 122, 124–26, 179; *see also* Classicism
neo-Edwardianism, 51
neoism, 128, 145, 150, 160
neo-liberalism, 52
Neo-Platonism, 86
Nevinson, C. R. W., 22
The New Age, 52, 63
New Criticism, 78
New Deal, 58
New Labour, 10, 166; *see also* Labour Party

New Left, 128, 136, 154, 155
New Right (British), 99, 153
New Right (French), 14, 132
New York Times, 14, 108
New York, 120
Nicaragua, 51
Nietzsche, 21, 27
Nietzscheanism, 6, 15, 21, 23–25, 43, 73
nihilism, Leftist, 76, 79, 128, 146, 153, 157; Rightist, 69, 70, 72, 79, 82
Nineteen Eighty-Four, 128, 148, 154
Nobel Prize, 70, 71, 77, 99, 111
Nordic culture, 118
Norman Conquest, 177
North Korea, 128
North of England, 173; of Ireland, 106; of the United States, 101 (*see also* Yankees)
Northern Ireland, 104, 106, 113
Notting Hill, 26

O

O'Casey, Sean, 105
O'Duffy, Eoin, 102–104, 107, 115
O'Hara, Larry, 149
O'Keefe, Paul, 29, 31
Oakeshott, Michael, 130, 132
Obama, Barack, 56, 61, 85, 120; his wife, 56
objective correlative, 69, 78, 85
occultism, 1, 52, 79, 100, 103
Ofili, Chris, 165–66
Old Masters, 17
Oliver, Revilo P., 60, 160
Olivier, Laurence, 147
onanism, conceptual, 158; *see also* conceptual art

Onassis, Aristotle, 18
One-Dimensional Man, 57
Ono, Yoko, 142
Operation Torch, 54
Orage, A. R., 52
organic society, 68, 72, 73, 82, 91, 92, 177, 178
originality, 43
Orpen, William, 1, 145
Ortega y Gasset, José, 3–4
Othello, 146–47
Outsider art, 159

P
Pacher, Michael, 1, 2
Paolozzi, Sir Eduardo Luigi, 2
Pareto, Vilfredo, 20
Passchendaele, Battle of, 19
Peabody Museum, 7
Pearse, Patrick, 111
Pearson, John, 38
Peninsular War, 168
Perspectives, 149
Peterhouse College, Cambridge, 130
philistinism, 4, 38, 77
Phillip's, 15
philo-Semitism, 51, 68, 71, 80, 139
The Philosopher's Pupil, 43–44
philosophy, 133, 136, 139, 151
photography, 1, 5, 126, 142
The Physical Impossibility of Death in the Mind of Someone Living, **163–64**
physics, 131, 134
Picasso, Pablo, 7
Piccadilly Road, 165, 170
Pierce, William, 60
Pieta (Buffet), 125
Pisa, 55
Plaid Cymru, 115

plastination, 162
Plath, Sylvia, 72–73
Plato, 86
Pluto Press, 151
poetry, 8, 12, 46, 48–49, 60, 62, 65, 68–70, 72–73, 77–78, 84, 93, 97, 101, 111, 114, 116, 120, 123; Victorian, 101
Pol Pot, 133, 149, 161
Poland, 137
political correctness, 38, 71, 141
Pollini, Francis, 128
polytechnics, 37, 134
Pop Art, 17
Pop Will Eat Itself, 171
Pope, Alexander, 37
pornography, 1, 158
Porsini, 35
Porterhouse Blue, 130
A Portrait of the Artist, 30
Portugal, 12
post-modern art, 141, 171
post-modernism, 4
post-modernity, 76, 168
Pound, Ezra, 7, 10, 18, 19, 22, 26–28, 36, **45–67**, 69, 75–76, **80–83**, 143; on Chinese culture, 49, 55, 65; translations, 65; works: *ABC of Economics*, 60; *Cathay*, 49; *The Cantos*, 48–49, 56, 64–65; *How to Read*, 60; "Hugh Selwyn Mauberly," 45–46; *Jefferson and/or Mussolini*, 60; *Pisan Cantos*, 19, 56
Pound, Omar Shakespear, 47
The Possessed, 70
Poussin, Nicola, 3
Powell, Enoch, 73, 88, 94, 106
Praxiteles, 2
pride, 140; national pride, 9,

105
progress, social, 83, 91, 110, 140, 155; spiritual, 69
progressivism, 91
Promethean attitudes, 6, 23
Protocols of the Learned Elders of Zion, 36
psychoanalysis, 39
psychology (academic subject), 84, 133; sports psychology, 134
psychopathology, 159
Punch, 35, 161
Purgatory, 25, 35
Puritanism & Puritans, 72, 77, 85, 88, 95, 100

Q
Quinn, Marc, 16–17, 167, 179

R
race, Stewart Home's theory of, 153
Rachewiltz, Mary de, 77
racing, 146
racism, 3, 15, 80, 131, 146
Radio 4, 71, 113, 150
Rand, Ayn, 44, 127
Rastafarians, 151
Rattigan, Terence, 89
reactionary, 13, 84, 109, 130, 134, 136, 155, 171, 178
ready-made, 16, 146, 166, 170
Reagan, Ronald, 52
realism, socialist, 125
Rechy, John, 157
Red London, 149
Red Shelley, 68
Redon, Odilon, 3
Reformation, 178
religion, 7, 17, 76–77, 84, 86, 93, 99, 137

Rembrandt van Rijn, 1
Renaissance art, 177
Renier, Gustaaf Johannes, 21n21
Renoir, Jean, 2
Republicans (Ireland), 4, **101–102**, 111
Republicans (United States), 46, 61, 129, 160
revisionism, 31, 59, 140; Holocaust, 124
revolution, 11, 15, 131, 135, 145, 152; French, 9; German, 135; in the soul of man, 19, 33; Soviet, 9
The Revolution of Everyday Life, 143–44
Revolutionary Communist Party (UK), 137
revolutionary conservative, 3
Richards, I. A., 78
Right, 50, 79, 80, 82, 86, 92, 112–13, 119, 132, 143, 155
Right-wing modernism, 11
Right-wing psychology, 41
Ripon Cathedral, 174
Rising (Irish), 102, 111, 116
Roberts, William, 22, 173
Robinson, Joan, 131
Rocky Horror Show, 161
Rodin, François Auguste René, 9, 126, 179
Roman Catholic Church, 25, 103, 112; theology, 33, 105; role in Irish politics, 103–104, 112
Romanesque art, 175, 176, 178
Romanticism, 49, 51–52, 77, 79, 82, 109, 116
Roosevelt administration, 58
Rops, Félicien, 2
Rosenstein, John, 36

Ross, Jonathan, 151
Royal Academy, 165, 170
Royal Chamberlain (i.e., Lord Chamberlain), 150
Rudge, Olga, 47
Russell, Bertrand, 133
Russell, John, 14

S
Saatchi, Charles, & Saatchi Gallery, 18, 170
Sammael, 25, 34
Sandinistas, 51
Sartre, Jean Paul, 24, 76
Saunders, Helen, 22
Saussure, Ferdinand de, 135
Saville, Jenny, 169, 173
Schreiber, Siegfried, 125
Schwarzkogler, Rudolf, 144–45, 161
scientism, 155
The Scorpion, 139, 149, 151
Scotland, 106, 113, 114
Scott, Sir Walter, 177
Scottish National Party, 115
Scruton, Roger, 132
Second World War, 7, 13, 17, 25, 48, 51, 54, 74, 81, 99, 106, 146, 154, 180; *see also* European Civil Wars
Second World, 12
Self, 167
Sensation Exhibition, 165, 170
sensibility, 11, 39, 101, 102, 122, 125, 143; in Eliot, 69, 77, **84–85**, 91, 93
sentimentality, 2, 18, 23
Serota, Nicholas, 157, 162, 163, 164, 180
Seurat, Georges Pierre, 14
sexism, 3, 80
sexology, 133

Shakers, 48
Shakespear, Dorothy, 47, 63, 64
Shakespear, Olivia, 47
Shakespeare & Co., 63
Shakespeare, William, 20, 90, 93, 105, 134, 146–47
Sharpe, Tom, 130
She's My Bitch, 149
Shelley, Percy Bysshe, 69
Shoah, 124, 147
Short, Claire, 129
Sinn Féin, 102, 107
Situationism, 14, 145, 149, **159–61**
Sitwell, Edith, 28
Sitwell family, 20, 38
Skalds, 118
skepticism, 22
Skinhead, 149
skinhead aesthetic, 158
Sky (network), 35
Slade School of Fine Art, 9
Smile (nihilist magazine), 153, 157, 158
Smith, Christopher Robert, 165–66
Smith's (bookstore), 149
Social Credit, **49–51**; *see also* economics; Douglas, Major Clifford Hugh
Socialist Workers' Party (UK), 137
Society of the Spectacle, 143
sociobiology, 110
Soho Square, 28
Solzhenitsyn, Aleksandr, 111
Some Sort of Genius, 31
Sorbonne, College de, 132
Sorel, Georges, 8
Sotheby's, 15, 17, 144
South African, 111, 93

South London, 141, 166
South (United States), 101, 139
Southern Ireland, 102–104, 106–107, 119
Southgate, Troy, 3
Soviet art, 4
Soviet Communist Party, 12
Soviet Union, 2, 13, 129
Spain, 12
Spartacus (novel), 158
Spengler, Oswald, 83, 109, 160
spiritualism, 1, 100
St. George's Chapel (Windsor Castle), 172
St. Elizabeths (mental hospital), 47, 56, 62
St. Wiggenhall's Church, 178
Stalin, 2, 12, 122, 33
Steiner, George, 67
Stoics, 123
Storm of Steel, 42
Stotzer, Walter, 125
Strasserism, 158
strength, 2, 3, 30, 112, 158
Stroheim, Erich Oswald Hans Carl Maria von, 2
structuralism, 39, 135, 140
Suedehead, 149
Surrealism, 14, 143–45, 159, 169, 170, 174
Sutherland, Graham, 125, 176–77
Sweden, 110
Syberberg, Hans-Jürgen, 2
The Symbolist Movement in Literature, 69
Symonds, Arthur, 69
Synge, John Millington, 100, 105

T

T. S. Eliot, Anti-Semitism & Literary Form, 68, 71, 92
Tarkovsky, Andrei, 2
Tate Gallery, 7, 157, 158, 163, 164, 169
Tato (Guglielmo Sansoni), 4
Taubman, A. Alfred, 17
taxidermy, 16, 162, **163–64**
technology, 14, 19, 22, 33
television, 35–36
Texas, 120
Thalidomide, 16, 167
Thatcher, Margaret, 52, 89
The English: Are They Human?, 21
The Observer, 135
The Who, 161
theory, pure, 137
Theosophical Society, 109
Thinkers of the Right: Challenging Materialism, 64–65
Thion, Serge, 140
Third Way in politics, 103, 112
Third World, 12, 26, 114
This Difficult Individual: Ezra Pound, 59n5
Thomas à Becket, 70, 88
Thorak, Josef, 2, 127
Thorez, Maurice, 159
Throbbing Gristle, 161
Thus Spake Zarathustra, 177
Tolkien, J. R. R., 176
Tolstoy, Count Lev Nikolayevich, 99
Tom & Viv (play & film), 72
Tone, Wolfe, 100
Tories, 8, 19, 62, 89, 108, 160
totalitarianism, 37, 50, 82, 128, 133
The Tournament, 177
Townsend, Pete, 161
Traditionalism, 21
Trafalgar Square, 16, 167

tragedy, 126; Greek, 84, 90; Renaissance, 90
transcendence, opposition to, 150, 157, 159
transcendentalism, in Yeats, 99; among Celts, 113
translations, Pound's, 65
Treddis, Mrs., of North Wales, 148
Trotsky, Leon, & Trotskyism, 12, 64, 132, 153, 160
troubadours, 46, 57, 65
Troubles (Northern Ireland), 104
Truffaut, François Roland, 2
Turandot, 146
Turk, Gavin, 141, 166
Turner Prize, 10, 13, 16, 141, 157, 162, **163–80**
Tytell, John, 59

U

ugly Americans, 168
Ulster, 104, 113
Ultra-Modernism, 3, 6, 10, 11, 17, 27
Ultra-Rightwing, 3, 6, 11, 14, 112
Ulysses, 42, 50, 64
unconscious, 1, 83, 100, 159
unicorn (symbol), 178
Unionism (British), 100–101, 104, 106
Unitarianism, Eliot's conversion from, 70, 71, 76
United States of America, 7, 11, 17, 46, 48, 51, 54, 55, 58, 50, 72, 73, 78, 85, 101, 103, 110, 129, 139, 146, 154, 156
University College London, 9
University of Alabama, 139
University of Pennsylvania, 54
University of Slough, 131
University of Sussex, 132
Unkindest Cut of All, 89
Unpopular Books (publisher), 159
usury, 45, 51, 52, 61–62

V

Vaneigem, Raoul, 143, 159, 160
Vanguardism, 3, 108, 129, 133
Vatican Museum, 122
Vaughan, Henry, 69, 84
Venner, Dominique, 157
Venus of Willendorf, 167
Vermin from the Sewers, 161
Versailles Treaty, 83
Virago (publisher), 48
Virgil, 123
Virgin Mary, 165
von Hagens, Gunther, 162
Vorticism, 6, 14, 22, 27, 39, 53

W

Waiting for Godot, 124
Warhol, Andy, 15, 16, 171
Waterstones, 150
Waugh, Alec, 20
Waugh, Evelyn, 8
Weimar Germany, 8, 169
Wesker, Arnold, 89
West, Rebecca, 41
Westminster Abbey, 93
What is Situationism?, 159, 161
Wilde, Oscar, 39, 105
Williams, William Carlos, 54
Williamson, Henry, 22
Wilson, Henry Hughes, 99
Wilson, Woodrow, 83
Worcester Cathedral, 177
worm ouroboros, 174–75
Wyndham Lewis Society, 29, 36

X
Xenakis, Giannis Klearchou, 149

Y
Yale School of Deconstruction, 11, 139
Yale University, 11
Yankees, 48, 63; *see also* North, of the United States
Yeats, Jack B., 99
Yeats, W. B., 7–8, 19, 36, 47, 49, 53, 89, 93, 98, **99–121;** works: "Easter, 1916," 116–17; *The Green Helmet*, 111; "The Second Coming," 117–18
Yockey, Francis Parker, 60, 92
York Chapter House, 174
Yorkshire, 172, 173, 174, 175
Young Woman with Cloth, 127

Z
Zarathustra, 177
Zeus, 122, 126, 159, 178
Zoroastrianism, 177

About the Author

JONATHAN BOWDEN, April 12, 1962–March 29, 2012, was a British novelist, playwright, essayist, painter, actor, and orator, as well as a leading thinker and spokesman of the British New Right. He was the author of some forty books—novels, short stories, plays for stage and screen, philosophical dialogues and essays, and literary and cultural criticism—including *Pulp Fascism: Right-Wing Themes in Comics, Graphic Novels, & Popular Literature*, ed. Greg Johnson (Counter-Currents, 2013); *Western Civilization Bites Back*, ed. Greg Johnson (Counter-Currents, 2014); and *Extremists: Studies in Metapolitics*, ed. Greg Johnson (Counter-Currents, 2017).

www.ingramcontent.com/pod-product-compliance
Lightning Source LLC
Chambersburg PA
CBHW020904180526
45163CB00007B/2625